Healing Multiple Sclerosis:
Diet, Detox & Nutritional Makeover for
Total Recovery

# HEALING MULTIPLE SCLEROSIS

## Diet, Detox & Nutritional Makeover for Total Recovery

~~~~~~~~~~

## Ann Boroch

Foreword by Ann Louise Gittleman

QUINTESSENTIAL HEALING, INC. PUBLISHING

LOS ANGELES

Library of Congress Control Number: 2006901724

13 12 11 10 09 08 07          2 3 4 5

ISBN: 0-9773446-0-6

Published by Quintessential Healing, Inc., Publishing
Ann Boroch
Web site: www.annboroch.com
Phone: 818.763.8282

Cover design: Allison Boroch, Designing Elements
Web site: www.designingelements.com

Interior design and production: Robert S. Tinnon Design

This book is intended to serve only as a resource and educational
guide. I cannot assume medical or legal responsibility of having the
contents of this book considered as a prescription for anyone. Treat-
ment of health disorders needs to be supervised by your physician or
licensed health-care professional.

*To my mother:*

*You are my Rock of Gibraltar*

*and . . .*

*to those heroes who*

*have the courage and tenacity*

*to conquer disease*

# CONTENTS

# ACKNOWLEDGMENTS

This book is the product of much time, reworking, and editing, and I'm grateful to everyone who has helped me to shape it:

- Monica, thank you for making my vision of this book become a reality.
- Allison, thank you for your creativity with the cover.
- Bob, for the production and layout.
- Rena and Sarah, for the careful editing and the eagle eye.
- Nigel for guidance in putting this book out there.

As is true for us all, my journey has been blessed with much support and guidance along the way. I want to express my sincere gratitude to:

- All my friends, teachers, and health-care professionals who have helped me reach this point.
- My patients, who have taught me to be the best I can be.
- The late Dr. William Crook, who was a model of courage in writing his truth and helping so many.
- Dr. Bob, you are a shining light—thank you for being there and supporting my healing journey.
- Peter, you cleared up the cobwebs and gave me the confidence to be a great healer.
- Linda, for helping me during my darkest days.

- Josh, for your support and belief in the work I now do.
- Mom, you're my biggest cheerleader and have always been there for me.
- Irene, for your loyal support.
- Jasmine, because without you there was no hope or light at the end of the tunnel. I am eternally grateful for your magnificent gift.

# FOREWORD

True healing is like peeling the skin of an onion. There is no one single cause, and the various layers differ with each individual.

As the author of twenty-five books on health and healing, I believe with all my heart and all my soul that there is an answer to every disease—we simply have to look in the right place. The body is an incredible system with an infinite capacity to heal, provided that we lessen our toxic load and provide the right nourishment and environment for regeneration to occur.

The sad news is that today we are living in a sea of toxins that is making us fat and making us sick. For the first time in history, cancer overtook heart disease as the number-one killer of all Americans in 2004.

According to the National Cancer Institute, there are over 100,000 chemicals used by Americans in household cleaners, solvents, pesticides, food additives, lawn care, and other products. And every year, another 1,000 are introduced. One new chemical enters industrial use every twenty minutes. The average person living in twenty-first-century America is now contaminated with up to 500 industrial toxins, the majority of which haven't been tested for harmful effects. The CDC has been keeping an eye out on our collective "body burden" for a while and has found that we are all 100 percent polluted.

Over the past sixty years, our diets, lifestyles, and environment have undergone a revolution, placing a huge burden on our body's detoxification organs. Our tired and overloaded livers are

being exposed to more toxins than they can handle, our GI tracts are sluggish and constipated without enough fiber-rich food; we are lacking critical nutrients needed for the liver's detox pathways, and the liver's detox enzymes are being inhibited by common medications, excess sugar, caffeine, and trans fats.

Cancer rates have risen between 20 and 50 percent since 1970. Breast cancer will impact one out of eight American women if we live long enough. Asthma has increased by 75 percent since 1980. The diagnosis of autism has increased nearly 20 percent every year.

Type 2 diabetes is epidemic among young people in their thirties, while the incidence of autoimmune diseases like lupus, rheumatoid arthritis, and multiple sclerosis has gone through the roof.

And so, I am very pleased to say that Ann Boroch's book is right on the mark!

Her tumultuous four-year journey of reversing multiple sclerosis taught her firsthand to examine the layers that the body and mind take on to create disease. The result of her journey is a landmark book that identifies and unifies seemingly unrelated "root" causes that go beyond petrochemicals and targets candida/fungus, diet, silver fillings, parasites, vaccinations, geopathic stresses, trauma, and genetics, which are underlying hidden factors present in almost all autoimmune diseases. Best of all, Ms. Boroch provides workable, natural solutions for a practical self-help program that anybody with a desire to get well can follow.

Written in four parts, consisting of her personal journey, the causes of MS, and the solutions, Ms. Boroch's book also provides a wonderful treatment section chock-full of user-friendly charts, supplementation programs, recipes, and resources.

Ann Boroch will inspire and enlighten you. By following her program, you will not only experience more energy, heightened vitality, and mental clarity, but your overall health is sure to

improve. Ms. Boroch is to be congratulated for her courage and knowledge that disease is a wake-up call to clean up your act from the inside out!

ANN LOUISE GITTLEMAN, PH.D., M.S.

*New York Times* best selling author of
*The Fat Flush Plan,*
*Before the Change,* and
*The Fast Track One-Day Detox Diet*

# PREFACE

y doctor leafed through page after page of my medical chart—EEG results, neurological exams, evoked potential tests. . . . I had undergone two weeks of tests hoping to learn what was causing the spasms, numbness and tingling, and other neurological symptoms that had left me barely able to walk on my own.

"Well, Ann," he said, "the good news is, you don't have cancer. The bad news is . . . you have MS." With those words, I became a statistic, one of an estimated 500,000 North Americans, and three million people worldwide, who are afflicted by the debilitating disease of multiple sclerosis.

". . . Incurable . . . experiment with chemotherapy . . . slow the inevitable deterioration. . . ."

He went on speaking, but I was so much in shock that his words made no sense to me. Traditional Western medicine had failed to cure me of serious mononucleosis five years earlier. I had no confidence that it could help me now.

I left his office, and after two weeks of physical suffering, mental turmoil, and emotional torture, I turned my back on the traditional medical treatments for MS. I was only twenty-four, and terrified, but I refused to accept the prospect of spending my life in a wheelchair. "I will not be another MS statistic," I promised myself. And slowly, bit by bit, I created my own self-care program based on integrative medicine methods.

Four tumultuous years later, I had reversed MS.

You must understand that health is more than just the physical body. Health means a balance of the body, mind, emotions, and spirit. When you experience a chronic disease, all facets of the self must be examined. This means moving beyond the symptoms to address diet, lifestyle, stress, exercise, negative thoughts, fear-based emotions, and self-limiting belief systems.

Eventually, I hope, the usual paradigm in Western medicine will shift to a realization that even if two people have the same disease, they must be treated as individuals based on knowledge that each person's history is unique, that health is more than just treating the physical body, and that it is essential to go to the root cause. Then cures will be the rule, not the exception to the rule.

Most important, health is a choice. Yes, the body has an innate inner intelligence called *homeostasis* that works at keeping itself balanced. But this is not enough to maintain health if you are making unhealthy choices, entertaining negative thoughts, bombarding your body with depleted foods, overwhelming it with stress, and holding on to fear-based emotions. Whenever you make the apparently simple choice of what to eat each day, you are actually choosing whether you want health—or not.

Even as I took the first steps on my healing journey, it was clear to me that I would be moving, not only toward achieving recovery, but also toward helping others to move through the complexities of autoimmune disease. Today, I am a naturopath with a nine-year practice during which I've seen more than one thousand patients for various health conditions. Based on both my personal and my professional experience, it is my responsibility, and my passion, not just to educate you about the causes of MS and how to reverse it, but also to inspire you with the knowledge that you can triumph.

Society, your family, and your peers have more or less conditioned you to believe that you are powerless when it comes to MS—that drugs are your only options for living with this diag-

nosis. That is not so. There is a hidden truth to healing that has always been with us. This truth is the incredible individual power you possess to transform yourself—your body, your spirit, your mind, and your emotions. Making a choice to become healthy and then backing it up with belief and conviction are the keys to coming into your own power and turning around any disease.

This book is presented in four sections:

- Part One, "My Healing Journey," recounts my personal transformational journey and how I cured MS.
- Part Two, "The Real Cause of Multiple Sclerosis," describes all the causes of MS.
- Part Three, "You Can Heal Yourself: The Solutions," explains the solutions and why they are effective.
- Part Four, "Your Treatment Plan," gives you user-friendly charts, recipes, and exercises so you can create your own self-help treatment program.

PART ONE

# MY
# HEALING
# JOURNEY

# MY HEALING
# JOURNEY

As you will discover by reading my story, there are many ways to break down a body and create disease. I have learned that those components are not purely physical. When it comes to autoimmune disease, the imbalances of emotional, mental, and spiritual stress are just as important as poor diet, environmental toxins, and genetics.

My story is tumultuous but it does not mean that everyone with multiple sclerosis (MS) must go through the depths and layers as I did. What is important about my journey is that I now have the passion and knowledge to educate others. In this book I will reveal the causes and solutions available to you to reverse MS.

Let me take you back to where it all began . . .

~~~

I'd like to say I grew up in a happy, picture-perfect Father Knows Best household with mommy and daddy, but I didn't. My parents met and married at a very young age. I was conceived in a Corvette on the back roads of a small Connecticut town. Shortly thereafter, they moved to Southern California and settled in Montclair where I was born in 1965. I grew up an only child. My

mother is a beautiful, strong Italian woman with a great sense of humor. My father is a gregarious businessman of German/Polish descent. They made a handsome couple but bliss was short lived and they divorced when I was three.

As a teenager looking back at old pictures I felt a sense of loss and wondered what it would have been like to have grown up with both parents. Instead, I lived with my mother and saw my father every other weekend. Each household was a different environment and I found solace in each for what the other one couldn't offer. Until the age of nine, I was the center of attention in each home until my father remarried and then had my only half-brother.

My grandparents on my father's side were very influential in my life, especially my grandmother. She was a giving, strong-willed hypochondriac with no sense of humor. She spoiled me and I loved every minute of it.

The rivalry between my parents started early on and so did my anxiety. Their divorce was bitter and I felt their anger towards each other throughout my childhood.

As a way of distracting myself I started to participate in a variety of sports. My mother provided the funds for me to learn horseback riding, ice-skating, soccer, basketball, and baseball. Yet as good as I was, I ended up getting injured in every sport that I played. I started to become filled with doubt and fear when it came to playing any sport. In retrospect, I realize my fears and doubts were contributing to a vicious cycle of injury.

Besides these injuries, illness in my life was as commonplace as breathing. My childhood was centered around visiting doctor's offices with colds, ear and sinus infections, the flu, and impetigo —so often that I developed an immunity to penicillin by the age of nine. I had no idea that this standard routine of taking antibiotics would eventually send my body cascading down.

And little did I know that my poor eating habits of consuming sugar and processed foods were paving the way to constant

illness. The sugar I ate contributed to rotting almost every tooth I had. As a sugarholic, I had an entire mouthful of silver-mercury fillings by the age of twelve. With each dentist visit and each filling I became less afraid of going because I knew it was just a way to stop the toothache so I could eat more candy.

I grew up feeling like a mental and emotional Ping–Pong ball caught in the dynamics of a dysfunctional family, constantly being batted back and forth between my parents with only my grandparents as buffers.

On the outside I seemed to have it all under control. I was doing well in school, I had friends, and I had learned to appease whichever parent I was with. But inside, I was battling to find safe ground.

## COPING

The dynamics between my mother and me were intense. It was a love-hate relationship. She was, and still is, loving, spontaneous, fun, and full of energy. She was also controlling, critical, and strict with a fiery Italian temper. Our Italian household meant shoes and spoons came flying my way if I didn't behave. I feared her temper and felt my every action was scrutinized. There wasn't a time that I can remember feeling accepted for just being me. I became obsessed with being perfect, but the harder I tried to be perfect in her eyes, the clumsier I became, and the more stupid I felt.

My father was an alcoholic and emotionally detached. His preoccupation with business left little room for me. More than anything, I wanted to be "daddy's little girl," but to no avail. My father didn't know how to reach out emotionally and our connection was superficial. The end result was that I feared and mistrusted the man whose love and validation I so yearned for.

The psychological and emotional events that took place throughout my childhood were setting the stage for illness. Fear-based emotions such as abandonment, guilt, fear, and anger were settling into my body's cellular memory. Unconsciously, I was adopting a pattern of getting sick or injuring myself to receive unconditional love. That was how I coped. To make matters worse, I developed an addiction to "comfort" foods and lived on excessive amounts of sugar, refined carbohydrates, sodas, and processed foods. At that time I didn't know how detrimental refined sugars were in that they weaken the immune system by stripping essential vitamins and minerals needed to run the body. Also sugar makes the body acidic and increases inflammation, which lays the perfect breeding ground for disease to start. I was trying to kill my emotional pain, but in reality, I was depleting my immune system.

## SPIRALING DOWN

At age nineteen, on a beautiful Sunday afternoon in April, I went to the mall with a couple of friends. I walked into a candy store and suddenly everything went into slow motion. My skin felt numb, my head felt heavy and cloudy, and I couldn't feel the ground under my feet. A wave of panic overcame me, yet no one noticed. A hot flash swept over me as I stumbled from the store to shake it off. I asked my friends to take me home because I didn't feel well. They thought I just needed to get some food in my system. I got home, ate a little something, and went to bed early.

I awoke the next morning to the thought that the previous day had just been a nightmare and I would be back to normal. But as I opened my eyes I felt an enormous heaviness in my head. I sat up and felt disoriented. The symptoms from the day before had intensified. I skipped school and went to the doctor. After examining me and drawing blood for tests, which came back neg-

ative, he told me I had a viral infection in my chest and sent me home with antibiotics.

My symptoms never left and a month later my condition had worsened. I went through another round of tests and found out that I had mononucleosis and Epstein-Barr virus. My symptoms were fatigue, disorientation, brain fog, allergies (dietary and environmental), chest constriction, ear and sinus pain and pressure, sore throat, constipation, weight loss, depression, and dizziness. For two months I was exhausted and laid in bed with no signs of improvement. I went to several specialists searching for an answer. Over the next eight months I saw seven specialists who prescribed more than twenty different medications, mostly antibiotics and steroids. I took every test imaginable—MRI's, EKG's, hearing tests, urine samples . . . everything came up negative.

My whole world had been shaken to the core. I began feeling anger and frustration toward my doctors and traditional medicine for prescribing drug after drug with no signs of relief. More systems were breaking down in my body as a result of all the medication. Because doctors didn't examine or talk about lifestyle habits such as poor diet and stress in connection with illness, it made it even more difficult to uncover the root cause of what was ailing me. Lastly, I had no specific religion to lean on and I felt lost and hopeless. For the first time in my life I wanted to die.

## SEARCH TO GET WELL

One day near the end of November my mother went to lunch with a friend who asked how I was feeling.

"She's getting worse," she replied.

He told her about a woman friend of his who was a medical intuitive. My condition had worsened to such a degree that my mother was willing to try anything.

My mother contacted the medical intuitive and within a week I received a written reading in the mail with great detail. She said I had a severe condition called *candidiasis*, an overgrowth of the yeast *Candida albicans* brought about from a lifetime of antibiotic overuse, steroids, and a poor diet mainly consisting of refined sugars and carbohydrates. The yeast toxins had moved out from my gastrointestinal tract into my bloodstream and activated an antibody reaction, that in turn, had triggered an excessive production of white blood cells, which in turn, caused symptoms similar to mononucleosis. She also said that when my attacks were extreme, borderline symptoms of leukemia appeared. I was also suffering from a breakdown in red blood cell production, as well as diet deficiencies, and an inability to synthesize amino acids. The most critical factor was to regulate my diet by eliminating refined sugars, processed foods, dairy products, and yeast foods (peanuts, breads, mushrooms, vinegars, and condiments), along with taking an antifungal mediation to eradicate the yeast overgrowth.

A week after receiving the medical intuitive's diagnosis, I came across a newly released book by William Crook, MD, an emeritus member of the American Academy of Pediatrics and the American College of Allergy, Asthma, and Immunology. It was called *The Yeast Connection: A Medical Breakthrough*[1] and it confirmed my condition. I learned that candidiasis is a silent epidemic in the United States because of our poor diets and overuse of antibiotics and steroids.

*Candida albicans* is a single-celled yeast that naturally lives in our intestinal tracts, on our mucous membranes, and on our skin. Dr. Crook explained that taking an antibiotic wipes out both the good and bad bacteria in our bodies but doesn't kill the yeast. The absence of good bacteria allows the yeast to continually thrive on a poor diet of refined sugars, dairy, alcohol, and fermented foods. We then end up craving more of the foods that keep the yeast

multiplying. Over time, yeast turns into a fungus that migrates through the intestinal walls ("leaky gut syndrome") and into the bloodstream. To make matters worse, the yeast has seventy-nine by-products that it puts out. These weaken the immune system and create more imbalances. From there it can attack the genetically weakest and most vulnerable systems in the body. The brain fog I was experiencing was from one of the main by-products-acetaldehyde, which breaks down into ethyl alcohol in the liver and was causing me to feel disoriented and throwing off my coordination as if I were drunk.

Most important, yeast/fungal overgrowth will not go away and allow the body to return to its normal state unless treated with an antifungal drug and diet modifications.

When I read Dr. Crook's book, I actually cried for joy. I felt relieved knowing that I was guided on the right track. At last I was finding concrete answers. The correlations were easy. I was a classic case given my history of an extremely poor diet and the countless times I was prescribed antibiotics and steroids. Even while I was reading Dr. Crook's book, I was taking yet another round of antibiotics. The intuitive's reading and Crook's book had instructed me to start taking Nystatin, an antifungal drug. Nystatin is a concentrated soil-based organism that is listed as one of the least toxic drugs in the *Physician's Desk Reference* and is safe for pregnant women and infants. I was also instructed to change my diet. Refined sugar was lethal to my body and I needed to avoid any form of it—dextrose, fructose, maple syrup, molasses, and brown sugar. I was also advised to avoid dairy, wheat, refined carbohydrates, alcohol, and fermented products. I began to eat foods I hadn't even known existed, such as millet and quinoa. I drank water on a regular basis for the first time. I had grown up thinking the whole world of food consisted of pasta, canned soups, frozen dinners, sodas, and Ding Dongs. This was a rude awakening!

After one year of following this program I returned to health and vitality. I was amazed and hungry for knowledge that would expand my own empowerment. I wanted to know what my health challenges were trying to "tell" me. I started to read and do research on how the body and mind worked together. Yet as time went on my old patterns of sugar and stress resurfaced.

## DIAGNOSING MS

Four years later, at age twenty-four, my life again came to a screeching halt. I was eating at a restaurant with my friend Linda when I was slammed with an attack. I couldn't move, speak, or swallow. Panic surged through my mind and body. I gasped for air as my body spasmed uncontrollably. It lasted for only thirty seconds but it felt much longer.

After the attack subsided I asked her to take me home. She had to help carry me out of to the car because I was still having spasms. Linda called my mother who came to my rescue immediately and stayed with me late into the night, covering me in blankets and trying to calm me. I couldn't stop shaking, which seemed to be coming from the deepest parts of me, and my thoughts were fragmented. I knew this was serious. Finally, no longer able to fight the fatigue, I fell asleep.

The next day my mother took me to a specialist. I had extreme muscle weakness and fatigue and was barely able to walk into his office. Some parts of my body felt numb and I was having trouble speaking. I loathed being in a doctor's office again, but I was too unstable to think of an alternative. He did a complete neurological examination and sent me off to the hospital to take a number of tests, including an EEG (electroencephalogram, which measures brain waves) and EP's (evoked potentials, which record

the nervous system's electrical responses to the stimulation of specific sensory pathways such as visual, auditory, and general sensory).

For the next several days my body remained incapacitated. My mind was reeling with fear-filled emotions and thoughts. When I entered the doctor's office to get the results, I was trembling.

He sat me and my mother down and opened my chart. "Well, the good news is, you don't have cancer. The bad news is you have multiple sclerosis."

I was speechless. Now that I finally had a diagnosis and knew what was wrong with me, I didn't know whether I felt relief or terror.

The last words I remember him saying were, "MS . . . incurable, but there are experimental drugs like chemotherapy to work with . . . "

My mother, offended by the doctor's insensitive manner, helped me hobble out of the office. I was devastated and cried all the way home. I felt my life was over. I was only twenty-four but so physically ravaged that I couldn't bear to think about my future. How would I ever begin to accept this diagnosis and move on with what was left of my life?

I couldn't.

I had to quit work and struggled each day just to exist. The first year was unbearable. The days droned on with endless symptoms constantly reminding me that my body had completely changed again. My symptoms continued to worsen without periods of rest. For the first few months I was bedridden. I had daily immune response attacks in which I would lose control over my motor skills. My body would spasm and tremor uncontrollably. I was unable to carry out coordinated movements such as walking. I experienced numbness, muscle weakness, impaired

sensory perception, convulsive tremors, bladder dysfunction, and nervous exhaustion. My ability to speak, chew, and swallow was impaired. I also had trouble formulating thoughts and accessing memory.

Multiple sclerosis (MS) is an autoimmune disease of the central nervous system, which includes the brain and spinal cord. It affects more than three million people worldwide. Women are twice more likely to develop MS than are men. It is an inflammatory condition that destroys myelin, the white fatty tissue that insulates the nerves and prevents the conduction of nerve impulses. In MS, myelin becomes inflamed and detached from the nerve fibers. Eventually the detached myelin turns into hardened (sclerosed) patches of scar tissue that form over the fibers. These lesions can appear in various areas of the brain and spinal cord and produce many symptoms. MS is considered incurable, and millions of dollars have been spent trying to find its causes, and a cure.

The essence of life that I had taken for granted was now gone. Everything had happened so fast. I felt like someone who had been incarcerated for ten years, then released just long enough to adjust, only to be suddenly thrown right back in. I spent many days lying on the floor completely terrorized by a body that wouldn't function. I cried for hours and became exhausted from obsessing and trying to tolerate the bizarre symptoms I experienced. I had numbness and tingling throughout my limbs, and had difficulty walking, speaking, and swallowing. Every part of my body felt completely exhausted. My central nervous system, which controlled everything in my body, was completely incapacitated. I now knew what it felt like to be a quadriplegic. The utter horror of having no movement was enough to drive me insane. I lived in constant fear that my next breath would be my last.

I finally decided to call the medical intuitive that I had previously contacted to ask for another reading. Within a couple of days, I had a phone consultation with her. When she confirmed

that I did indeed have MS, my breath stopped and my heart sank.

But before I could react, she added, "You have the power to eradicate this disease."

"How?"

She told me to get back on Nystatin, to clean my diet up once again by staying away from sugars, yeast, dairy products, and alcohol. She also said I needed to have my fifteen silver-mercury fillings removed.

"Finally, it's essential for you to believe—to know—that you can eradicate this "so-called" incurable disease," she said.

When I hung up the phone part of me felt positive and hopeful, but another part of me felt clouded with more questions and uncertainty. However, one thing was for certain, I refused to be another MS statistic.

The first step I took was to have my silver-mercury fillings removed and replaced with non-toxic plastic composite fillings. The mercury in the fillings was a factor that was suppressing my immune system and part of the creation of MS.

The process of removal was no easy task for me. I could not tolerate any anesthesia or Novocain for it would produce an attack, which was like having a conscious epileptic attack, where I would spasm and tremor uncontrollably for several minutes and then become completely exhausted. Even though I wore a dental dam and a mask, I became severely ill after each extraction and replacement as the mercury vapors and residue leached throughout my body. I flushed my system by drinking two quarts of red clover tea daily. This served to cleanse my blood, kidneys, and liver. I was barely able to lift my head up and I experienced a couple of immune response attacks daily throughout the next two months that it took to complete the removal process. Mentally and physically I felt like a ninety-year-old witnessing the end of her life.

I endured the mercury removal yet saw no signs of improvement. Instead, the progression of the MS attacks became more

frequent and more severe. Afternoons into early evenings were my worst times because the body's level of cortisol, a hormone produced by the adrenal glands, typically drops at that period of time, and what little energy I had, plummeted.

One night, while lying on my mother's couch, with her and my stepfather close by, I felt my body shutting down and becoming completely paralyzed. My limbs were frozen, my breath slowed down, and I wasn't able to make a sound. Panic bubbled up in every cell of my body. I wanted to scream but couldn't. As my lungs collapsed, I took my last breath and felt detached from my body. I felt warmth and light as I approached a tunnel of light. Time had stopped. I floated farther from my physical body and closer to the light. Then I heard a voice say,

"Do you want to stay or go?"

I didn't want to go. Then there was silence.

Seconds passed and I heard, "Stay! There is more for you to do."

Within a second of making the choice to stay, I shot back into my body, bolted up off the couch, and let out a horrendous scream. My breathing had started again. My mother and stepfather leaped up and ran to my side. They had no idea what had just happened. They thought I was sleeping. My body was convulsing, my mind was like mush, and I couldn't formulate a word. Terror saturated every tissue as I returned from my "near-death" experience. As I wept in agony, I motioned for my mother to help me walk. I had to know I could still move. She assisted me around the living room while my body continued to spasm uncontrollably.

As terrified as I was to be back in my body, it was in that moment that I claimed my will to live and fight back with staunch courage and fierce tenacity. I vowed this illness would not destroy my life. The medical intuitive and Dr. Crook's work had given me exposure to alternative treatments that, albeit, temporary, had given

me relief in the past from my illness. I knew there was a way to overcome this insidious disease and I was determined to find it.

Although I was physically limited, I could still read so I began expanding the quest for a healing process. I read everything I could get my hands on with regard to the mind-body connection, nutrition, self-help, candidiasis, MS, and autoimmunity. The more I read the more it became clear that suppressed childhood emotions and fear- and anger-based thoughts were factors in disease. It became crystal-clear to me that treating the physical body alone was not enough to heal a chronic progressive disease.

My research took me back to the idea that yeast/fungal overgrowth was the major culprit in MS. Several follow-up sessions with my medical intuitive reinforced this. Through my research, I learned that candidiasis primarily targets the nerves and muscles but can attack any tissue or organ, depending on the body's predisposition. The most common symptoms are of candidiasis are indigestion, bloating, gas, fatigue, disorientation, poor memory, numbness, abdominal pain, constipation, attacks of anxiety, depression, irritability and shaking when hungry, lack of coordination, headaches, rashes, vaginal yeast infections, and urinary frequency.

In addition to Crook's *The Yeast Connection*, which made the correlation between yeast and autoimmune conditions, I found another book, *The Missing Diagnosis*, by Orian C. Truss, MD. Truss was a medical doctor who pioneered writing about candidiasis and presented case studies showing that yeast overgrowth negatively affects the body. In one such case study, he treated a female MS patient with Nystatin and diet modifications and she normalized to the extent that her neurologist found no more traces of MS.

So once again I started taking Nystatin, one 500,000-unit pill three times a day. I also adopted a very strict diet of no sugars, dairy, wheat or refined grains, no red meat, and no fermented or yeast-containing products. My goal was not only to eliminate

candidiasis by removing the foods the yeast thrived on, but also to rebalance my digestion and absorption so my body could utilize the proper vitamins and minerals to do its job to rebuild and regenerate.

The main supplements I took were vitamins C and E to support immunity and scavenge free radicals and B complex to help neurological function. Also omega 3 fish oil and omega 6 evening primrose oil to repair my myelin sheath. Daily, I drank a quart of red clover tea to cleanse my blood, liver, and kidneys. There might have been a couple of other supplements I don't remember taking, but my knowledge in this area was limited, so instead I focused on getting enough vitamins and minerals through the variety of my diet.

## CLEANING MY INTERNAL HOUSE

My most intense undertaking to help eradicate MS began when I decided to clean my internal house . . . emotionally, mentally, and spiritually. I started to challenge my outdated belief systems and embrace new ones, the main one being that I now believed my body could transform on a cellular level.

I began to peel away at my deep-seated fears. I realized how hard I was on myself and how my conditional love and self-judgment contributed to my ill health. I took responsibility for my illness and made getting well my most important priority.

My hardest realization was to accept that I had created this condition on a subconscious level. The subconscious mind is like a six year old, with no discerning capability, loves repetition, and truly controls the daily actions and reactions we make. Mine was filled with a history of fear, anger, and low self worth. Since I had not addressed these subconscious patterns I attracted new experiences with the same theme over and over again. As time passed these experiences stressed and weakened my immune system. I

knew I no longer wanted to be a victim and my acceptance allowed me to tap into the power of knowing that I could make a different choice. I stepped into the driver's seat and started to believe I could create a new reality and release MS.

Despite my enthusiasm I came up against much inner resistance. It was one thing to mentally grab onto new beliefs and thoughts, but it was another thing to feel them and to have my body agree. I discovered that physical matter, the body, didn't move as fast as my thoughts did. I wanted to incorporate other alternative therapies such as acupuncture and massage, but my body rejected the slightest stress by bringing about an attack.

Over time it became apparent that I had difficulty breathing in Los Angeles because of the petroleum pollutants, so at age twenty-five, I moved up to Sonoma County. This was a big step for me at such a vulnerable time in my life. I had made enough progress to walk and function on my own as long as I didn't push it. My threshold for stress had completely changed, and my body would let me know immediately by having an attack if I pushed it too far.

As soon as I moved, my body responded immediately to taking in more oxygen from the improved air quality. I kept up with my regime of eating healthy, drinking a lot of water and red clover tea, taking my supplements, and taking Nystatin. I started to take walks and noticed that I could go longer distances than before. But if I pushed it, my body would spasm and tremor.

Then there were the days when my extreme nervous exhaustion made it impossible for me to get out of bed. The cloud of despair would overwhelm me again and I would cry and lay there wondering whether I would truly get well. But I learned to ride the tide of good days and bad days, and eventually, I started to see more good days than bad.

A few months went by and I decided to challenge myself by accepting a part-time position at a bookstore. I did my best to take it day by day but at times my fear of having attacks created more stress, which then brought about mild attacks, but I kept pushing forward.

After six months of working and prevailing I decided to go back to college and enrolled at Sonoma State University. I changed my major from business marketing to psychology. I wanted to learn deeper dimensions of who I was and how other people operated. During this period, attacks were triggered only by stress that was moderate to high. For example, I noticed more flare-ups during examination time.

By now, however, I knew the routine of how to care for my body to get through the down time. My fears were not so intense, but I still entertained thoughts of, "Am I really getting better? Or am I just fooling myself?" I would try to drown out these thoughts because remission was not an option for me. I wanted a new body. I wanted cellular transformation, yet my body was not at the place I wanted it to be. I was still stuck in "believing" because "knowing" had not yet become part of my reality.

One day I realized that health was a choice and that on an unconscious level I had chosen this disease as a way of discovering my own worth. That recognition took my breath away. The next natural realization was, "I now have the power to choose a healthy body." This was a major breakthrough and a significant moment of enlightenment.

Although I was becoming clearer about my condition, my resistance was like a tug of war inside. How could I have so much awareness and still feel powerless over killing my demons and changing my negative thinking?

## PLUNGING THE DEPTHS

I was twenty-six when I flew back to Los Angeles for Thanksgiving. As we all began eating our Thanksgiving dinner my grandmother on my father's side started choking. She turned purple

and started gasping for air and waving her arms. I screamed for someone to help. My stepfather positioned himself behind her and administered the Heimlich maneuver until she coughed up a piece of turkey.

As she lay in an emergency room bed—her blood pressure had skyrocketed—I felt all my own terror about health start to gurgle in my throat. I could feel my stomach quivering with fear, hers and mine. I wanted to run out the door but I remained by her side. The doctors said she was fine and I took her back to my mother's house. But for the rest of the evening, while everyone was having fun, I couldn't shake the unsettling feelings, my grandmother's fears, and my fears. Little did I know how deeply my grandmother's choking episode would affect me.

November rolled into December. Finals were coming up and my stress level started to climb. I went out to lunch, ordered a couple of tacos, and had difficulty swallowing my first bite. Each bite was difficult to swallow. I thought maybe I was getting a sore throat. Dinnertime came and the same problem returned. Now I started to become worried and frustrated. I went to bed hoping this would all pass the next day.

The next day my swallowing continued to be difficult. I forced the food down and was angry and perplexed at what was taking place. The difficulty in swallowing continued meal after meal, and the difficulty transformed into a fear of swallowing rather than a physical imbalance.

Oddly enough, this fear of swallowing was in divine order, a step to help me in getting well. I didn't know it at the time, but it was the catalyst for releasing the suppressed, fear-based emotions I had been swallowing since childhood. Emotionally and mentally I was cleaning house whether I liked it or not.

My energy dropped to zero. Between dealing with MS and now being afraid to swallow, I felt tightness and panic sitting

on my chest all the time. I was in agony every waking hour and getting very little sleep. I was having a complete mental, physical, and spiritual breakdown. Unable to take care of myself I moved back into my mother's house in Los Angeles.

Thoughts of suicide begin to surface. The lack of sleep and food sent my mind into a tailspin of negative uncontrollable thoughts. I ran the events that had led up to all of this over and over in my mind. I was angry with my grandmother for choking. I thought that if I didn't have the fear of swallowing maybe I could deal with the MS. I fantasized about having a normal life, but my reality was anguish and despair. My state of mind and body was incredibly fragile. My body felt filled with electricity ready to short-circuit at any moment. I was about to crack.

September 1, 1992 at 4 a.m., age twenty-seven, I tried to take my life.

On the way to the hospital I drifted in and out of consciousness, with my entire life flashing and flickering before me like a silent movie. I was admitted to the hospital right away as an attempted suicide. My left wrist needed stitches because the wounds were so deep. Tears coursed down my face. Never in my wildest dreams did I think that this was how my life would turn out.

The doctor told my mother I would be put temporarily into a psychiatric detaining room until there was a space for me in the psychiatric ward. I was horrified. When they came to take me away I cried and begged for my mother to take me home. As they escorted me through a giant door, I turned and looked at her face, trying to capture every detail. The door closed and she was gone. I stood frozen in the abyss of the unknown.

I had entered the clinical world of drugs and psychiatric labels. Losing your mental faculties was a hundred times worse than losing your physical abilities. The doctors labeled me as being severely depressed.

As the days passed, I began to realize that the mind was the command station that ruled everything else in my physical and emotional existence. I could no longer ignore that thoughts created energy—that each thought, conscious or unconscious, spoken or unspoken, translated into electrical impulses that in turn directed the control centers in my brain as well as my central nervous system. And that the central nervous system controlled every motion, cell, feeling, and action I took every moment of the day. Simply put, my thoughts of suicide, fear, and negativity were manifesting in my reality.

## RECOVERING

On day thirteen I was released from the hospital and sent to a half-way house. As I gathered my things, I heard another patient say to me, "Be good, or else you'll be back." I valued those words like gold because I loathed the thought of having to come back.

The head counselor at the half-way house was a middle-aged black woman who ran the show with an iron fist. She ended up being a crucial player in my life because she understood my anger and helped me get in touch with it as a means to save my life.

It was determined that the root of my anger was my relationship with my mother and feeling abandoned by my father. The rage needed to come out, so day after day, my counselors relentlessly stirred up the hornet's nest of emotions that lived inside me. Slowly, one by one, the layers began to peel away.

After two weeks I was transferred to another half-way house nearby. Getting through a day was tough, as I was deeply saddened and horrified by the sights of the other mentally ill patients. A few weeks into my stay, something miraculous took place as I routinely got ready for breakfast. Desperate, I decided to speak

to God. I spoke the following words with conviction and passion from the depths of my soul.

"God, I might be really screwed up right now, but I don't deserve this treatment anymore."

This realization and proclamation was life-changing for me. It was in that very moment that I finally felt I was worth my existence. I now knew that worth is "inherent," based upon pure existence and has nothing to do with how much money you make, what you do for a living, or if your family loves you. It was in that moment that I had an epiphany and reached out and seized my power. I decided right then that I would no longer tolerate being a victim of low self-esteem and worth. I asked God to help me get better. I also asked for the strength to stand up for myself at any cost. And so my conversation with God had turned into the foundation from which my hopes became a reality. I was released and sent home two weeks before Christmas.

## SPIRALING UPWARD

Upon my release I started to see a psychotherapist. She was supportive and encouraging. With a big sigh of relief I thought to myself, "I'm not crazy after all!" I understood that my breakdown was because I was going through a rebirth on every level to transform my body. My therapist applauded me for my courage and reassured me that the worst was behind me.

By the end of February I was still struggling with my fear of swallowing. One afternoon I was mindlessly flipping through the cable channels and I stopped on the public access station. A Russian hypnotherapist was being interviewed. As I watched, it was as if someone grabbed me around the neck and said, "Go see this man!"

I made an appointment immediately. Peter was confident and told me that before long my fear of swallowing and other negative

patterns would be gone. For the first time in months I let down my guard and relaxed. I went deep into a hypnotic state not even remembering what was said during the session. When we were done, I had an absolute knowingness that I was going to get better. I had finally gone beyond believing. I "knew" I was being healed.

Within a month it was as if a miracle had happened. I was stronger, healthier, and more centered than I had ever been in my life. My thoughts were focused and positive. I was able to recognize old behaviors and feel neutral rather than negative emotionally. It was as if someone had cleared the cobwebs and removed my self-sabotaging ways. I was healthy inside and out, able to swallow and live each day without nagging fear. Because my psychological body was now whole, all the physical steps I had taken up to that point—nystatin, supplements, and detoxifying my body, solidified the transformation of my reversing MS.

Soon afterwards I was able to stop taking Nystatin and replaced it with Candida Cleanse to maintain balance. I continued to eat healthy, take supplements, drink red clover tea, and exercise regularly.

As I felt better spiritually and emotionally, I witnessed the continual periods of time that my physical body remained healthy. I had not experienced an attack in months. I started to feel normal without numbness and tingling in parts of my body. I became active and started to play social sports. I felt normal.

Feeling capable of working, I went back to the record company I had previously worked for. My expansion as a person became more evident, and after awhile I grew restless and left my job within a year. Because of my healing journey, I felt there was much more meaning to it than just getting better. It was a calling for what I was about to do next.

I moved to Taos, New Mexico and became inspired by the idea of writing about the incredible journey I had been on and how I healed myself. Writing was challenging and my mind started

to grab onto a larger prospect of becoming a healer. I went back to school to become a naturopath and clinical hypnotherapist. I graduated from the International Society of Naturopathy as a naturopathic doctor and became a certified clinical hypnotherapist from the Holmes Hypnotherapy School. At thirty-three I opened my own practice in Los Angeles. A couple of years later I added to my credentials by becoming a certified iridologist from Bernard Jensen's International Iridology Practitioners Association and a certified nutritional consultant from the American Association of Nutritional Consultants.

Initially, as a practitioner, I woke up almost every day and watched to see if my neurological symptoms were gone. To my pleasure, they were, and continue to be. I have not experienced the slightest sign or symptom of MS for the last ten years.

## TRIUMPH

I do not underestimate the journey I have walked. I have undergone a complete metamorphosis. For the longest time, I could not see the light, but I remained diligent in my efforts to reach my destination. I now know that, in the worst of times, I was guided and protected. I know the power of God.

My complete transformation could not have occurred without having challenged and addressed each component of my existence. Just following the diet, taking an antifungal and supplements, and having my mercury fillings removed, would not have been enough. It was also necessary for me to examine and release my fear-based childhood experiences. And to take these steps required awareness, self-acceptance, and taking responsibility for my physically ravaged body.

My relationships with those around me have changed, specifically with my parents. I now understand that the dynamics in which I grew up ignited my strength and courage, and made me who I am today. I can now interact with them from a place of confidence and neutrality.

They were my best teachers and I know they did the best they could. I understand that because their childhoods were difficult, certain negative patterns and cycles carried on. Humbly, I also know that with hindsight we would all make different choices where mistakes had been made.

I owe the Western medical community a debt of gratitude for having pushed me to the limits to go beyond their protocols and find answers. Turning myself into a guinea pig had its pluses, for I learned, firsthand, that the body can rejuvenate and repair itself, even in the face of adversity.

The attacking agent for MS—or any disease—is not simply yeast, or a virus, or an organ system that has failed. It is much more than that. It is a culmination of the history of each individual's thoughts, emotions, stress levels, spiritual connection, genetics, diet, and environmental factors. The body's cellular memory stores every element, and part of regaining health is to uncover it, release it, and restore vitality. The body inherently seeks health and balance. It is only when the toxins we are harboring overpower our body's ability to remove them that autoimmune disease occurs.

In Dr. Andrew Weil's book, *Spontaneous Healing*, he states, "One of the most effective ways to neutralize medical pessimism is to find someone who had the same problem you do and is now healed. Whenever I come across people who have solved serious health problems, I ask them if they will allow me from time to time to send similarly affected patients for advice and guidance."[2]

For the last nine years I have helped thousands of patients reclaim their health. In part three you will read the success stories of some of my patients. My expertise is in my ability to help others find the root causes of their disease. My mission is to impart to those who are struggling with illness as I was, that a cure is possible. With determination, patience, the proper protocol, and the "knowing," everything is within your power to transform the body and mind.

PART TWO

# THE
# REAL CAUSE
# OF MULTIPLE
# SCLEROSIS

# MS AND THE CANDIDA CONNECTION

## WHAT IS MULTIPLE SCLEROSIS?

Multiple sclerosis (MS) is an autoimmune disease of the central nervous system (CNS—the brain and spinal cord). It affects more than three million people worldwide and at least 500,000 people in the United States. Women are twice as likely to develop MS as men. The disease occurs more often in temperate climates such as the United States and Northern Europe and usually strikes adults in their twenties to forties.

A variety of tests, including magnetic resonance imaging (MRI); electroencephalography (EEG); spinal taps; blood assay tests; and visual, somatosensory, and brainstorm-evoked potentials (EPs, the electrical signals that result from sensory stimuli), are used to diagnose MS.

As an inflammatory demyelinating condition that destroys and prevents the conduction of nerve impulses, MS produces many symptoms. Myelin is a white fatty tissue that insulates the nerves. In cases of MS, myelin becomes inflamed and detached from the nerve fibers. Eventually, the detached myelin turns into

hardened patches of scar tissue (scleroses) that form over the fibers. These lesions can appear in various areas of the brain and spinal cord. MS is considered incurable, and million of dollars have been spent trying to find a cause.

### Symptoms and Classifications

No one set standard or classic case defines MS. Symptoms include fatigue, spasticity, paralysis, blurred and double vision, numbness, lack of coordination, tingling, dizziness, speech and swallowing impairments, bladder and bowel problems, sensitivity to heat, cognitive dysfunction (memory loss and thought patterns), sexual dysfunction, pain, and tremors.

Multiple sclerosis is classified as:

- Benign: usually one or two attacks with complete recovery. This form does not worsen.
- Relapsing-remitting: unpredictable relapses (attacks, exacerbations) during which new symptoms appear or existing ones worsen. Flare-ups are followed by periods of remission.
- Primary progressive: from the first appearance of symptoms, neurological function deteriorates without periods of remission.
- Secondary progressive: initial relapsing-remitting MS, followed by a stage of continuous deterioration later in the course of the disease.
- Progressive relapsing: primary progressive MS with the addition of sudden episodes of new symptoms or a worsening of existing ones.

## THE WESTERN MEDICAL PROTOCOL

Western medicine states that MS is incurable. Most research points to an infection, or perhaps a virus, as the cause, but nothing concrete has been identified.

Pharmaceutical companies have developed drugs designed to reduce the symptoms and slow or stop the progression of MS.

- Intravenous corticosteroids such as Prednisone and Solu-Medrol are prescribed to reduce inflammation and shorten the duration of flare-ups.
- Baclofen, Zanaflex, Klonopin, and Lioresal are administered to treat spasticity and pain.
- Amantadine and Provigil are used for fatigue management.
- Antivert is used for vertigo.
- Ditropan and Tegretol are both prescribed for urinary problems.
- Prozac, Zoloft, Celexa, and Effexor are used to minimize depression and anxiety.
- Beta interferons such as Avonex, Betaseron, and Rebif are genetically engineered copies of proteins used to help the body fight viral infection and improve the regulation of the immune system.
- Copaxone, a synthetic drug made up of four amino acids, is designed to mimic the reactive portion of myelin that the immune system destroys.
- Naltrexone is used to boost the immune system by briefly blocking opioid receptors which increases endorphin and enkephalin production.
- Even chemotherapy drugs, such as Novantrone, Cytoxan, and Imuran, are used to treat MS.
- One of the most recent drugs to enter the marketplace is

Tysabri, formerly known as Antegren and was voluntarily suspended by the makers in 2005 due to a couple of fatalities, is now back on the market.

All of these drugs come with side effects. Mild reactions include flu-like symptoms, nausea, headaches, and muscle aches. More severe side effects are liver damage, convulsions, suicide, hallucinations, and paralysis.

The annual cost of these drugs is between $10,000 and $14,000. Unfortunately, pharmaceutical companies apparently have a more important mission than finding a cure. Their main priority is to make sure that their revenues continue to soar.

I do believe in drug therapy for symptom management in the last stages of MS. You may be one of those people who have benefited from drug therapy—but why settle for alleviating symptoms when you can get to the root cause?

## CURRENT RESEARCH

Stem cell research that would involve transplants of embryonic and adult stem cells is at the forefront of MS research today. Stem cells would be injected into the bloodstream with the hope of repairing nerve damage to the brain and myelin sheath. Bone marrow transplantation, which would replace the body's faulty immune memory with "cleansed" immune cells is another approach.

Scientists are also studying whether intravenous immumoglobin (protein cells that defend the body) taken from healthy human donors and are injected into people with MS might stimulate growth of myelin-producing cells. Other avenues being explored include T-cell vaccines, bee-venom therapy, and antiviral medications. These all may have some value, but they are still not the comprehensive picture.

## THE HIDDEN CAUSE OF MS

*Candida albicans* overgrowth and its by-products (mycotoxins) are the primary cause of MS.

However, this pathogenic (disease-producing) yeast/fungus is continually ignored by Western medicine even though it is the missing key to reversing MS.

*Candida albicans* is a harmless yeast that naturally lives in everyone's body: male, female, and child. It resides in the gastrointestinal tract, on the mucous membranes, and on the skin. In a healthy body, it lives in a symbiotic (balanced) world.

Unfortunately, this harmless yeast can overgrow and turn into an opportunistic pathogen.

As Dr. Michael Goldberg states: "Because it is a commensal organism [one that benefits from another organism without damaging or benefiting it] present in virtually all human beings from birth, it is ideally positioned to take immediate advantage of any weakness or debility in the host, and probably has few equals in the variety and severity of the infections for which it is responsible."[1]

Candida overgrowth and its mycotoxins can attack any organ or system in your body. The attack is relentless, twenty-four hours a day until treated. If not arrested, yeast overgrowth will change form into a pathogenic fungus with roots that cause myriad symptoms.

This fungus burrows its roots into the intestinal lining and creates leaky gut—porous openings in the gut lining—that allow the yeast/fungus and its by-products to escape into the bloodstream. This systemic yeast/fungal infection is called *candidiasis*, and "*Candida albicans* is the most common human systemic pathogen, causing both mucosal and systemic infections, particularly in immunocompromised people."[2]

## WHAT CAUSES CANDIDA OVERGROWTH?

The major causes of *Candida albicans* overgrowth are: antibiotics, steroids (cortisone, prednisone), birth-control pills, estrogen replacement therapy, poor diet, chemotherapy, radiation, heavy metals, alcohol overuse, drugs, and stress. It is easy to see why the incidence of candidiasis is so high, because the main contributing factors are mainstream Western medicine protocols, rampant poor diet, and stress overload in our society today.

## THE DRAWBACKS OF TAKING ANTIBIOTICS

North America, including the United States and Canada, and pockets of Europe have the highest numbers of people with candidiasis because Western medicine's standard protocol is to use antibiotic therapy for common infections.

There is no question that antibiotics have saved thousands of lives, but we've pushed a good thing too far by overprescribing these medications. Overuse also creates "super germs" that are resistant to common antibiotics, so germs that could once be killed off have become life threatening.

A vicious cycle starts with the use of antibiotics (see Figure 2.1). For example, you have an infection, usually a cold or flu, and you visit your doctor. The problem starts right there because both colds and flu are viral infections, not the bacterial ones that antibiotics are designed for. Antibiotics are useless against colds and flu.

Nonetheless, you take the antibiotic, which kills both good and bad bacteria in your gastrointestinal tract because it cannot distinguish between the good and the bad. Antibiotics do not affect *Candida albicans*, so without the friendly bacteria such as *Lactobacillus acidophilus* and *Bifidobacteria* to keep the *Candida albicans* under control, the candida will now multiply.

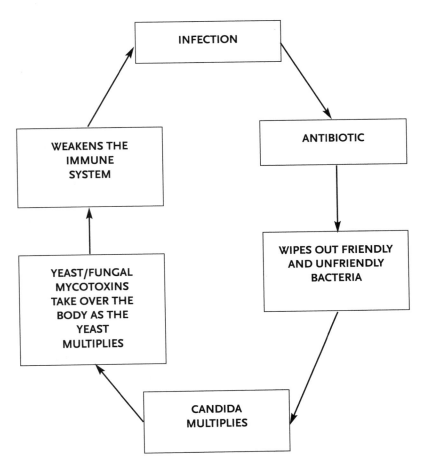

Courtesy William G. Crook, *The Yeast Connection Handbook*, Professional Books, 2000. Used with permission.

**FIGURE 2.1. The Vicious Cycle of Antibiotic Overuse**

It only takes one dose of antibiotics in your lifetime to raise your yeast levels, which create imbalances in your body. Think about how many times you've taken antibiotics—not to mention the antibiotics you ingest from consuming dairy and animal products.

## CANDIDA MYCOTOXINS

Once candida is in an overgrowth state, the body has to deal not only with the overgrowth but also with the fact that *Candida albicans* puts out its own toxic by-products or "mycotoxins"—"79 at latest count,"[3] according to Orian C. Truss, MD—all of which weaken your immune system and attack the myelin sheath in those with MS.

Mycotoxins are neurotoxins that destroy and decompose tissues and organs. Mycotoxins are so powerful that they upset the very communication of cell interactions, disrupt RNA and DNA synthesis, damage and destroy neurons, are carcinogenic, and produce ataxia (lack of coordination), and even convulsions. These pernicious yeast toxins confuse body systems, which accounts for the cross-wiring problems of your immune system once you have MS.

Candida toxins commonly get through the gut lining when it becomes leaky. They then enter the bloodstream, where the liver can detoxify them. However, if the liver's detoxification ability is impaired due to inadequate nutrition and toxic overload, these toxins will settle in other organs and tissues such as the brain, nervous system, joints, skin, and so forth. Over time, chronic disease will occur.

One of the major toxins produced from *Candida albicans* is acetaldehyde, which is transformed by the liver to ethanol (alcohol) and creates feelings of intoxication, brain fog, vertigo, and loss of equilibrium. Acetaldehyde alters the structure of red blood cells and the transportation pathways of materials needed to feed dendrites (nerve-cell extensions). This causes the dendrites to atrophy and die off, which creates a deficiency of thiamine (vitamin $B_1$), critical for brain and nerve function (see Table 2.1). $B_1$ is essential for the production of acetylcholine, which is one of the brain's major neurotransmitters. The deficiency brings on emo-

TABLE 2.1. Damage from Acetaldehyde

---

**Acetaldehyde Damages Brain Function**

- Impaired memory
- Decreased ability to concentrate ("brain fog")
- Depression
- Slowed reflexes
- Lethargy and apathy
- Heightened irritability
- Decreased mental energy
- Increased anxiety and panic
- Decreased sensory acuity
- Increased tendency to alcohol and sugar
- Decreased sex drive
- Increased PMS and breast swelling/tenderness in women

**Source:** *Vitamin Research Products Nutritional News*, James A. South, M.A., July 1997

---

tional apathy, depression, fatigue, insomnia, confusion, and memory loss. Acetaldehyde also depletes niacin (vitamin B$_3$), which is key to helping the cells burn fat and sugar for energy. Niacin also helps in the production of serotonin, which affects mood and sleep, and in producing a coenzyme that breaks down alcohol. Acetaldehyde also reduces enzymes that help to produce energy in all cells, including brain cells.

Gliotoxin, another mycotoxin, causes DNA changes in the white blood cells, which suppresses the immune system and deactivates important enzymes that move toxins through the body.

As your immune system continues to weaken from yeast/fungus and mycotoxins, more infections arise, and you end up at the doctor's office—being prescribed more antibiotics, which just perpetuates the vicious cycle.

## FACTORS THAT ENCOURAGE
## YEAST OVERGROWTH

Yeast overgrowth thrives on diets high in refined sugars, refined carbohydrates, dairy products, alcohol, processed foods, and hormones from high stress levels. Acute and chronic stress elevates cortisol, a hormone produced by the adrenal glands. Excessive cortisol raises blood sugar, and the fungus doesn't care whether the increased sugar in your body is due to eating a candy bar or to having an episode of extreme stress. It will use the sugar as fuel to reproduce itself.

As I mentioned above, it takes only one dose of antibiotics in your lifetime to raise yeast levels. If you last took a course of antibiotics when you were ten years old, it's your poor diet and high stress levels that have continued to feed the yeast until it begins to cause symptoms.

## CANDIDA'S PREFERRED TARGETS

*Candida albicans* overgrowth primarily targets the nerves and muscles, yet it can attack any tissue or organ depending on your body's genetic predisposition (see Table 2.2). Think of your body as having two skins of protection that keep out foreign invaders. One is the outside skin and the other your inside skin, which starts in your nasal passages and runs all the way down to your rectum. This tissue is the same from top to bottom, and if it becomes inflamed or irritated, the membranes become more porous. This allows foreign invaders to get into the bloodstream and to break through the blood-brain barrier.

## TABLE 2.2 Yeast/Fungal Overgrowth
## (Conditions caused directly or indirectly by overgrowth)

**Autoimmune Diseases**
ALS
Chronic Fatigue Syndrome
Fibromyalgia
HIV/AIDS
Hodgkin's Disease
Leukemia
Lupus
Multiple Sclerosis
Muscular Dystrophy
Myasthenia Gravis
Rheumatoid Arthritis
Sarcoidosis
Scleroderma
**Blood System**
Chronic Infections
Iron Deficiency
Thrombocytopenic
Purpura
**Cancer**
**Cardiovascular**
Endocarditis
Pericarditis
Mitral Valve Prolapse
Valve Problems
**Digestive System**
Anorexia Nervosa
Bloating/Gas
Carbohydrate/Sugar Cravings
Colitis
Constipation/Diarrhea
Crohn's Disease
Dysbiosis
Food Allergies
Gastritis
Heartburn
Intestinal Pain
Irritable Bowel Syndrome
Leaky Gut
Malabsorption/Maldigestion
**Respiratory System/**
**Ears/Eyes/Mouth**
Asthma
Bronchitis
Dizziness
Earaches
Environmental Allergies/
Chemical Sensitivities
Hay Fever
Oral Thrush
Sinusitis

**Endocrine System**
Adrenal/Thyroid Failure
Diabetes
Hormonal Imbalances
Hypoglycemia
Insomnia
Over-/Underweight
**Skin**
Acne
Diaper Rash
Dry Skin and Itching
Eczema
Hives
Hair Loss
Leprosy
Liver Spots
Psoriasis
**Nervous System**
Alcoholism
Anxiety
Attention Deficit Disorder
Autism
Brain Fog
Depression
Headaches
Hyperactivity
Hyperirritability
Learning Difficulties
Manic-Depressive Disorder
Memory Loss
Migraines
Schizophrenia
Suicidal
**Urinary/Reproductive**
**(Female/Male)**
Cystitis
Endometriosis
Fibroids
Impotence
Loss of Libido
Menstrual Irregularities
PMS
Prostatitis
Sexually Transmitted
Urethritis
Yeast Vaginal Infections
**Virus**
Epstein-Barr Virus

As the world-renowned neurologist David Perlmutter says about MS:

> The frequency of focal white matter lesions in patients with inflammatory bowel disease is almost as high as that in patients with multiple sclerosis. These findings provide convincing evidence supporting that relationship between gut abnormalities and brain pathology. New research clearly reveals a very important relationship between MS and problems in the digestive system like inflammatory bowel disease, yeast overgrowth, and low levels of healthful bacteria. This organism (*Candida albicans*) has been associated with hyper immune diseases and specifically MS.[4]

*Candida albicans* and its mycotoxins accumulate in the central nervous system, where they attack and create lesions on the myelin sheath. At this point, the whole body is saturated with toxins, which cause the secondary systems of other parts of the body to deteriorate. As the immune system continues to weaken from the constant attack of fungus, its by-products, and inflammatory agents, the body is thrown into a catabolic state and the tissues, muscles, and organs break down. Chronic toxicity overtaxes the immune system, which then loses its ability to function and starts attacking itself. This is a simplified explanation of how autoimmune disease is created.

Perlmutter routinely screens for yeast overgrowth and integrates anti-yeast treatment when working with his multiple sclerosis patients. He states:

> The possible link between various autoimmune diseases and infection with the yeast *Candida albicans* has been described by well-respected researchers over the past two decades. We believe that these data provide compelling evi-

dence that candidiasis may, at the very least, be a frequent occurrence in patients with multiple sclerosis. In addition, these data seem to indicate that intestinal dysbiosis may be common in MS patients. We now routinely perform serum analysis for candida immune complexes and candida antibodies (IgG, IgM, and IgA) as well as a comprehensive digestive stool analysis on our MS patients. Our success in reducing fatigue in MS with treatments designed specifically to reduce candida activity lends further support for the suggested relationship between MS-related fatigue and candida activity. Further we suggest that intestinal dysbiosis may play a pivotal role with respect to the actual pathogenesis of MS as an autoimmune disease entity.[5]

Another neurologist, R. Scott Heath, did a study with MS patients by putting them on a candida diet and Diflucan. Heath said that "no patients experienced exacerbations while on diet and Diflucan."[6]

## EMOTIONAL AND MENTAL IMBALANCES

Emotional and mental imbalances are a common occurrence with *Candida albicans* overgrowth. Depression and anxiety are almost constant components of systemic illness related to chronic yeast growth in the tissues. The reason, as described by J. P. Nolan in an article in *Hepatology*, is the link between the gut and the brain: "An individual's ability to protect against brain-active substances depends upon the status of his or her intestinal flora, GI mucosal function and hepatic (liver) detoxification ability."[7] This means that, when leaky gut is present and the liver is overstressed, the door is open for toxins to reach the brain via the bloodstream.

Unfortunately, too many physicians assume that all mental or emotional imbalances have psychological causes such as neuroses or psychoses, when, as Truss points out in *The Missing Diagnosis*:

> I would like to make a special plea that we speak of man-
> ifestations of abnormal brain function are viewed not
> as "mental symptoms," but as "brain symptoms." Inher-
> ent in the term "mental symptom" is the connotation that
> somehow "the mind" is a separate entity from the brain,
> that "mental" symptoms are occurring (at least initially)
> in a brain that is functioning normally chemically and
> physiologically. We speak of kidney, liver, or intestinal
> symptoms when abnormal function manifests itself in
> these organs, but we use the term "mental symptoms"
> rather than "brain symptoms" when a similar problem
> occurs with brain physiology.[8]

If you have MS, anxiety and/or depression can be debilitat-
ing, but these symptoms are a chemical imbalance caused by an
overtaxed immune system combined with the psychological stress
of having a serious condition. Your mental and emotional imbal-
ances are therefore to be treated, not ignored or discounted.

## WESTERN MEDICINE'S DENIAL

To this day, intestinal/systemic candidiasis is not accepted by
Western medicine. Don't be surprised if you take this informa-
tion to your neurologist and he or she dismisses it or tells you
that you are crazy. It's odd that doctors who routinely recognize
and treat *Candida albicans* overgrowth in cases of oral thrush,
vaginal infections, or with HIV/AIDS patients whose immune
systems are severely compromised, refuse to recognize MS in

the same light, since it is also another condition of a compromised immune system.

However, antibiotics, hormone replacement drugs, birth control pills, and steroid drugs equate to millions of dollars. Doctors are going to be the last ones to acknowledge that intestinal candidiasis exists or to admit that the drugs they prescribe so freely are creating the problem. There are some good doctors who will treat intestinal/systemic candidiasis, but they're still few and far in between.

## MAKING THE CONNECTION: CANDIDA AND MS

All or most autoimmune diseases are caused by yeast/fungal toxins. The difference is whether the fungal toxins are the primary or secondary cause. For people with MS, it is the primary attacking agent.

The similarities between candidiasis and MS are these:

- MS affects more women than it does men, so does candidiasis.
- MS symptoms are ones that impair the nervous system (numbness, tingling, fatigue, poor coordination, urinary frequency, depression, and erratic vision). These are also the symptoms of chronic candidiasis.
- The most common symptom in both conditions is fatigue.
- Intestinal dysbiosis, an imbalance between the good and bad bacteria in the gut, is common.
- Both conditions suppress the immune system and cause the body to be in an inflammatory state.
- Candidiasis patients have vitamin and mineral deficiencies, as do people with MS.

- Food allergies and gluten intolerance are common in both conditions.
- Both conditions have been linked with the Epstein-Barr virus.
- Finally, both conditions will respond with dietary changes and an antifungal regime.

You can eliminate MS by changing your lifestyle, dietary factors, eliminating heavy metals from the body, reducing stress, and changing geographical location. The variances of these factors account for periods of lapses and remission of the symptoms. No matter what your stage of MS, treatment of candidiasis is essential to turning your condition around.

The correlation between candidiasis and MS is simply stated, but it is not to be overlooked. It is the missing ingredient you have been looking for. *Candida albicans* overgrowth is the invisible catalyst that causes this "incurable" disease.

# SECONDARY FACTORS THAT CONTRIBUTE TO MS

## THE FACTORS THAT BRING ABOUT DISEASE

In today's world, there are more factors than ever before that are affecting your body in ways that bring about disease: the depleted foods you eat, the synthetic chemicals and toxins you absorb, and the overload of emotional/mental stress you endure.

When your capacity to eliminate toxicity becomes overburdened, disease sets in. Your doctor gives you drugs, but these only add more toxins to the body and cover up symptoms without getting to the root cause. Yes, there are times when drugs are useful, but most are designed to alleviate symptoms.

The point is to move beyond symptoms and to ignite your body's own defense mechanisms to heal itself. When toxins and distress are eliminated, and vitamins and minerals are balanced, the body will do its job to repair itself. It is not outside factors such as germs that you pick up. Rather it's your internal environment that becomes compromised and produces favorable conditions

for microbes such as bacteria, viruses, parasites, and yeast to take over. Even Louis Pasteur, the famous French scientist who discovered the germ theory, said near the end of his life it was more important to look to the body's internal environment than to germs as causes of disease.

Even though candidiasis is the primary cause of MS, other secondary contributors are worth examining. These include amalgam fillings, viruses, vaccinations, poor diet and food allergies, physical trauma, psychological stress, and environmental toxicity.

### Silver-Mercury (Amalgam) Fillings

Silver-mercury fillings consist of 52 percent mercury. The remaining metals are silver, tin, copper, and traces of zinc. Numerous studies have shown that amalgam fillings suppress the immune system and can create illness (see Table 3.1). MS is one of the primary conditions linked to mercury poisoning.

Many countries in Europe ban the use of amalgam fillings, but the American Dental Association still stands firm in proclaiming that they are safe. Mercury is a poisonous and toxic metal that accumulates in the nerves, brain, kidneys, and liver of those exposed to it. Most of us received amalgam fillings at a young age and still have them in our mouths as an adult. Amalgams came into use primarily because of its durability. The problem is that over time there is wear and tear on these fillings: "The mercury escapes from fillings in the form of vapor created by chewing. It then enters the bloodstream and is delivered to all parts of the body, including the brain. It is our conclusion that mercury toxicity is an autoimmune disorder. Mercury is the most toxic nonradioactive element on earth, and an amalgam filling contains 52 percent mercury."[1]

## TABLE 3.1 Symptoms of Chronic, Low-Dose Mercury Exposure

- Abdominal pain
- Abnormal reflexes
- Adverse outcome of pregnancy
- Anorexia (lack of appetite)
- Anuria (cessation of urine production)
- Ataxia (difficulty in moving)
- Disturbed gait
- Erethism (nervousness, irritability, mood instability, blushing)
- Excessive salivation
- Gastroenteritis (stomach upset)
- Gingivitis (inflammation of the gums)
- Glioblastoma (brain cancer)
- Immune system dysfunction
- Impaired hearing
- Impaired nerve conduction
- Infertility
- Mouth pain
- Nephritis (kidney disease leading to kidney failure)
- Personality change
- Pneumonitis (lung disease)
- Prickling, tingling, or creeping sensations on the skin (paresthesia)
- Renal damage
- Speech disorders
- Suicidal tendency
- Tremor
- Uremia (appearance of urine products in the blood)
- Visual disturbances
- Vomiting

Not everyone with MS has amalgam fillings, so this is only one part of the puzzle. I would recommend that those with MS and have amalgam fillings get them removed. This is a factor that you want to examine in consult with your health practitioner and your dentist.

### Viruses and Bacteria

Almost all of us have been exposed to viruses as children. The strength of your immune system determines what viruses will take hold during your lifetime.

As fungus and its by-products take over, your body is depleted of oxygen. This imbalanced ecology creates a perfect breeding ground that allows bacterial, viral, and parasitical infections to surface.

Several viruses and bacteria show up more consistently than others in the bloodwork of those with MS. They are: *borrelia burgdorferi*, which is transmitted through tick bites that are responsible for Lyme disease; human herpes virus 6 (HHV-6), which commonly causes roseola in infants; chlamydia pneumonia, commonly involved in respiratory infections; cytomegalovirus; and Epstein-Barr virus, which can bring on mononucleosis.

In a December 2001 article, "Viruses and Multiple Sclerosis" *JAMA*; 286 (24), 3127-29, Donald H. Gilden, MD, cited findings that the Epstein-Barr virus that can cause mononucleosis may also increase the risk of MS.[2] Epstein-Barr virus surfaces in those with candida overgrowth. The yeast toxins produce a suitable environment for the virus to take over. Candida overgrowth is the precursor to the Epstein-Barr virus becoming active.

All these infections are relevant and need to be dealt with when you have MS. By treating candidiasis, you will also treat viruses, bacteria, and parasites.

## Vaccinations

Vaccinations are controversial, to say the least. The purpose of a vaccination is to create resistance to a disease by injecting a weakened or killed microorganism of the same disease. Unfortunately, vaccinations can cause or contribute to several severe complications, including autism, allergies, sudden infant death syndrome, and autoimmune disease.

The risk is heightened because thimerosal, a water-soluble, cream-colored crystalline powder that is 49.6 percent mercury by weight is used as a preservative in many vaccines. As I discussed above, mercury is poisonous and toxic.

One example of vaccination complications occurred in the early and middle 1950s, when the administration of penicillin as an antibiotic came into common use.

This was at the same time that the first polio vaccinations were being administered. The indiscriminate use of penicillin and the polio vaccination set the stage for the two to interact and cause fungal infections.

The repercussions were retroviruses that surfaced later in adulthood. Post-vaccination damage is not always immediately obvious. It can take weeks, months, and even years to show up in the body. In 1967, the *British Medical Journal* published several studies showing a connection between polio, diphtheria, measles, tetanus, and smallpox vaccines, with the development of multiple sclerosis several years later.[3]

The latest concern is the correlation between the hepatitis B vaccination (HBV) and MS. An article in the *Annals of Pharmacotherapy*[4] concludes that HBV is associated with multiple sclerosis along with many other serious conditions. This vaccine is now given to newborns before they leave the hospital. But this vaccine is a highly toxic substance to infants, whose blood-brain barriers and immune systems are not yet fully developed.

## Stress

Stress is today's number one "body breaker." Stress is the sum total of all the mental and physical input we encounter. When your capacity for input goes into overload, stress essentially becomes distress. Job pressures, relationship problems, health conditions, noise and pollution, financial concerns, and keeping up with the fast pace of life today all create distress. We all need some stress in our life to feel purposeful, but most of us are on overdrive physically, mentally, and emotionally, to the point of creating imbalance.

Those with MS usually have one thing in common before they were diagnosed—an extremely traumatic psychological event and/or high levels of chronic stress. Physical, emotional, and mental stress weakens your central nervous system.

## How Chronic Stress Damages Your Body

The body has a parasympathetic and sympathetic nervous system. The parasympathetic dominates when you are at rest, breathing comfortably, and experiencing a normal heart rate. Sympathetic dominance is your flight-or-fight response. It puts you into action by flooding your body first with adrenaline and then with cortisol, which continues to work for hours afterward. Both systems have their place, but most people today stay in sympathetic mode too much of the time.

Chronic stress ultimately creates adrenal exhaustion. Eventually the adrenal hormones cortisol and dehydroepiandrosterone (DHEA, an anti-aging hormone also produced by the adrenal glands) malfunction and produce little or no output. This abnormal ratio of cortisol to DHEA compromises your immune system, and you feel exhausted. The suppressed activity of the white

blood cells affects your endocrine (hormonal) system, depletes nutrients, and sets the stage for yeast, viruses, and bacterial infections to thrive. Free radicals (atoms that cause damage to cells), known as oxidative stress, also become more abundant, and these destroy brain cells and tissue, i.e., the myelin sheath.

Elevated cortisol to DHEA ratios increase blood pressure, respiration, and heart rate; lower blood sugar and decrease insulin sensitivity; accelerate bone loss, fat accumulation, and muscle wasting; cause insomnia; and impair the body's ability to detoxify heavy metals. Most importantly, elevated cortisol lowers levels of secretory IgA (mucosal antibodies), which protect the mucosal lining of the gut. When this barrier is weakened, yeasts, fungus, undigested food particles, and other antigens (foreign invaders) escape into the blood and lymph system, create an inflammatory response, and compromise your immune system.

*Acidic Body*

For optimal health, your body needs to maintain a balance between acidity and alkalinity. Different parts of the body have different optimal pH values (for example, the blood, 7.35; saliva, 6.4–6.8; and the large intestine, 5.6–6.4).

Acidity is one of the main causes of inflammation because it disrupts body chemistry. Inflammatory antigens caused by acidity attack the myelin sheath and cause demyelination. What are we exposed to in today's world that is acidic? Stress hormones, caffeine, alcohol, drugs, pharmaceutical medication, cigarettes, unhealthy foods (refined sugars and carbohydrates, excess red meat, pasteurized dairy products, and processed foods), and environmental chemicals. An acidic body leads to an inflamed and pained body, which over time becomes a diseased body.

The bloodstream must maintain an alkaline pH of around 7.35 at all times to sustain life. Your body maintains that blood pH by using sodium and then calcium as a natural buffering system if needed. However, if blood calcium is used to buffer the body, eventually bone loss or osteoporosis occurs. Other proteins and minerals will also become imbalanced, causing deterioration of other tissues, organs, joints, and bones. This depletion can go unnoticed for many years because blood tests will give "normal" results until an organ or system is in an exhausted state. Then you wonder why all of a sudden you have an autoimmune disease.

### Trauma

It has been well documented in a number of cases that MS has erupted after people have experienced a physical trauma to the head or spinal column. Such injuries can be minor, such as a bump on the head, or severe, such as whiplash from a car accident, or a serious fall. In any case, the injury site in the neck or spinal column becomes the portal that allows toxins to reach the central nervous system. Whenever there is an injury to the body, inflammation occurs, and wherever there is inflammation, yeast toxins follow.

### Poor Diet and Food Allergies

Diet alters your body chemistry either positively or negatively. You must eat to not only survive but also to sustain vitality and to optimize the functioning of the more than 300 trillion cells that make up your body.

A poor diet consists of refined sugars, white flour products, dairy, trans fats, and processed foods, all of which destroy cellular function and disrupt the ecology of your digestive system.

Poor digestion results from eating denatured foods, which leads to proteins being unable to break down properly. Undigested proteins putrefy in your gut and enter your bloodstream. Once these proteins leave the gut, they alert the immune system that an antigen has entered your body. The immune system then begins producing protein antibodies to fight the invader. Your adrenal glands, which supply natural antihistamine, weaken over time, as does your immune system function, and you become allergic, not only to food, but also to environmental toxins. This response creates an inflammatory response, and food allergies arise.

### Environmental Toxicity

Our polluted environment is another factor in how the body's tissues become saturated with toxicity. Heavy metals (cadmium, lead, and mercury), pesticides and insecticides, molds, and synthetic chemicals surround us.

Our bodies absorb these toxins and cannot excrete them as fast as they enter the body. These toxins add to the burden of our immune system, which is already under attack by digestive and microbial toxins.

### Genetics

Your inherited genes may determine your strengths and weaknesses. However, it is my observation that one's phenotype—the observable physical or biochemical characteristics of an organism as determined by both genetic makeup and environmental/lifestyle influences—plays a more-important role in determining which imbalances will surface rather than genetics. For example, a family history of MS.

## CONCLUSION

Many factors create MS. Some people have more psychological stress, some more microbial overgrowth, and others are exposed to more heavy metals. The combination of the factors mentioned in this book account for the variations of MS. This variability also makes it difficult to find a single cure and accounts for the inconsistent responses that a patient shows to treatment.

The best approach to reversing MS is to become informed and to apply the therapies and treatments that fit your specific needs and symptoms.

# POOR DIET:
## TRASH IN = TRASH OUT

### THE IMPORTANCE OF DIET

You are what you digest, absorb, utilize, and eliminate. Diet is one of the most important components to preventive health and to healing a diseased body. It can rebuild or weaken your immune system. It can also determine the quality of your aging process.

The increasing numbers of people with allergies, diabetes, heart disease, mental illness, autoimmune diseases, and cancers can be attributed in part to having an unhealthy diet. The average American diet consists of large amounts of trans fats, refined sugar, refined carbohydrates, caffeine, alcohol, and processed foods that are filled with chemicals and preservatives. How can our cells thrive on artificial depleted food? They can't.

The liver, which has more than 500 functions, is your body's main detoxifier. When you eat a poor diet, your liver, lungs, skin, kidneys, and bowels must work that much harder to eliminate food toxins, chemicals, preservatives, and to counter the assault of the environmental toxins that you encounter each day. What you eat is vital to keeping your body running smoothly and to easing the

stress on organs. Chronic disease equates with being nutritionally deficient and toxic over a period of time. Signs of degeneration and deprivation set in slowly until the wake-up call is loud enough that you can no longer ignore your condition. At that point, though, physicians are likely to box you with a diagnosis, such as MS, that many of you feel you can never overcome.

It is important to stop and analyze your relationship to food. It's a mistake to think that junk food will not negatively affect every cell in your body. The answer is very simple: trash in = trash out. Your body will pay the price. The most common symptom that my MS patients report is lack of energy, and fatigue is the result of a toxic and nutritionally deficient body. The great news is that you have control over the food choices you make, and once you educate yourself, you can start to make these modifications—and you'll quickly notice improvements.

## THE IMPACT OF NUTRITION

With all of our money and technology, the United States is one of the sickest nations in comparison to the rest of the world. Our poor-quality diet of antibiotic- and hormone-laden meat and dairy products, trans fats, refined carbohydrates, and sugar is to blame.

Medical students receive about 52,000 hours of medical training but only six hours of education about nutrition. Patients tell me that their doctors say to them, "What you eat has nothing to do with your condition. Neither does taking vitamins." This couldn't be further from the truth.

There is also a general view in our society that "I'm going to die anyway, so what does it matter what I eat?" This viewpoint needs to be re-examined. It is true that all of us will pass over someday, but it is possible to age with quality and to retain our physical and mental agility, flexibility, and soundness. Each of us has an

obligation to take care of our bodies. Although you are more than your body, without it you do not exist. Anyone with MS knows how precious it is to have health. Making the choice to eat a healthy, balanced diet is one of the secrets of conquering MS.

## THE MENTAL AND EMOTIONAL EFFECTS OF DIET

One of the most neglected factors regarding diet is how much it affects your nervous and emotional system. Poor diet can create depression, anxiety, and serious mental illness. A lack of B vitamins due to excess intake of refined carbohydrates and sugar disrupts neurotransmitters (chemical messengers of the nervous system) that help you to sleep and think rationally. Anxiety and depression are common conditions that stem from a poor diet.

According to Gerald Ross, MD, "Food sensitivities, nutritional imbalances, and indoor air pollution can profoundly influence brain function."[1] Like every system in the body, the brain, and the gut are interconnected. There is a direct correlation between the toxicity that occurs when undigested food particles and toxins pass through your gut and reach the brain. They cause not only physical symptoms but psychological ones as well—your emotions and thoughts are affected by what is going on in your brain, your gut, and your overall physiological functioning.

Healthy eating is as important to your mental and emotional health as it is to your physical well-being. The canning and processing of food depletes them of enzymes, vitamins, minerals, and micronutrients. Our grocery stores have been filled with aisles of dead food since World War II, when we first began canning and processing food for our soldiers. But that war ended more than a half-century ago—it is time for you to educate yourself about how the depleted foods sold are assaulting your body.

## DIET FADS

What happens when the proteins, fats, and carbohydrates that you ingest are broken down in your body? They become amino acids, fatty acids, glycerol, monosaccharides, vitamins, minerals, and water, all of which your body needs.

So-called diet experts are making fortunes putting out books that urge you to eliminate carbohydrates, proteins, or fats. The fact is that no two individuals are the same, and no one diet can apply to everyone. Some of these books make valid points, but you need to be discerning. Avoiding or eliminating any food group altogether will create imbalances in the body. You need to understand what you're doing and how your body will respond and compensate if you eliminate certain foods. I sometimes eliminate a food group from an MS patient's diet, but it is only temporarily, as a transition to assist in detoxification or to manage a crisis state. After that, it's back to balance and moderation.

### Refined Sugar

Refined sugar in any of its forms (sucrose, fructose, corn syrup, etc.,) is one of the most harmful substances you can consume. Sugar depletes the vital vitamins and minerals that you need to sustain yourself. White sugar has absolutely no nutritional value. Refined sugars deplete the body and wreak havoc with your blood sugar, pancreas, and immune system.

Well-known nutritionist Ann Louise Gittleman states: "There are over sixty ailments that have been associated with sugar consumption in medical literature."[2] Cancer, *Candida albicans*, and human immunodeficiency virus (HIV) all thrive on sugar.

Exacerbations of MS symptoms worsen and become more frequent when patients ingest high-sugar foods because of the

inflammatory response that sugar produces in the body. According to Ray C. Wunderlich, MD, and Dwight K. Kalita, PhD, "The ingestion of large amounts of sugar paralyzes the phagocytic capacity of our white blood cells."[3] This means your white blood cells, which play a major role in the functioning of a strong immune system, cannot identify and destroy foreign invaders. Over time, this incapacity will create disease and imbalances in the body.

When you begin to read labels, you will see almost every food on the market, from canned goods to breads to salt, contain sugar in some form. Refined sugar is disguised as sucrose, fructose, dextrose, brown sugar, glucose, evaporated cane juice, high-fructose corn syrup, lactose, and maltose.

The United States is a nation addicted to sugar. In 1890, the average American ate 10 pounds of sugar a year. Today, that figure is between 150 and 200 pounds.

Unfortunately, in our society sugar is not just something that tastes good. It has also become an emotional pacifier. Refined sugar may satisfy your psychological needs for a moment, but ultimately it will destroy your body. The most important step you can take to stop the progression of your MS is to get the refined sugar out of your diet (see Table 4.1).

### Trans Fats (Bad Fats)

The United States is finally recognizing that trans fats, which have already been banned in Denmark and Canada, are major contributors to heart disease and other serious health conditions.

Any food that lists "partially hydrogenated" or "hydrogenated" oil among its ingredients contains trans fats. This means that the oil has been heated to a high temperature for the sole reason of preserving the food product for a longer shelf life. Trans fats are

TABLE 4.1. **Fifty-nine Reasons Why Sugar Ruins Your Health**

1. Sugar can suppress the immune system.
2. Sugar upsets the minerals in the body.
3. Sugar may cause hyperacidity, anxiety, difficulty concentrating, and crankiness in children.
4. Sugar produces a significant rise in triglycerides.
5. Sugar contributes to the reduction of the body's defense against bacterial infection.
6. Sugar can cause kidney damage.
7. Sugar reduces high-density lipoproteins (HDL).
8. Sugar leads to chromium deficiency.
9. Sugar can lead to cancer of the breast, ovaries, intestines, prostate, or rectum.
10. Sugar increases fasting levels of glucose and insulin.
11. Sugar causes copper deficiency.
12. Sugar interferes with absorption of calcium and magnesium.
13. Sugar can weaken eyesight.
14. Sugar raises the level of neurotransmitters called serotonin.
15. Sugar can cause hypoglycemia.
16. Sugar can produce an acidic stomach.
17. Sugar can raise adrenaline levels in children.
18. Sugar malabsorption is frequent in patients with functional bowel disease.
19. Sugar can cause signs of premature aging.
20. Sugar can lead to alcoholism.
21. Sugar leads to tooth decay.
22. Sugar contributes to obesity.
23. High intake of sugar increases the risk of Crohn's Disease and ulcerative colitis.
24. Sugar can cause symptoms often found in people with gastric and duodenal ulcers.
25. Sugar can lead to arthritis.
26. Sugar can contribute to asthma.
27. Sugar can cause *Candida albicans* (yeast infection).
28. Sugar can contribute to gallstones.
29. Sugar can lead to heart disease.
30. Sugar can cause appendicitis.

Source: Nancy Appleton, Ph.D., *Lick the Sugar Habit.* Used with permission.

---

**TABLE 4.1. Fifty-nine Reasons,** *continued*

31. Sugar can lead to multiple sclerosis.
32. Sugar can cause hemorrhoids.
33. Sugar can contribute to varicose veins.
34. Sugar can elevate glucose and insulin responses in oral contraceptive users.
35. Sugar can lead to periodontal disease.
36. Sugar can contribute to osteoporosis.
37. Sugar contributes to salivary acidity.
38. Sugar can cause a decrease in insulin sensitivity.
39. Sugar leads to decreased glucose tolerance.
40. Sugar can decrease growth hormones.
41. Sugar can increase cholesterol.
42. Sugar can increase the systolic blood pressure.
43. Sugar can cause drowsiness and decreased activity in children.
44. Sugar can cause migraine headaches.
45. Sugar can interfere with absorption of protein.
46. Sugar can cause food allergies.
47. Sugar can contribute to diabetes.
48. Sugar can cause toxemia during pregnancy.
49. Sugar can contribute to eczema in children.
50. Sugar can lead to cardiovascular disease.
51. Sugar can impair the structure of DNA.
52. Sugar can change the structure of proteins.
53. Sugar can contribute to sagging skin by changing the structure of collagen.
54. Sugar can lead to cataracts.
55. Sugar can cause emphysema.
56. Sugar can cause atherosclerosis.
57. Sugar can promote an elevation of low-density proteins (LDL).
58. Sugar can cause free radicals in the bloodstream.
59. Sugar lowers the enzymes' ability to function.

---

found in pastries, breads, crackers, processed foods, microwave popcorn, chips, cookies, and margarines. Research has shown that margarines with trans fats—not butter—are the real cause of blocked arteries. These bad fats are poison to anyone with MS because they set off an inflammatory response in the body.

## REFINED CARBOHYDRATES

I call refined carbohydrates such as white flour, white rice, and refined grains "glue and goo." These foods include pastries, cookies, muffins, bagels, breads, donuts, and crackers. Refined carbohydrates coat the lining of your gastrointestinal (GI) tract and interfere with the process of absorbing nutrients and of eliminating waste. They are irritants that create leaky gut syndrome and ultimately lead to inflammation, allergies, and malnutrition.

Wonder Bread says that it is enriched with vitamins and minerals that have been added back into it, but the truth is that many micronutrients, fiber in particular, are lost when flour is bleached and refined. Fiber is essential for proper elimination and for keeping your blood cholesterol levels down. Refined carbohydrates contribute to the alarming rates of people with constipation, irritable bowel, and imbalances in blood sugar levels because they convert rapidly to glucose (sugar). This leads to both hypoglycemia (low blood sugar) and diabetes. Also the bleaching agent used in refined flour, nitrogen trichloride is poisonous and has been linked to ulcers, schizoprenia, and MS.

## DAIRY PRODUCTS

Bovine (cow) dairy products are the leading cause of food allergies. Allergies to these products cause sinus problems and gastrointestinal complaints such as gas, bloating, cramps, and diarrhea. Hyperactivity and irritability are common, especially in children. Asthma, headaches, joint and muscle pain, depression, lack of energy, and skin problems are also attributed to dairy allergies.

The introduction of Lactaid milk, in which the lactose or milk sugar has been removed, was to help those who are lactose intol-

erant. However, there's a difference between being lactose intol-
erant and having a milk allergy. Most people have both condi-
tions. Lactose intolerance means that you lack the enzyme that
breaks down lactose. Having a milk allergy means that the body
is unable to recognize the milk protein, sees it as a foreign
invader, and defends itself by creating an allergic response.

Medical books tell us the best way to get calcium is from drink-
ing milk. Women are especially targeted because of the rising lev-
els of osteoporosis in our country. However, milk is not the best
way to get calcium. Only 30 percent of the calcium in eight ounces
of milk is actually absorbed in the body. Pasteurization destroys
the enzyme phosphatase and without phosphatase our bodies can-
not use phosphorous. And without phosphorous we cannot assim-
ilate calcium.

Think about it—we're the only species that drinks milk from
another species. How do cows get their calcium? Not by drink-
ing milk from another species but by eating grass (if they're being
raised humanely).

Plant foods, such as sesame seeds, almonds, broccoli, car-
rots, and dark-green leafy vegetables, are high in calcium, some
more than cows' milk.

The real cause of calcium deficiencies—and osteoporosis—
is excessive consumption of high-acid foods, such as animal
meats, caffeine, refined carbohydrates and sugars, and pasteur-
ized milk and dairy products.

Consumption of these foods force the body to leach calcium
and minerals from the bones to buffer the acidity in the blood-
stream, which, as mentioned earlier, must maintain an alkaline
condition of pH 7.35 (alkaline), or death will result. To maintain
that pH balance, the blood robs minerals from the rest of the body
which are alkaline. And the body's biggest storehouse of miner-
als is the musculoskeletal system.

*Antibiotics and Hormones in Milk*

The major factor you need to consider when deciding whether to ingest dairy products is the use of antibiotics and hormones that are added to them. According to a *Newsweek* article, "Milk is allowed to contain a certain concentration of eighty different antibiotics—all used in dairy cows to prevent udder infections. With every glassful, people swallow a minute amount of several antibiotics."[4] Bovine growth hormone (RBGH), which was produced through gene splicing to increase milk production, is also added. These hormones and antibiotics, which are permitted by the government, are creating imbalances in our children and adults.

I'm not talking just about milk but also about products made from milk such as cheese, ice cream, sour cream, and yogurt. The American Dairy Association is spending big bucks to convince you that "Milk does a body good," but I ask you to think again.

## ANIMAL PROTEIN

Animal proteins, such as red meat, pork, chicken, turkey, and fish, are also in question. Pork, beef, chicken, and turkey that are not organically raised contain antibiotics and hormones. These are passed on to consumers and cause hormonal and yeast imbalances.

Pork contains higher concentrations of parasites because of what pigs are fed and because they don't eliminate toxins efficiently. Red meat is more acidic to your body chemistry (especially when cook beyond medium rare) than chicken and turkey. This acidity adds to inflammation in the body and makes MS symptoms worse. Organically raised chicken and turkey are better choices.

Unfortunately, our oceans are polluted with heavy metals and chemicals that have entered our fish supply. Shellfish are partic-

ularly high in contaminants because they are bottom feeders and absorb higher concentrations of chemicals and mercury. Fish such as salmon and cod are high in essential fatty acids, which help to restore the myelin sheath, so there are advantages to eating them. However, finding clean sources can be a challenge.

## CAFFEINE

Caffeine, whether in the form of coffee, soda, tea, or chocolate, is acidic and raises blood-sugar levels in the bloodstream. Caffeine stimulates the adrenal glands to release hormones that put the body into an adrenaline rush response. This increases the heart rate, so stored sugar is released and the pancreas kicks out insulin to bring sugar levels back into balance. If abused, this cycle exhausts the adrenals and the pancreas, both of which are important for optimal energy. The rise in sugar also feeds candida overgrowth in the body.

In addition, excessive acidity irritates your nervous system and creates inflammation, bringing pain and destruction to your myelin sheath.

## ALCOHOL

Alcohol is nothing more than refined sugar that goes directly into the bloodstream, where it increases blood sugar levels, feeds candida, creates an inflammatory response, and depletes vitamins and minerals in your body.

For anyone with MS, consuming alcohol is a sure-fire way to accelerate the degeneration of your central nervous system.

## FOOD ALLERGIES

Food allergies arise when there are imbalances in your gut such as maldigestion from eating refined, depleted, and processed food. Large quantities of undigested food particles irritating and passing through the linings of the GI tract will cause an allergic reaction in the bloodstream. The most common food allergies are to milk, corn, soy, citrus fruits, chocolate, eggs, nightshade vegetables (eggplant, peppers, potatoes, and tomatoes), and wheat. Allergies to even healthy foods, such as certain fruits and nuts, can also arise.

Gluten intolerance is becoming more common, and people with MS need to pay special attention to it. Rye, oats, barley, spelt, kamut, and wheat contain gluten, a protein that is abrasive to the GI tract and can strip the villi, the fingerlike projections attached to the intestinal walls that help to absorb and keep the gut clean of yeast and bacteria. Staying away from these grains for about three months will correct the problem.

Soy is also another topic for debate. In America, the market is flooded with genetically modified soy protein foods, processed tofu, and soy protein powders. However, if you examine how Asians used soy, you'll find they use fermented soy products such as miso and tempeh, and in small amounts. Unfortunately, fermented soy products are not allowed on a candida diet because they can aggravate candida.

A lot of people have soy allergies causing gas and bloating. Larger amounts of soy protein can disrupt thyroid function. Therefore, I feel small amounts of organic soy is acceptable.

## SUPPLEMENTATION

In today's world, diet alone can't keep your body healthy, let alone reverse MS. Along with a healthy diet, your body requires sup-

plementation. You must eat five times the amount of what your grandparents ate to obtain the same nutrients. Modern agricultural practices have depleted our soil, and your body must cope with more environmental toxicity from pesticides, herbicides, heavy metals, and synthetic chemicals than ever before. Stress levels have also increased. In Part Four, page 183, you'll learn how to decide which supplements are right for you.

## WATER

Last but not least is the topic of water. As the eminent researcher F. Batmanghelidj has stated, "We are a dehydrated society, and dehydration is the number-one stressor of the human body or any living matter."[5]

How can you keep your body running smoothly if it's made up of 80 percent water but you drink fewer than eight cups of water a day? You can't. As a result, your "plumbing" gets backed up—your lymphatic system becomes sluggish with toxins, your kidneys are overstressed, your colon is constipated, your liver and gallbladder become congested, and autotoxicity sets in as you reabsorb the toxins that your body is trying to eliminate. These conditions set the stage for autoimmune diseases and cancer.

# THE DIGESTIVE SYSTEM AND IMMUNITY

## THE SEEDS OF DISEASE

Most chronic progressive and autoimmune diseases start with an imbalance in the digestive system, which is comprised of the mouth and salivary glands, the stomach, the pancreas, the liver, the gallbladder, and the small and large intestines. As naturopath Mark Percival has stated in his seminar literature: "Destructive eating habits lead first to gastrointestinal dysfunction and then subsequently contribute to virtually every noninfectious disease known to us (and likely some of the infectious diseases as well)."[1]

It is known that ten times as many bacterial cells live inside the GI tract, the stomach, and intestines as there are human cells in the entire body. The small and large intestine are twenty to twenty-five feet long. A balanced ecosystem in the GI tract equates to having a ratio of 85 percent healthy microorganisms to 15 percent unhealthy ones. Inadequate diets that are based on depleted nutrients, chemicals, and preservatives upset this ratio and can create maldigestion, malabsorption, intestinal dysbiosis (overgrowth of microbes such as fungi, parasites, bacteria, and viruses

in the gut), and elimination problems. What's more, these problems are not just isolated conditions. They also affect other systems of your body (see Figure 5.1).

## MALDIGESTION

Maldigestion occurs when the body is unable to properly break down food. Reasons for this include lack of hydrochloric acid (HCL) in the stomach, inadequate chewing, poor food combining, drinking excessive liquids with meals, pancreatic enzyme deficiencies, hiatal hernia, and stress.

Chronic poor diet contributes to maldigestion. When food goes undigested, the particles and their toxic by-products become intestinal irritants that can cross the mucosal lining of the stomach and enter the bloodstream (leaky gut syndrome). The blood sees these particles as foreign invaders and creates an antibody response by having the white blood cells come to the rescue to defend your body. However, this activity produces inflammation and allergic reactions and sensitivities. Symptoms of maldigestion include belching, bloating, gas, abdominal pain, and heartburn.

## ENZYMES

Enzyme deficiencies are a major contributor to maldigestion because cooking, processing, or refining foods to a temperature of more than 118°F destroys enzymes. Enzymes are proteins—catalysts that ignite chemical reactions in the body. The body manufactures its own enzymes but also makes use of ones in food. Raw or lightly steamed foods contain enzymes, whereas cooked foods do not. Therefore, when enzymes are lacking, the pancreas, which secretes digestive enzymes, takes on a greater load. The pancreas also produces insulin,

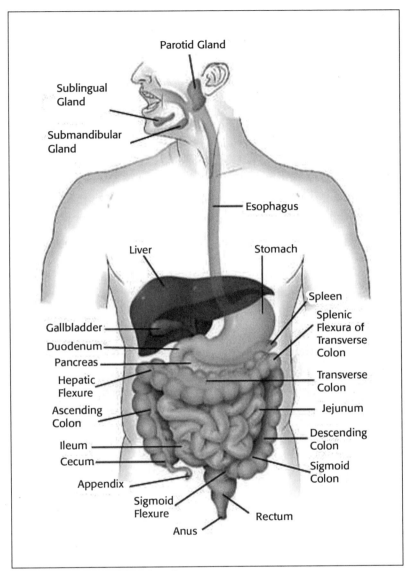

**Figure 5.1 Anatomy of the Digestive System**

the hormone that maintains blood sugar. Diets loaded with refined carbohydrates, sugar, and cooked and processed foods overwork the pancreas and weaken its performance.

## MALABSORPTION

Malabsorption occurs when the uptake of food from the intestines is impaired. Without proper absorption, you cannot nourish your cells, and they begin to degenerate. Nutrients are absorbed from food by villi (hair-like projections), but a poor diet and toxic overload in the body can strip or inhibit the function of the villi which creates malabsorption.

The main causes of malabsorption are maldigestion and microbial overgrowth (bacteria, fungi, parasites, worms, and viruses). Common symptoms of malabsorption are fatigue, thinning hair, dry skin, depression, susceptibility to bruising, unexplainable weight loss, and constipation or diarrhea.

## DYSBIOSIS

Intestinal dysbiosis is an imbalance of microorganisms (yeast, bacteria, parasites, and viruses) which create more upset in the digestive system and interfere with nutrient absorption. Dysbiosis is caused by poor diet; alcohol; drugs; stress; maldigestion; elimination problems; the overuse of antibiotics; steroids such as cortisone, prednisone, and birth-control pills; nonsteroidal anti-inflammatory drugs (NSAIDs); heavy metal toxins; and immunosuppressive drugs.

When unhealthy microorganisms take over the gut, your immune system is put under constant stress to defend your body from these infections. Intestinal dysbiosis is a contributing cause

in rheumatoid arthritis, MS, vitamin $B_{12}$ deficiency, chronic fatigue, cystic acne, the early stages of colon and breast cancer, eczema, food allergies and sensitivities, inflammatory bowel disease, irritable bowel syndrome, psoriasis, Sjögren's syndrome (a postmenopausal immunological disorder), and steatorrhea (excess fat in the stools). The most common form of intestinal dysbiosis is *Candida albicans* overgrowth.

## LEAKY GUT SYNDROME

Maldigestion, malabsorption, and intestinal dysbiosis set the stage for a condition known as *leaky gut syndrome*. Leaky gut is a condition in which the intestines' mucosal lining becomes irritated, inflamed, and more porous.

This allows undigested food particles, microorganisms, and their by-products to pass through the lining into the bloodstream. Candida overgrowth, NSAIDs, poor diet, heavy metals, daily aspirin use, and gluten sensitivity (wheat, rye, barley, and oats) are the contributors that irritate the lining.

"Leaky gut triggers a state of continuous and prolonged stress in and on the immune system."[2] Allergies are one of the first conditions to occur when someone has leaky gut.

The gut lining acts as a protective mucosal barrier and is your first line of defense to prevent infection. When pathogens and foreign organisms come into contact with the mucosal barrier, immune cells inside the gut produce secretory immunoglobin A (SigA), an antibody that attacks them. Chronic stress continually suppresses SigA production and thus allows pathogens to enter your bloodstream and eventually to migrate to your brain and other tissues.

Over time, the presence of bacteria, yeast/fungi, parasites, and viruses traveling in the bloodstream means that the body is

under siege. As these toxins are reabsorbed back into the blood-stream, organs such as the liver, the lymph glands, the brain, the lungs, and the kidneys become overloaded, which can then alter your RNA and DNA. Simply put, leaky gut causes chronic inflammation, which equates to chronic immune dysfunction as seen in MS. Your genetic predispositions will determine which organs and systems will be affected.

## ELIMINATION

Elimination is another factor that is grossly neglected. The optimal transit time for food to go from your mouth out through your rectum is twenty-four hours.

Most people have transit times that range between forty-eight and seventy-four hours. The result is a nation that is suffering from an epidemic of constipation, irritable bowel syndrome, and colitis. The main cause of all these conditions is inadequate fiber intake from fresh fruits, vegetables, and whole grains, most of which are stripped away when grains are refined.

Many patients tell me that their doctors have said that daily bowel movements aren't necessary. This is false. Daily elimination is essential, and two to three movements a day are optimal. If your bowels are backed up, your GI tract must focus more on getting rid of waste than on absorbing nutrients, and this sets the stage for malnutrition and dysbiosis.

Elimination problems also cause autotoxicity. Toxins that are not released from your body fast enough are reabsorbed into the bloodstream.

Constipation can also make the pH level in the large intestine more alkaline, which creates a breeding environment in which yeasts/fungi, parasites, bacteria and viruses thrive.

## LEAKY GUT AND THE LIVER

The liver is an amazing organ. The largest organ in the body, it has more than five hundred functions. You can't live without your liver. It assists with metabolism, storing vitamins and minerals, and detoxifying toxic compounds. The liver's portal vein carries digested food from your small intestine into your liver and then sends nutrients through your circulatory system to feed every cell of your body.

One of the liver's many tasks is to recognize and neutralize the poisons, such as heavy metals, pesticides, toxic foods, alcohol, cigarettes, synthetic chemicals, medications, and stress hormones that the body creates. Leaky gut makes the job of the liver more difficult by forcing it to break down undigested food particles, as well as deal with microbes and their by-products that have now entered the bloodstream. These factors in combination interfere with the liver's efficiency.

Bile, which is stored in the gallbladder, releases toxins from the liver. In a toxic body, the bile can kill off good bacteria in the small intestine. This sets the stage for candida to take over. Estrogen hormones reduce bile flow through the liver and also elevate bile cholesterol levels, thus posing a risk of gallstones and recirculation of estrogens. Imbalanced hormones are common in people with MS.

As N. Klotz and N. Ulrich state: "When the gut becomes leaky, more toxic substances are delivered to the liver, and if the liver's functional ability to detoxify is impaired, more metabolically active substances are delivered through the bloodstream to other tissues, including the brain."[3]

Like the GI tract, the blood-brain barrier can become leaky. This means that toxins that escape the liver and become stored in fatty tissues such as the cells of the brain and the central nervous

system cause inflammation and oxidative stress. This accounts for the wide range of noninfectious diseases you see today, specifically MS. Detoxifying the liver and gut are essential to keeping inflammatory processes out of the rest of the body.

## IMMUNE SYSTEM

Last but most important is the immune system, which is simply your body's ability to identify self (what naturally belongs in the body) from non-self (foreign material) and to use antigens to destroy or neutralize whatever is foreign (see Figure 5.2).

The immune system is composed of lymphocytes (B- and T-cells), the thymus, the spleen, the bone marrow, the lymph nodes, the tonsils, the adenoids, the appendix, the lymphatic vessels, the liver, and Peyer's patches (clumps of lymphoid tissue in the small intestine).

This gallant army of organs and cells comes to your rescue whenever foreign invaders attack your body. However, the immune system becomes compromised from chronic maldigestion, malabsorption, leaky gut, intestinal dysbiosis, elimination problems, compromised liver function, heavy metals, medications, stress hormones, and poor diet. A toxic body gives rise to autoimmune diseases in which immune cells such as the T-cells, B-cells, and macrophages mistakenly attack its own tissues.

### All Body Systems Are Connected

You now understand that every organ and system in your body is interlinked. All the systems "talk" to each other. If one organ becomes compromised, another organ will take over and try to

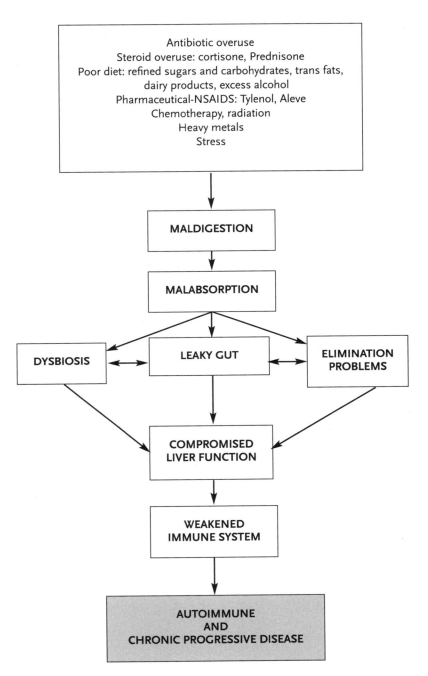

FIGURE 5.2: Digestive Tract and Immunity

compensate. When your gut is leaky, it compromises your blood-stream with toxins. A polluted bloodstream and lymph system compromise your immune system. An overtaxed immune system allows chronic inflammatory agents to enter your brain. MS is one of the conditions caused by an immune system that can't keep up with accumulated stressors.

# ENVIRONMENTAL TOXICITY

Although industrialization and technology have created many conveniences, your body is paying the price from exposure to an excessive amount of synthetic chemicals, heavy metals, electromagnetic frequencies, and pesticides and herbicides. Chemicals store in fat tissues, and the brain is composed of 60 percent fat. Over time, this accumulation can become a disease factor in those with MS. The many health conditions that are caused by high levels of environmental toxins include allergies, asthma, attention deficit disorder (ADD), cancers, autoimmune diseases, and Alzheimer's and Parkinson's disease, to name just a few.

## CHEMICALS

Chemicals, such as formaldehyde, dioxins, benzenes, asbestos, and carbon monoxide, are a tremendous stress upon the body. One study cited a US Environmental Protection Agency (EPA) estimate "that 1.5 trillion gallons of pollutants leak into the ground each year, with the highest incidence of contaminants from lead, nitrates (from fertilizers), and radon. Over 700 chemicals have

been found in tap water, but testing is done on less than 200 of these."[1] Another statistical report said that "551,034,696 pounds of industrial chemicals were dumped into public sewage storage. The total amount of air emissions pumped into the atmosphere was 2,427,061,906 pounds. The EPA estimates a grand total of 5,705,670,380 pounds of chemical pollutants were released into the environment in 1989."[2] These numbers are high enough to make anyone sick.

## INDOOR POLLUTION

One of the major health hazards that environmental and health organizations are concerned about is indoor health pollution. Advances in technology have allowed us to build more energy-efficient buildings and homes, but we have also created "sick building syndrome," meaning that chemicals and pollutants stay trapped inside buildings and houses. In 1998, *Scientific American* stated that the chemical vapors from new carpet are equal to smoking three cigarettes a day[3], and some medical writers have expressed concern because "indoor air pollution can have profound effects on brain function."[4] Fumes from cleaning products, dust mites, molds, petroleum pollutants, and dead skin are also suppressing your immune system.

## GENETICALLY ALTERED FOOD

In addition to being treated with synthetic fertilizers and pesticides, your food is genetically modified. The government claims that producing genetically modified food will end world starvation and produce better crops, but the truth is that chemical companies are managing this biotechnology and selling these altered

seeds to farmers who end up using more chemicals and pesticides. Thus, making money and greed motivate the drive to bring genetically modified food into our markets. These same chemical companies also produce pharmaceuticals. We already know that pesticides and herbicides are toxic to the body, but the full effects of genetically modified food are yet to be known.

## TAP AND BOTTLED WATER

Our water supplies are contaminated with bacteria and chemicals. Contaminants in our water include microbial agents such as bacteria, viruses, and parasites; inorganic contaminants such as salts and metals from industrial and domestic wastewater discharging, pesticides, herbicides, and nitrates; organic chemicals from industrial processing and petroleum production; and radioactive contaminants from oil, mining, and gas production, among others. Chlorine, used to "purify" water supplies by killing bacteria, is also toxic to our bodies. Fluoride is added to protect bones, but research shows that it is harmful. Bottled water has no strict regulations so we don't know what we are getting unless we use our own filtration systems.

## MOLDS/FUNGUS

More than 400 species of yeasts and molds can attack our bodies. Some are airborne, as spores in the air that we breathe, and some live on the contaminated food that we eat. Cryptococcosis, aspergillus (found on corn, wheat, and cheese), fusarium (found on bananas) dermatophytosis, histoplasmosis, penicillium (used in the antibiotic penicillin), dipolodia, claviceps, and stachybotyrs are among the most common.

## XENOESTROGENS

Synthetic chemicals, pesticides, and herbicides produce xenoestrogens. Phthalates, for example, are chemicals used to soften plastics and increase the life of fragrances. These substances mimic hormones and have estrogen-like properties that negatively affect women and men. Endometriosis, breast, and uterine cancer have been attributed to xenoestrogens. For men, these foreign estrogens are adding to the increasing incidence of prostate cancer and benign prostatic hyperplasia.

It's almost impossible to avoid exposure to these chemicals, which are found everywhere. Dioxins, common in pesticides and herbicides, are now found in our air and water. Ethanol from alcohol and glycol ethers are used in glue, ink, antifreeze, sealants, and caulking compounds. Styrene is contained in the plastic used in food containers, carpets, and paper. Trichloroethylene is found in dry cleaning fluid, paint, cleaners, and drain cleaners. PCBs (polychlorinated biphenysis) occur in plastics, flame retardants, copy papers, and adhesives. And vinyl chloride is used in the plastic wrap used for food and CDs.

## ELECTROMAGNETIC FIELDS

You're exposed to electromagnetic field (EMF) radiation, another potentially dangerous element to the body, from x-rays, fluorescent lights, air travel, power lines, appliances, radar, television, electric blankets, cell phones, computers, microwaves, copiers, printers, and other electrical devices. These low frequencies can pass through walls, floors, and your body and cause imbalances. The radiation destroys good bacteria in the body and creates damage from free radicals, both of which weaken an immune system.

# PSYCHOLOGICAL AND SPIRITUAL STRESS

n addition to all the preceding factors that cause MS, we must also look at the role of psychological imbalances. Negative thinking, outdated beliefs, and fear-based emotions are major catalysts that suppress your immune system.

## WHAT IS THE MIND?

The mind consists of the conscious, subconscious, and unconscious. We can no longer ignore that thoughts create energy. As psychologist Shad Helmsetter says, "Leading behavioral researchers have told us that as much as 75 percent of everything we think is negative, counterproductive, and works against us. At the same time, medical researchers have said that as much as 75 percent of all illnesses are self-induced."[1]

What does all this mean? It means that each thought you think, each conscious or unconscious thought you say to yourself, translates into electrical impulses that direct the control centers in your brain and your central nervous system. And these

electrically and chemically affect and control your every motion, cell, feeling, and action, every moment of every day. Simply, the thoughts that you think each day manifest your reality and the body that you walk around in.

## YOUR THOUGHTS ARE IN
## EVERY CELL OF YOUR BODY

Thoughts do not reside just in the brain. In reality, they're in every cell of your body. Each cell thinks and has its own memory. Your body shifts and changes with your thoughts and actions. However, the brain, which is the seat of your emotions, intellect, logic, and creativity, also maintains balance within all body systems.

The new field of psychoneuroimmunology (PNI), which studies how the nervous system affects your immune system, has found scientific proof that thoughts affect your immune response. Depression has been proven to suppress the immune system. Therefore, chronic depression can also lead to physiological conditions when the immune system is suppressed for a long period of time. What is apparent is that the body and mind are not separate. To categorize an illness as being either physiological or psychological is limiting. An illness may start in your body but eventually affect your mind, and vice versa. Every system and organ is interrelated, and, over time, negative thought patterns create disease.

*Conscious, Subconscious, and Unconscious Mind*

The conscious mind is your gatekeeper to the subconscious. The conscious mind gives you free will to discern and entertain thoughts of your choice. The subconscious is the place from

which you truly act, and the unconscious is all that is known and unknown. The subconscious mind is like a huge computer bank that has stored in it every event that you've experienced in your lifetime so far. The subconscious mind does not know how to discern right from wrong, nor does it have a sense of humor. It is literal, and your best friend.

It's through the subconscious mind that you can tap directly into your higher self, the unconscious, which is the all-knowing part of you that feels rightly and that you experience when you feel "hunches" and intuition. Most important, your subconscious controls your central nervous system, which controls every cell, tissue, and organ in your body.

The subconscious is like a tape recorder that plays the messages you've been programmed with since birth—until you change them. So, what you think most often, speak most often, feel most often, and do most often is what you are. That is why negative and fear-based patterns will eventually play out in your body.

## Emotions

Examining your thoughts leads us to your emotions and how the two work together. Thoughts feed emotions and emotions feed thoughts. The two are inseparable, and if negatively based will create a vicious cycle that affects your health. Emotions are feelings in reaction to a given situation, whether in past or the present. They come about based upon our perceptions and interpretations of life experiences. Emotions are feelings such as joy, fear, rage, abandonment, love, sadness, and anger. They heighten your daily experiences, and without them you wouldn't be human. Ultimately, what you feel deep within you determines your life and the actions, or nonactions, that you take.

*Fear-Based Emotions*

Problems arise when you hold onto fear-based emotions from past experiences. Fear-based emotions include abandonment, shame, anger, guilt, fear, jealousy, rejection, and blame. Emotions are to be felt and then let go.

Unfortunately, we often either suppress or hold onto emotions throughout our life—"emotional baggage." The body has a cellular memory, and it retains information, especially about events that are fear-based and unresolved. Over time, feelings such as harbored guilt or rage will weaken your body.

*The Nature of Fear*

The emotion I especially want to call your attention to is fear. Fear is second only to stress in breaking down a body. Fear is the trickster, the culprit, the dragon, and one of your greatest teachers.

What is fear? It is false evidence that appears real. Fear is about an experience in the past, whereas fear about the future is anxiety. Fear takes you out of your place of power, the now moment, and creates imbalances both psychologically and physiologically. It can paralyze you from moving forward in life, cause panic attacks, and create disease.

Typically, we give reality to fears around death and dying, lack of money, relationships, illness, job security, and our purpose in life. Fear dominates the lives of so many of us. Spiritual leaders tell us there are only two emotions that we truly act from: love and fear. I believe that this is true.

Also, there's a difference between survival fear and the fear you create in your own mind. Feeling fear as you run across the street to escape an oncoming car is survival fear, or the fight-flight mechanism. It's instinctual and protective. On the other hand,

fear of flying that originates from watching news stories about airplane crashes is a self-created fear and is destructive.

When you have MS, it's easy to be dominated by fear because something that you took for granted—your body functioning optimally—is now gone, and you fear what's next.

### Every Disease Has an Emotional Core

I believe that all diseases have an emotional component to them and that certain fear-based emotions correlate with the most common diseases of our time. For example, cancer equates to guilt as an emotional core, and MS is related to low self-worth and suppressed anger. Authors such as Carolyn Myss (*Anatomy of the Spirit*) and Louise Hay (*You Can Heal Your Life*), go into detail about how the core emotions we carry create and relate to disease. The weight of our unresolved emotions will take its toll on the body unless we resolve them.

### Beliefs

Beliefs are the feelings of certainty that something exists or is true based on perceptions, experiences, and feelings. Beliefs are extremely powerful because they are the basis upon which you make choices and take action in the world. They affect how you think and feel. Most important, they change your DNA.

Beliefs aren't laws written in stone. They're tools. They become outdated and need to be changed, like a worn-out tire. Outdated beliefs keep you unhealthy and limited. Unfortunately, most of your beliefs were ingrained in you at an early age, when you did not have the conscious power of choice, and you've held onto them into your adult life. See Figure 7.1 to recognize how stressed out you are.

**Digestive System Imbalances**
Maldigestion,
Malabsorption,
Intestinal dysbiosis,
Elimination problems

**Environmental Toxicity**
Heavy metals, Pesticides,
Synthetic plastics, Petroleum
pollutants, Molds

**Electromagnetic Stress**
Cell phones, X-rays, Computer
screens, Power lines

**Genetics**

**Mental/Emotional Stress**
Negative/fearful thoughts,
emotions, habits

**Overuse of Antibiotics,
Steroids, and NSAIDS**

**Physical Stress and Lack of Exercise**

**Poor Diet and
Nutritional Deficiencies**
Refined sugars, Refined carbohy-
drates, Trans fats, Cow dairy products
Processed foods, Lack of water,
No supplementation

Weakened
Immune
System
Equals
Disease
Over Time

**Spiritual Disconnection**
Outdated beliefs,
Lack of trust,
Conditional love

**FIGURE 7.1: How are You Stressed Out?**

From your early childhood, you created a foundational picture of yourself. It didn't make any difference whether the pictures you created of yourself were true or not—you accepted what you heard and felt from your family, peers, and society as they defined who you were. Now it's time to change that definition.

### Spiritual Disconnection

Your spiritual connection is essential to your health. You are more than just your body. Science tells us that energy never dies and that it just changes form. So what are you? You're a unique energy form called a soul.

No two souls are alike, nor are any two bodies. Spirituality deals with trust, faith, beliefs, and your feeling that there is something greater than you. What you are part of and connected to will determine your outlook and quality of life. It will determine where your belief systems lie. And your belief systems will determine your perceptions and the actions you take day in and day out. Your beliefs are the framework of how you operate.

It doesn't matter what religion, sect, or practice you belong to. It doesn't matter whether you participate in an organized religion or not. If you're an atheist, believe in your own power to transform your life. There is no right or wrong way.

All that matters is that you know that you're connected to something that is greater. I call it *God, Tao,* or *Universal Energy*. I believe that we are part of it and it is part of us, which makes up the entirety of all that is and exists. It is this omnipresent, unseen force that becomes visible in such phenomenal events as the creation of a baby, the communication of cells with one another inside the body—and miraculous healings from "incurable" diseases.

Spiritual disconnection creates imbalances physically, mentally, emotionally, and spiritually. Depression, lack of purpose and

worth, hopelessness, and fears take greater hold when you can't find solace with something greater. Disconnection makes you feel alone and isolated.

When I had MS, my hardest times were when I felt disconnected to God. I felt hopeless and full of anxiety, and I knew that if I remained hopeless, I would die.

PART THREE

YOU CAN HEAL
YOURSELF:
THE
SOLUTIONS

# THE CANDIDA CURE

I n the United States, candidiasis is a silent epidemic that affects up to 80 million American women, men, and children. In other words, one out of three people are afflicted with *Candida albicans* overgrowth.[1] Western medicine has persisted in ignoring this condition because its symptoms mimic so many other conditions and because it is iatrogenic (caused by physicians themselves). However, it is to be taken seriously and is the main cause of MS.

As I mentioned in Part One, William Crook, MD and his book *The Yeast Connection* were godsends when I was twenty and went through my first health crisis. He was an expert on candida and his book describes candidiasis in detail. I've included his questionnaire in Part Four, page 185, so you can score yourself and become more aware of the symptoms that correlate to candidiasis.

The place to start is with your digestive system. Maldigestion, malabsorption, intestinal dysbiosis, and leaky gut syndrome are the main factors that cause this condition. *Candida albicans* overgrowth upsets the internal environment within the body and weakens the immune system. It is the main factor in dysbiosis. By way of leaky gut, *Candida albicans* overgrowth and its by-products filter into the bloodstream twenty-four hours a day and attack the genetically most vulnerable parts of your system. In the case of an MS patient, it is the central nervous system that is being attacked.

## PIONEER DOCTOR REVEALS CANDIDA AND ITS EFFECTS ON THE IMMUNE SYSTEM

Another pioneering doctor, C. Orian Truss, has brought to our attention the severity of candidiasis and how our immune system can become paralyzed from fungal overgrowth. He states:

> The very existence of *Candida albicans* in the tissues on a chronic basis reveals an immune system at least partially "paralyzed" and "unresponsive" to its antigens–an immune system that is "tolerating" the continued presence in the tissues of the "foreign invader." Virtually any organ seems susceptible to the effect of products carried to it in the bloodstream, once released by the yeast after it has successfully invaded the tissues."[2]

Other experts state: "The passage of viable *Candida albicans* through the gastrointestinal (GI) mucosa into the bloodstream is believed to be an important mechanism leading to systemic candidosis."[3]

Once *Candida albicans* and its by-products have entered the bloodstream, they so severely debilitate the body that victims could become "easy prey for far more serious diseases such as acquired immune deficiency syndrome, multiple sclerosis, rheumatoid arthritis, myasthenia gravis, colitis, regional ileitis, schizophrenia, and possibly, death from candida septicemia."[4]

## HOW TO IDENTIFY CANDIDA OVERGROWTH

The best way to identify if you have *Candida albicans* overgrowth is to see a health-care practitioner who treats this condition. By taking Crook's test, you will start to see how some of your MS

symptoms correlate to candidiasis. In my office, I examine patients' responses to Crook's test, take an extensive case history, and use various noninvasive testing techniques to identify imbalances in your body. If desired, a blood test and/or stool test to detect *Candida albicans* overgrowth can also be taken.

In my experience, though, I've found yeast and fungus to be very evasive. They like to hide out in the organs and tissues, and blood and stool tests give inconsistent results. When patients' test results are negative, that doesn't mean that I won't treat them for the condition in connection with MS because I also rely heavily on my examination and their case history.

## THE MYTH OF LAB TESTING

Due to many factors, lab tests are not always accurate. For example, your sensitivity level may differ from the standard. Also, the blood can be the last system to show imbalances. The body has different pH (acidity level) ranges. When it comes to survival, the blood pH is the priority. Blood needs to be at pH of 7.35. If it varies by even a few tenths of a percent, symptoms appear, and if it varies more than one-half of a pH unit, serious illness and death occur. Because the rest of the body will compensate to maintain the blood pH, other tissues and organs in the system may be very unhealthy without your doctor knowing. Furthermore, investments of time, money, and research into developing better functional tests to diagnosis candidiasis and other gut imbalances have been lacking because of the discrimination from Western medicine.

Millions of unhealthy people are running around with negative blood, urine, stool, and other lab results and not being treated because their conditions are "subclinical," meaning undetected by standard medical tests. Many of my patients have had their doctors tell them, "There's nothing wrong" or, "It's all in your head" because

a set of tests come out negative. Blood, urine, and stool testing are only a few of the tools available for diagnosing a condition. If you're in this predicament, continue to search for the right health-care practitioner—someone who goes beyond lab tests to make a diagnosis. Science, like any other field, is on a learning curve and continuing to improve its technology to make more accurate diagnoses. As long as you don't give up, there are answers to be found.

## TREATMENT

The goal of treating candidiasis is to kill off the excess yeast and fungus in the body and to bring it back into balance. You never fully get rid of yeast; you just want it back into balance. Achieving this balance requires a two-pronged strategy: first, taking an antifungal supplement to kill the yeast/fungal overgrowth fungal, and second, modifying your diet to starve off the excess yeast. The treatment is simple but takes diligence, discipline, and consistency.

## ANTIFUNGALS: NYSTATIN, DIFLUCAN, AND HERBAL ANTIFUNGALS

The antifungal source supplement is crucial. It can be either herbal or pharmaceutical. The pharmaceutical antifungals are Nystatin, Diflucan (fluconazole), Nizoral (ketoconazole), Sporonex (Itraconazole), and Lamisil (terbinafine). Many of them are harsh on the liver, so from these choices my recommendations are Nystatin and Diflucan.

Herbal antifungals are safer and I recommend the following: Candida Cleanse, Primal Defense, or pau d'arco (lapacho).

Getting your doctor to prescribe a pharmaceutical antifungal can be challenging, especially if he or she isn't open to acknowledging the connection between yeast and MS. Not to worry—herbal antifungals are just as effective, and it's easy for you to get started on your own.

## NYSTATIN

Nystatin is a concentrated extract of a soil-based organism that works by directly killing the yeast. One pill (500,000 units) taken three times a day is usually the recommended dosage for an adult. If you use the powder form (Nilstat), take one-eighth of a teaspoon three times a day orally, either directly on the tongue or mixed with a little water.

The difference between the powder and the pill is that the powder does not contain any dye and does a better job of actively killing yeast living in the mouth and esophageal tract as well in the gastrointestinal tract. Do not take Nystatin liquid; it contains sugar, which only feeds the yeast.

As the authors of *The Yeast Syndrome* state, "Nystatin is virtually nontoxic and nonsensitizing. All age groups, including debilitated infants, accept the drug without demonstrating major side effects, even on prolonged administration. Most MS patients make the greatest progress after taking the medication for one to two years."[5]

Nystatin is not well absorbed into the bloodstream, but with prolonged use it does get into the blood and thus helps those with autoimmune diseases. The problem is that most doctors prescribe Nystatin for less than six weeks. Results are better if usage continues for six months or longer. In my case of MS, I took Nystatin for three years.

## DIFLUCAN

Diflucan (fluconazole) is a synthetic antifungal drug that is effective against systemic candida overgrowth. This is applicable if you have MS. It is ten times stronger than Nystatin but also more toxic to the liver. If you use Diflucan or any other systemic antifungal (Nizoral, Sporonex, Lamisil) for more than a couple of weeks have your doctor test and monitor your liver enzymes. If you have symptoms of depression or anxiety, Diflucan can give you a jump start on eradicating the fungus. I recommend taking a total of four pills of Diflucan, one pill every other day and then switching to Nystatin because it is safer. Unlike Diflucan, Nystatin permeates the areas of the GI tract where yeast overgrowth usually originates, and to cure candidiasis, it is essential to tackle both the blood and the gut.

**Note:** If you are wheel-chair bound or bedridden, Nystatin and Diflucan may be too strong for your body to initially handle. Since circulation is compromised and toxins do not move out of the body efficiently, herbal antifungals are a safer choice.

## HERBAL ANTIFUNGALS

Herbal antifungals are easily available and are safer. I recommend:

- Candida Cleanse (Rainbow Light)
- pau d'arco (lapacho)
- Primal Defense (Garden of Life)

Candida Cleanse, Primal Defense, or pau d'arco (liquid tincture, pills, or three cups of tea daily) are effective products. All these formulas have antifungal properties to get rid of yeast overgrowth and contain antiparasitic, antibacterial, and antiviral herbs as well.

Start with one tablet, one dropperful, or one cup of tea and slowly increase, every couple of days, until you reach the dose recommended.

If you cannot find any of these products (see Resources, at the back of the book, page 299), then look for yeast-eliminating products at your health food store that contain one or a mixture of some of the following ingredients:

- pau d'arco (lapacho)
- Oregon grape root
- garlic
- berberine sulfate
- undecylinic acid
- caprylic acid
- black walnut
- citrus seed extract
- oregano oil
- ginger
- gentian root
- marshmallow
- fennel

## DIE-OFF REACTIONS

You need to be aware that starting a program of food elimination and taking an antifungal can create a Herxheimer reaction (also known as "Jarisch-Herxheimer" reaction) in which you experience die-off symptoms from killing the yeast. This detoxification process may make you feel worse before you feel better, and you may experience flu-like symptoms, headaches, aches, abdominal distress, or a worsening of your MS symptoms. To assist with this process, make sure that all your elimination pathways—your liver, bowel, kidneys, lungs, and skin are being attended to.

Slowly work up to drinking one quart (four eight-ounce cups) of red clover tea (hot or cold) daily to assist with cleansing your blood, liver, and kidneys. To make the tea, bring one quart of filtered water to a boil. Turn it off, add four to six teaspoons of bulk herb (put in tea ball or French press), and let it steep for fifteen minutes. Ice can

then be added. Whatever amount is made must be consumed the same day or it will get moldy. Initially, red clover tea can keep some people up at night. Although it doesn't contain caffeine, it does stimulate the movement of waste out of the body. If you feel affected when you drink the tea at night, finish your last cup by 6 p.m.

If your die-off symptoms are too intense, cut down on your dosage of the antifungal and red clover tea. Increase these again, slowly, as you feel better. Stick with the program and work with your practitioner. These symptoms usually mean that you're on the right track because toxins are coming out into the bloodstream. These initial symptoms usually pass within a couple of days to a week. Drink as much water as possible in addition to drinking the red clover tea.

A daily bowel movement is essential. If you need additional fiber use a source with citrus pectins, flaxseed, or rice bran. Avoid products that contain psyllium (unless you have diarrhea) because it can create more gas and bloating. Gentle Fibers (Jarrow) is a good product. Take one level tablespoon in ten ounces of water. After the first week, increase the dosage to two tablespoons if needed. Grapefruit pectin tablets (Carlson) and Fiber Smart (Renew Life) are other beneficial fiber sources.

I recommend that even people who eliminate daily take added fiber, such as ground flaxseed, because it not only assists with going each day but also removes the toxins, such as mucous, yeast, other by-products, that build up on your colon walls. Fiber can be used indefinitely.

If fiber is not doing the trick and you have stubborn constipation, use Magnesuium Citrate (Metagenics), Naturlax 2 or 3, or Aloelax (Nature's Way). You can use these products for up to six months. Start by taking one pill after dinner and see if you eliminate in the morning. If you're still having constipation, increase to two pills after dinner. If needed, continue to increase the dose by adding one pill after breakfast until you start going daily. The

goal is to have full normal movements, not diarrhea, so adjust the dose until it is right for you. Once you're moving easily, switch to a probiotic formula such as Ultra Flora Plus DF (Metagenics) or Pb8 (Nutrition Now), Dr. Ohhira's Probotics 12 Plus (Essential Formulas) and/or fiber for long-term maintenance.

Because 75 percent of the toxins you eliminate will leave your body through your lungs, do deep breathing exercises several times a day. Focus on your belly, expanding and contracting as you inhale for a count of seven, hold for a count of seven, then exhale slowly for a count of seven. Do this for two minutes four times a day.

Sweating out toxins is helpful. An infrared sauna is the only kind of heat your body can tolerate. Avoid regular dry or steam saunas because they heat up the body's core and make your symptoms worse.

Finally, exercise if you can. This will stimulate the lymphatic system to detox. Brisk walking, swimming, isometric exercises, qigong, or yoga is sufficient.

## CANDIDA DIET

Diet is your second line of attack against yeast and fungal overgrowth. You need to eliminate all sugars, dairy products, and refined carbohydrates while you are taking an antifungal. In addition, eliminate yeast products and wheat for the first one to three months. Although these don't directly feed yeast, they create an allergy and sensitivity response, and it's beneficial to eliminate them in the beginning of your treatment program.

If you have a mild case of *Candida albicans* overgrowth, you can expect to feel better in six weeks to three months. Autoimmune conditions require from six months to two years of tak-

ing an antifungal and following the diet to get the full benefits. Starving off the excess yeast requires both taking an antifungal and following a candida-free diet for a long enough period of time. Trying to do one without the other will not produce positive results.

Study the "Foods to Eat" and "Foods to Avoid" charts in Part Four, page 183. Note that these are general outlines and that individual body chemistries will have certain sensitivities. Listen to your body. It will tell you what it wants and doesn't want as you begin to clean out. Your body may react negatively to certain foods that are listed as acceptable on the chart. Trust your body and pay attention to its messages.

## HOW TO DEAL
## WITH YOUR NEUROLOGIST

The best way to deal with your doctor is to educate yourself. If he or she doesn't agree with your choices, that's okay. Don't let yourself feel intimidated.

Doctors' knowledge is based on what they've have been taught, which is pharmacology. But it's your body, and you're in charge, so make decisions that feel right for you. Take action that makes you feel peaceful because fear-based choices will win out and create or prolong your symptoms.

You may find that working solely with either Western or alternative medicine works best for you, or that you respond best to a combination of Western and alternative approaches. No one plan will suit everyone. Each body is unique and individual, and you need to listen to what yours is telling you.

If you're prescribed an antibiotic and you choose to take it, ask for an antifungal drug such as Nystatin to take along with it.

Take one tablet three times a day while you're taking the course of antibiotics and for another two weeks after you've finished. Doctors usually don't offer antifungals without being asked, but they need to be willing to do so if you ask. If you can't get Nystatin, take one of the herbal antifungals I mentioned earlier.

*Candida albicans* overgrowth is real and is at the root of MS. It's so common that, as I said earlier, one out of three North Americans have it in some form, from mild to severe. Women are more affected than men because of their anatomy and hormone fluctuations, but that doesn't mean men aren't vulnerable as well. Also, candidiasis can be transmitted back and forth between sexual partners.

## DON'T GIVE UP HOPE

Curing *Candida albicans* overgrowth requires both patience and discipline. Grocery stores and restaurants may make you feel depressed with their lack of choices of what to eat, but shopping in health food stores will show you there are many choices. No matter where you shop, be sure to read labels carefully. It's best to approach getting rid of candida overgrowth as a lifestyle change rather than as a temporary deprivation. Once you feel better, you'll understand how food affects your body and mind and ideally won't want to go back to making poor food choices.

Persevere, and the results will come. You'll notice improvements in your health in as little as two to four weeks, and greater changes will be experienced after three to six months. Strict monitoring of your diet is essential, because if you continue to eat sugar every day, even in small quantities, *Candida albicans* will continue to be fed and your progress will be delayed. However, if you find that you ate something that's not on your diet, don't beat yourself up. Just get back on the regime and keep going.

## REINOCULATE YOUR GUT

As you restore your health you need to maintain it. During your candida treatment program and afterwards to keep ecology balanced take a probiotic ("good bacteria") product that contains strains of acidophilus and bifidum and is dairy-free. Follow the directions on the bottle. Probiotics replace the good bacteria that keep the yeast in balance. Ultra Flora Plus DF (Metagenics), MegaFlora (MegaFood), or PB8 (Nutrition Now), Dr. Ohhira's Probotics 12 Plus (Essential Formulas) are good products. PB8 and Dr. Ohhira's Probotics 12 Plus doesn't require refrigeration, unlike most probiotics, which lose their effectiveness if not refrigerated.

## ONCE YOU'RE WELL

Curing candidiasis is a necessary first step for reversing MS. It can come back more virulently if you go back to old habits of eating poorly. In cases with MS, it's important to take at least a reduced dose of an herbal antifungal compound every day for the rest of your life, and you need to increase it during stressful periods such as holidays and while traveling. You can take Candida Cleanse, pau d'arco, or Primal Defense at a maintenance dose of one pill, 1 dropperful, or one cup of tea, twice daily for life. Rotate these products to make sure you're getting the full benefits of using them.

Even after you reach the end of your treatment, you need to practice moderation in your diet. Avoid indulging in foods that contain sugar, dairy, yeast, and refined carbohydrates. A good way to be moderate is to eat healthy on Mondays through Fridays and to enjoy a little of the "no-no" foods on weekends. But if you notice food intolerances and reactions—a rapid pulse (90 to 180 beats per minute), fatigue, itching internally or externally, hives, gas,

bloating, headaches, or other symptoms after eating these foods, eliminate them. Otherwise, you might ignite another flare-up.

## NO SIDE EFFECTS

The good news is that following the *Candida albicans* elimination protocol can't harm you. It consists of only two elements: cleaning up your diet and taking an antifungal supplement. This is a protocol that would benefit almost everyone, especially those with autoimmune diseases. Many references are now available to help you educate yourself about this condition and how to cook and eat properly. (See Part Four, page 183, and Resources, page 299 for more information.)

You have nothing to lose by choosing to treat candidiasis as a possible cause of your MS, and it can be monitored by you to make sure the detox process is manageable. Certainly, making the choice to clean up your diet by eliminating sugar and refined and processed foods will make a difference in alleviating your symptoms.

# INTERNAL DETOXIFICATION AND REMEDIES

## YOUR BODY'S INTELLIGENCE

Your body is an amazing system that constantly works to keep you in homeostasis, a place of balance. It miraculously orchestrates communication of more than three hundred trillion cells. Your body replaces each cell every two years, and in a healthy environment it can regenerate in eleven months. Depending on how well you take care of yourself, you have new skin every seven days, a new digestive tract every three days, and a new liver every four to seven weeks. Because of this inherent intelligence, my task is simply to assist my patients to make choices that will accelerate their natural healing mechanisms and to suggest ways they can strengthen their immune systems to overcome disease. Healing the body naturally means using nutritional therapy, hydration, removing toxins, and strengthening internal resistance.

Keeping your immune system strong is essential for health. The four components to keeping your immune system healthy

are good nutrition, exercise, breathing, and meditation. Nutritionally rich foods and supplements are necessary to feed and repair your cells, tissues, and organs. Exercise alleviates distress, detoxifies your body, and keeps it strong and agile. Breathing is by far the most important way of eliminating toxins because 75 percent of toxins are eliminated through the lungs compared to just 25 percent through urination, defecation, and perspiration. Focused deep breathing is thus a daily essential. Meditation is a practice which slows down the mind and puts you into the "now" moment.

In autoimmune disease, a polluted internal environment has developed. Healing requires removing accumulated wastes, free radical damage, inflammatory agents, and antigens. You need to incorporate detoxification methods that will clean up your gastrointestinal system, cleanse your liver and gallbladder, tonify your kidneys, and purify your blood and lymphatic system. You must also repair damaged tissues and organs by reinoculating your body with nutrients. Diet alone cannot repair your body. Repairing your nervous system and rebuilding your myelin sheath requires an integrated regimen of supplementation, including vitamins, minerals, and herbs.

## TIME IS THE KEY

Patience and knowing that your body will take time to repair are the most important things to keep in mind in your healing process. Your central nervous system is one of the slowest systems to repair, so it's crucial that you set a realistic time frame for your treatment program. A person who is ambulatory with MS will usually heal faster than someone in a wheelchair whose circulation is more compromised. Also, be aware that people with MS don't all experience exactly the same constellation of factors. This

accounts for the differences in how fast symptoms abate and why one type of therapy or supplement works for one person and not another. It's important to individualize your treatment plan based on your unique body chemistry and by working with your practitioner or doctor.

## DETOXIFICATION

Detoxification begins the process of removing inflammation and toxicity from your body. When you have MS, your body is delicate, and it's important to take it slow. The die-off from the fungus can be intense for the first couple of weeks, with symptoms such as increased fatigue, headaches, cold-like or flu-like aches, and a worsening of your MS symptoms, so it's advisable to work with a health-care practitioner who knows how to deal with this process. Die-off symptoms mean your elimination pathways (colon, liver, kidneys, lungs, and skin) are sluggish and you need to decrease the dosage and slow the pace of your antifungal formula and red clover tea because the toxins aren't able to leave your body as fast as you're asking them to. There's no need to rush your detoxification. Proceed at a pace that allows toxins to exit your body easily rather than ping-ponging to other tissues and organs.

## IMPROVING YOUR DIGESTION

The first place to start making sure your body is running smoothly is digestion. Start eating more uncooked, organic, unprocessed food. Chew your food thoroughly and avoid eating in moments of extreme stress. If your digestion is severely imbalanced, you might need to steam or cook your vegetables in the beginning.

In addition, take digestive enzymes to ensure that digestion is optimal and that undigested food particles aren't continuing to toxify your body. Enzymes assist with the proper breakdown of your food and get rid of symptoms of indigestion, heartburn, gas, and bloating. Buy a plant-based digestive enzyme such as Digest Gold (Enzymedica) that will break down fats, protein, and carbohydrates. For more severe digestive complaints purchase a digestive enzyme with pancreatin such as Azeo Pangeon (Metagenics) or Metagest (Metagenics) with Hcl and pepsin.

## CLEANSING YOUR COLON

Second of importance is making sure your bowels move daily. Your colon walls have been affected by years of stress, poor diet, and internal and external pollutants. It's important to remove this cumulative buildup. One bowel movement a day is mandatory, and two to three are ideal.

The key to keeping the bowels moving daily is drinking enough water. You need to drink one-half of your body weight in ounces per day. Also, be sure that you take the time to move your bowels when you have the urge. Regular exercise also promotes healthy bowels.

If you are still constipated, you need to ensure a daily bowel movement, otherwise your die-off symptoms from taking an anti-fungal are likely to intensify.

Naturlax 2, 3, Aloelax (Nature's Way), or Magnesium Citrate (Metagenics) are good formulas that you can use for the first couple of months if needed to keep you regular.

Start by taking one pill after dinner and increase your dose daily by one pill until you achieve daily bowel movements. Be sure not to take so much that you have loose stools or diarrhea. Take just enough to create formed stools daily.

Liquid chlorophyll (mint-flavored) is another way to move your bowels and bring oxygen into your body. Take as directed on bottle. Aloe vera juice (Lily of the Desert, 4 oz. a.m and 4 oz. p.m) can also heal the lining of the GI tract and keep your bowels moving daily. Triphala (Planetary Herbals or Himalya) is yet another gentle bowel cleanser and regulator. Formulas that help bowel consistency (fiber, aloe vera, triphala) can be used long term but not stimulants such as Naturlax 2 or 3.

Fiber is also beneficial for keeping your elimination optimal and sweeping the linings of your colon. Gentle Fibers (Jarrow) or Fiber Smart (Renew Life) are good fiber sources. These are available in health food stores. Psyllium is another fiber source that works well for some people. However, because psyllium expands to forty times its volume, it can cause more bloating and gas. I usually recommend psyllium in cases of diarrhea and not for constipation.

Stubborn and long-term cases of constipation can benefit from colonics, high water irrigation treatments. Usually a series of three treatments are enough to accelerate the detoxification process. These treatments can restore bowel motility so that movements are daily. Colonics are not advisable if you have ulcers, Crohn's disease, ulcerative colitis, or diverticulitis. See the Resource section, page 299 for places to get a colonic.

## CLEANSING YOUR
## GALLBLADDER AND LIVER

Third is to go deeper into making sure detoxification is able to filter properly. Therapeutic cleansing herbs and therapies will help your overtaxed liver to recover so it can do an efficient job of neutralizing internal and external poisons. It also makes sure that toxins released don't recirculate. During the first and second month of your program take a liver/gallbladder formula such

as Metacrin DX (Apex), or a product that contains milk thistle seed, dandelion root, N-Acetylcysteine, minerals, tumeric and/or B vitamins, artichoke leaf, beet root, ginger, choline, taurine, and/or dandelion root.

## TONIFYING YOUR KIDNEYS AND BLOODSTREAM

Fourth step is to make sure the blood is cleansed and removed of toxins, i.e., heavy metals, mycotoxins from yeast/fungus, etc. Many people with MS suffer from urinary incontinence or urgency. Drink two to four cups of red clover tea daily to assist with cleansing your blood, kidneys, and bladder. In the beginning, it may seem as if you're making a lot more trips to the bathroom, but eventually you'll see the benefits. If overactivity and urgency is still a problem try Bladder-Control (The Natural Bladder).

For reoccurring urinary tract infections, you can try Kidney Formula (Nature's Way) or a product with cranberry, uva ursi, marshmallow, and slippery elm. Another remedy is D-mannose, a naturally occurring simple sugar that knocks out *Escheria coli* (E. coli) bacteria, which attach to the bladder walls. D-mannose coats E. coli so it can no longer stick to the tissues. It doesn't disrupt blood sugar levels or feed candida. A formula to help tonify and strengthen kidney/bladder function is Uro-Kid (Doctor's Research).

## STIMULATING YOUR LYMPHATIC SYSTEM

Last but not least is keeping the lymphatic system moving optimally. The lymph system's main job is to move waste out of your body. It does this by pushing gravity through its vessels all the way to the heart area in the thoracic duct, where it dumps waste into the bloodstream.

The best ways to cleanse your lymphatic system are to exercise regularly, do daily deep-breathing exercises, and get massages once a month.

Also, skin brush your body dry for five minutes each morning before showering. Buy a vegetable fiber brush from your local health food store and brush with short strokes, starting from the bottom of your feet upward to your heart. Your lymph fluid is right under your skin, so you don't need to dig deeply into your skin with the brush. Gently stroke up your back and down you're your shoulders to the center of your chest. Softly brush down your neck to your heart and around your breasts into the center of your chest. Brush your fingers and up your arms into your chest. You'll feel your circulation increasing, and you may feel a tingling sensation. Skin brushing helps your skin to bring up new cell growth. After your shower/bath when your skin is still moist self massage coconut, almond, or jojoba oil into the skin.

## IMPROVING YOUR CIRCULATION

Optimal circulation is essential for ridding your central nervous system of waste and moving nutrients into your organs and tissues for repair. As mentioned previously, skin brushing is essential. Also, ginger, gingko biloba, niacin, and hawthorn berry improve your circulation. Antioxidant Supreme (Gaia Herbs) or Gingko Rose (Metagenics) are good formulas.

## OXYGEN THERAPY

One of the most effective ways to improve your circulation is to bring oxygen into the body. Oxygen also creates an environment that's hostile to pathogenic microbes and helps to regenerate your nerve cells. Hyperbaric oxygen treatment (HBOT) is one method.

HBOT alleviates oxygen deficiency, improves circulation, neu-tralizes toxins, renews sleeping or dormant neurons, stimulates neural stem cells, stimulates the growth of new blood vessels into damaged tissues, and reduces brain swelling.

If you don't have access to or can't afford to try HBOT, the next-best remedy is liquid oxygen. Oxygen Elements Plus (Global Health Trax) is my favorite formula. This supplement turns into oxygen when poured into water. The oxygen crosses the cell membranes immediately to discharge waste and bring oxygen into your cells.

Because waste will move out of your body, you need to start slowly by taking three drops once a day for two to three days. Then increase your dose to seven drops twice a day for two to three days. If you are ambulatory, gradually increase your dose to up to ten drops three to five times a day. Therapeutic doses for MS patients who are bedridden can be as high as ten drops ten times a day. At levels higher than five times a day, add in a chelated cal-cium/magnesium or Hydrilla (MegaFood, green food source) to your supplement regime.

## IONIC CLEANSING

The rate at which bodies are able to eliminate toxins can be slow. To assist with the process, ionic cleansing sessions are fantastic. They involve putting your feet into a small tub of warm water with the ionic device between your feet and near your ankles. The device creates positive and negative ions that draw out toxins from the body at an accelerated rate. Twelve to fifteen sessions would be recommended, and each session lasts 15 minutes. You can find a practitioner or purchase this system for home use (units cost $595). I recommend using the brand Ionic Spa that gives you 250 uses and the replacement unit is $100 therafter. (See Resources, page 299.)

## RELIEVING SPASTICITY, PAIN, DEPRESSION, AND ANXIETY

*Cannabis* (marijuana) is a therapeutic herb not available to the public. When medical marijuana can be obtained it will decrease spasticity, alleviate pain, and relieve anxiety and depression.

The best way to use this herb is as a tea, not by smoking it, which can damage cells. You can use any part of the herb. Grind it up and scoop one teaspoon into one cup of hot water. Let it steep for fifteen to thirty minutes, and drink once or twice a day, or more as needed.

The other option is to grind up the herb, mix one teaspoon into one cup of almond butter, and take a spoonful or two each day. Drinking cannabis tea on an empty stomach avoids the "buzzy" feeling.

## ENZYME THERAPY

Enzyme therapy is useful in accelerating the body's healing. Taking doses of plant or pancreatic enzymes on an empty stomach has a different effect than taking them with food. Taking enzymes with food helps to digest what you've eaten, while taking enzymes on an empty stomach has several functions: decreasing inflammation, decomposes toxins, improves circulation, purifies the blood, helps to speed tissue repair, stimulates immunity, removes scar tissue and plaque, and strengthens and restores your body's general resistance. Enzymatic therapy is useful during an exacerbation period because it can eliminate the need for steroids.

Your body recognizes fungus, bacteria, and viruses as enemies (antigens) and produces antibodies (proteins produced by the immune system), which couple with the antigen to form a cirulating immune complex. These complexes circulate in the bloodstream

and/or fix themselves to tissues in the body. It is known that MS patients have higher levels of circulating immune complexes. Enzyme therapy destroys these complexes, specifically ones that are attacking the myelin sheath and other tissues.

I recommend Vitalyzm X (World Nutrition). The dosage depends on the individual but I would recommend doing the maxium dose on the bottle (2 capsules three times a day without food) for one to three months. During an exacerbation I would take 5 capsules three times a day which may avoid the need for steroids.

The improvements that you're looking for are: more energy, decreased spasticity and inflammation, increased range of motion and mobility, and an overall lightness within the body.

**Note:** Because enzymes liquefy the blood and slow coagulation, enzyme therapy is not recommended for pregnant women or anyone with ulcers, gastritis, hemophilia or anyone on blood thinning medication.

## REBUILDING
## YOUR MYELIN SHEATH

While you're treating candidiasis, it's also important to focus on rebuilding your myelin sheath. It was once thought that neurons could not regenerate, but now scientists know differently. As one researcher has stated, "the lesions of chronic multiple sclerosis reportedly contain substantial numbers of oligodendrocyte precursor cells."[1] Another researcher found "that central nervous system myelin can be repaired and mechanisms that promote endogenous remyelination may represent a feasible therapeutic strategy."[2]

According to neurologist David Perlmutter, "Creating the most advantageous environment for repair and regeneration of myelin requires an adequate supply of EFAs (essential fatty acids).

About 75 percent of myelin is composed of fat, with a substantial amount coming from the essential fatty acids."[3]

A lipid or fat is part of the sheath of the brain, and is found in nerve and muscle cells. Omega 3 and Omega 6 are essential fatty acids that need to be taken daily because they're the building blocks of brain and nerve tissue. You can get them from foods such as raw nuts and seeds, cold-water fish (sardines, mackerel, salmon, preferably wild and not farmed), dark, leafy greens, and legumes, but to reach therapeutic levels you need to take EFAs in liquid supplement form. I recommend high quality products such as EPA/ DHA High-Potency Oil (Metagenics), Fish Oil (Carlson), or Ultimate Omega Liquid (Nordic Naturals). The therapeutic dosage would be twice the daily recommended dose on the label.

Mynax (Koehler) is a supplement with chelated calcium, magnesium, and potassium EAP (ethanol-amino-phosphoric acid). EAP is an essential part of the myelin sheath and part of the cell membrane. This German mineral formulation assists with repairing myelin, the proper firing of neurons, and can be helpful in balancing and supporting the CNS, such as alleviating muscle spasms, tremors, fatigue, moodiness, and headaches.

## NUTRIENTS FOR
## CENTRAL NERVOUS SYSTEM (CNS) REPAIR

Crucial supplements for restoring central nervous system function are vitamins C and E. Vitamin C is an anti-oxidant that protects the brain and spinal cord from free radical damage and strengthens the immune system. Vitamin E, another antioxidant, improves oxygen utilization, protects cell membranes from free radical attack, and also enhances the immune system. Dosages for MS patients need to be higher than for the average person. Therapeutic levels of vitamin C range between 3,000 and 7,000

milligrams (three to seven grams) daily. Vitamin E doses are 1,200–2,000 IU (international units) daily if ambulatory and 3,000 IU for those who are bedridden or wheelchair-bound.

Acetyl-L carnitine, grape seed extract, all the B vitamins, particularly B$_{12}$, N-acetylcysteine, phosphatidylcholine, phosphatidylserine, D$_3$, Co Q10, alpha lipoic acid, and gingko biloba are additional requirements for reversing MS. Brain Vitale (Designs for Health), Ceralin Forte (Metagenics), and NeuroActives (iNutritionals) are combination formulas that include some of the items above and will reduce the quantity of pills to be taken.

## TREATING VIRUSES, BACTERIA, AND PARASITES

The solution to ridding your body of other microbial infections is to eliminate their food supply. Viruses, bacteria, and parasites, as well as yeast/fungus, all thrive on sugar. Eliminating sugar from your diet is essential to stop infection in your body. By following the candida diet and antifungal protocol, you'll kill off more than just candida—you'll also be treating viruses, parasites, and bacteria. Viruses become dormant, unhealthy bacteria is eliminated, and yeast are put back into a balanced ratio.

However, some bacterial infections require additional treatment. If you test positive for *Chlamydia pneumoniae*, a bacterial infection, the best course of action is an antibiotic called *doxycycline*. Ask your doctor to prescribe it at 100 milligrams twice a day for fourteen to twenty-one days. While you're taking it, be sure to take an antifungal (i.e., Nystatin or Candida Cleanse) along with a probiotic that contains acidophilus and bifidus to keep yeast in check.

If you test positive for Lyme disease, a bacteria carried by ticks, one of the best treatments is cat's claw, a rainforest herb, or pau

d'arco (lapacho). Pau d'arco is a powerful antimicrobial herb and is effective to rid the body of viruses, bacteria, yeast/fungus, and parasites. Antibiotic therapy is usually recommended for treating Lyme's, so if you decide to use this method make sure to take an antifungal while you are taking antibiotics.

## AMALGAM REMOVAL AND CHELATION THERAPY

One of the best indicators of high mercury levels in the body is a urine test. Second best is a hair analysis. If you decide to have your silver-mercury fillings removed, which I would recommend, work with a dentist who has experience in doing so. Be sure that he or she follows proper protocol by using a dental dam to prevent particles of mercury from going under your tongue and having you wear a mask so mercury vapors don't go up your nose during drilling.

Working with dentists that test for compatible materials to replace your fillings is up to you and can get quite expensive. I have found that composite fillings, ones that match the color of your teeth and are made of plastic are just fine.

Even if you use a mask and dental dam, mercury vapors will still leach into the body. It's essential to chelate or pull out the metal residues. Red clover tea is one of the best chelators. It will pull the mercury residue from your organs and tissues and clean up your blood, kidneys, and liver. Drink two quarts of red clover tea daily during and after the procedure and for three months after your last fillings have been removed. You must also take a multimineral without iron to put minerals back into your body.

Another chelating agent is cilantro, which you can take in liquid tincture form or add to a fresh vegetable juice. When you take cilantro, which mobilizes mercury and other heavy metals, you

also need to take chlorella to transport it out of the body. So using both together for one month after amalgam removal is recommended.

A new cutting-edge chelating product that I highly recommend is Natural Cellular Defense by Waiora (see Resources, page 299). It contains zeolite, a volcanic mineral which chelates out heavy metals without pulling out the good minerals, such as calcium, magnesium, potassium, etc. Work up slowly to 10 drops three times a day in water. You need only buy one 4-pack which will take 6 to 8 weeks to consume.

Even if you don't have amalgam fillings, heavy metals have accumulated in your body from the air you breathe and the food and water you take in, so chelation at some point is necessary.

I would wait at least six months after starting a candida/detox program before considering having your amalgams removed and doing a chelation therapy. The purpose is to help the body be in a stronger position to handle the possible detoxifying effects of having the metals removed.

## SLEEP

Getting enough sleep each night is crucial to repair and replicate healthy cells. Going to bed by 10 p.m. and having a minimum of 6–8 hours each night is ideal. If you have trouble falling asleep or staying asleep then try drinking a cup of organic chamomile tea one hour before bed or use natural products such as valerian root, Sound Sleep (Gaia Herbs), 5 HTP (Jarrow), Benesom (Metagenics), or homeopathic formulas. Breathing exercises and hypnosis CD's can also help you fall to sleep. Make sure your room is as dark as possible so that the pineal gland can produce optimal levels of melatonin, a powerful antioxidant.

# NUTRITION: REGENERATING YOUR TOXIC AND DEPLETED BODY

## A HEALTHY DIET

When I lecture, people frequently ask, "Everything causes cancer, so what do we eat or drink?" It's true that your body has to adapt more than ever before because of pollutant overload, but you don't need to walk around in fear either. The body can handle more than you think—yet there is a point where abusing yourself with poor dietary choices, living in a polluted environment, putting energy into negative thoughts and emotions, and continually operating at high stress levels will start to shut down a body.

What is a healthy diet? It's one that consists of organic fresh fruits, vegetables, whole grains, raw nuts and seeds, beans and legumes, unrefined oils and sweeteners, fish, and meats that are free of hormones and antibiotics. By adopting a diet of wholesome, unprocessed food and water, you can starve out the MS

disease process and help healthy cells, tissues, and organs to repli-
cate in your body.

You need to know which foods are beneficial and which ones
to avoid.

Fruits, vegetables, and plant foods are abundant in phyto-
chemicals that prevent cancer, and reverse disease.

Most important to consume daily are dark leafy green veg-
etables such as spinach, watercress, collard greens, mustard
greens, poke greens, turnip greens, dandelion greens, arugula,
baby greens, bok choy, kale, and sprouts. They are filled with vita-
mins and minerals, especially $B_6$ and magnesium, which are
required for your body's many metabolic processes. Cruciferous
vegetables such as broccoli, brussels sprouts, and cauliflower con-
tain natural compounds, which assist with healthy liver function.
Raw nuts and seeds contain essential fatty acids needed for the
cellular membrane around each cell.

The more we discover beneficial compounds in our whole foods,
the clearer it becomes that eating a healthy diet is essential. By doing
so, you stop the progression of disease and reduce the amount of
added supplementation you need to maintain your health.

## ORGANIC FOOD

We don't yet fully understand the negative effects from genetically
modified food, but we do know that synthetic pesticides and herbi-
cides used in genetically modified "designer foods" are carcinogenic.

You can get the best quality nutrients and avoid chemicals by
supporting certified organic farmers and buying organic food for
your fruits, vegetables, meats, and dairy. These foods are more
expensive, but you and your health are worth the investment.
Quality outweighs convenience when it comes to healing your
body. Be sure to wash all your fruits and vegetables with a little
soap and water or a natural fruit and vegetable wash product.

## VEGETARIAN DIET

Vegetarians make a number of valid points about the negative aspects of eating meat. It's true, unfortunately, that animals are treated inhumanely and that the use of hormones and antibiotics is widespread. Yet I find that eating some animal protein (grass-fed, antibiotic- and hormone-free) each week is the easiest way to keep your body in balance. It's important to make sure your body is sustaining muscle mass, and it can decrease if you're in a wheelchair. Lean animal protein such as chicken, turkey, and fish helps to avoid this problem.

On the other hand, saturated fat from animal protein, in particular excessive red meat, can increase inflammation in your body, so, because MS is an inflammatory condition, it's beneficial to avoid red meat or to consume in small amounts.

Vegetarianism is a personal choice that only you can make. If you decide to become a vegetarian, or already are one, educate yourself. Most of my vegetarian patients are unhealthy because they're not compensating for the nutrients—such as amino acids and certain B vitamins—they are lacking from avoiding eating meat. Also, I find that their diets often contain excessive amounts of refined carbohydrates and sugar, which deplete vitamins and minerals and lead to degeneration in the body.

## WHOLE GRAINS

Whole grains are complex carbohydrates that have not been bleached or stripped of their fiber. Whole grains include amaranth, barley, brown rice, buckwheat, corn, kamut, millet, quinoa, oats, rye, spelt, teff, tricale, and whole wheat.

Grains contain important B vitamins that keep your central nervous system in balance. They also have fiber, which is important in helping with daily bowel elimination and keeping the linings of the

colon healthy. My least recommended are corn and wheat because of potential allergic reactions.

## GOOD FATS

As I discussed in earlier, there are major differences between good and bad fats. Your body needs good fats such as omega 3, 6, and 9 because every cell membrane is covered in them. Good fats assist with the regulation of hormones, blood pressure, heart function, inflammation, pain, and nerve transmission.

Your body can't manufacture the omegas, so you must include them in your daily diet.

Foods high in Omega 3 essential fatty acids (EFAs) are deep-sea fish, dark leafy greens, coconut, flax, fish oil, hemp seed oil, krill oil, olive oil, raw nuts and seeds, avocados, and even small amounts of unsalted organic butter, which also has vitamins A and D. To repair your myelin sheath and reduce inflammation, it's essential to eat foods particularly high in omega 3 fatty acids and to take additional supplementation.

Omega 6 essential fatty acids are found in eggs, raw nuts and seeds, oils, grass-fed meat, and you also need to take in supplementation.

Saturated beneficial fats are in eggs, coconut meat and oil, butter, ghee, raw goat cheese, and grass-fed meat.

Don't be fooled by "low-fat" foods. They often contain high concentrations of chemicals and refined sugars.

## ANIMAL PROTEIN

Fish, eggs, and antibiotic-free chicken and turkey break down into amino acids, which your body needs to regenerate and repair

cells, tissues, and organs. Most people with MS do best having some animal protein daily because it keeps sugar levels balanced. Consuming animal protein fewer than three times a week will probably create deficiencies in your body unless you're becoming a vegetarian. If you are, you need to pay special care and attention to keeping carbohydrates balanced.

As mentioned above, it's usually best to avoid red meat, but some body types do well on small amounts of grass-fed meat. Listen to your body to feel if you're craving it. Best to prepare rare to medium rare. The key is to make sure you are digesting it well. The use of a protein digestive enzyme that contains HCl and pepsin would be beneficial if you have trouble digesting meats.

Because of high mercury levels in fish, canned tuna and all shellfish are to be avoided. All fish contain heavy metals but I feel the positives outweigh the negatives with such fish as Pacific wild salmon, halibut, cod, and most other whitefish are okay to eat in moderate quantities.

## BEANS AND LEGUMES

The wide variety of beans and legumes available include adzuki, black, fava, garbanzo, kidney, lentils, lima, mung, navy or white, peas, pinto, and soybeans. They're high in protein but also in starch, which converts to sugar in the body, so small servings are best. Adzuki and mung beans are high in protien, so larger portions are okay. Soy is overconsumed and overprocessed in this country. Small amounts of organic soybeans, tofu, and soy milk are acceptable. Best to avoid soy protien isolate found in liquid protein powder and protein bars.

To avoid flatuence, soak beans, discard water and cook soaked beans in fresh water. Cook beans in the following herbs and

spices for optimal digestion and taste: cumin, clove, caraway, dill, fennel, sage, thyme, onion, oregano, ginger, garlic, rosemary, tarragon, or tumeric.

## VEGETABLES

Vegetables (organic) are loaded with phytochemicals that your body needs to help it regenerate. Because vegetables have alkalinizing properties, they balance out your body's acidity, which reduces inflammation. Green leafy vegetables are nutrient-dense foods and contribute greatly to reversing MS. You need to consume them daily, and is advisable to take a supplemental green food source. (See Supplementation, page 247.)

## FRUITS

Fruits (organic) have many beneficial vitamins and minerals that keep your body balanced. You need to limit your intake, though, because fruits are high in natural sugars that can feed candida, and a high-sugar diet adds to the progression of MS. Berries contain the smallest amounts of sugar and the skins have beneficial antioxidant properties. Limit yourself to one fruit a day or one every other day.

## DAIRY

I've found that small amounts of unsalted butter and raw goat and sheep products are beneficial in supplying the body with amino acids, vitamins, and minerals.

Pregnant and nursing women with MS seem to assimilate goat and sheep milks and cheeses better because of their similar molecular structure, whereas cow products are congesting to the body.

The general consensus is that eating and drinking more milk is the best way to supply the body with calcium. As I discussed earlier, I disagree.

It's more beneficial to eat more plant sources (dark green leafy vegetables) that contain calcium as well as trace minerals that assist calcium to enter your bones. Pasteurization and homogenization of cow's milk alters them chemically. This process, which leaches calcium from the body, alters minerals and makes your body more acidic.

Hydrilla (MegaFood), Nettle Leaf (Gaia Herbs), and alfalfa are excellent green sources to feed the body calcium and other minerals. Goatein (Garden of Life) is a high-potency goat dairy powder that is predigested so lactose intolerant individuals can consume it.

Vitamin D deficiency is prevalent in those with MS and plays a critical role in immune function. I do not recommend getting it from dairy sources but rather cod liver oil or vitamin $D_3$ supplementation.

## UNREFINED SWEETENERS

You can use stevia, an herb from South America, throughout your candida program and afterwards. It helps to balance blood sugar and get rid of candida. After your candida is back in balance, raw, unfiltered honey, and agave nectar in small quantities is acceptable. Raw honey has amino acids, enzymes, and vitamins and minerals that are beneficial to your body. Agave nectar is another good sweetener that doesn't drastically increase blood sugar levels and can be used in small quantities.

Xylitol, which is obtained from the bark of birch trees, is a carbohydrate but is metabolized slowly, so it doesn't increase sugar levels rapidly. It's has been found effective in preventing and reducing

bacterial infections in the mouth, sinuses, and ears. I find it only acceptable in small amounts, such as in lozenges and mints.

## RAW VERSUS COOKED FOODS

The more raw foods from vegetables and fruits you eat, the more enzymes and nutrients are available for your body to take in. Cooking destroys enzymes that your body needs to digest and assimilate the foods. If your digestive system is unbalanced, you might find initially that you do better with steamed or cooked vegetables and taking digestive enzymes, and then gradually increase raw food intake with each meal.

## FOOD COMBINING

Food combining is either eating protein with vegetables or grains with vegetables, but avoiding mixing protein with grains at the same meal. This is beneficial for some people who have digestive problems. Others find that having a little protein with each meal, whether from an animal or a plant source, keeps both blood sugar and energy levels more stable.

The answer is: listen to your body. If you're hypoglycemic (low blood sugar), then you'll do best to start off your morning with protein and work your complex carbohydrates into your lunch or dinner meals.

Most people with MS have sugar imbalances and do best with eating three meals a day plus snacks mid-morning and afternoon because this keeps metabolism and energy levels balanced. If you are prone to excessive weight loss, then only eat three meals a day and avoid snacking to slow metabolism down.

## FOOD ALLERGIES

The best cure for food allergies and intolerances is abstinence. Eliminate trigger foods for at least one to three months to get rid of allergy reactions. The most common trigger foods are milk, citrus fruits, chocolate, eggs, sugar, nighshade vegetables (tomatoes, peppers, potatoes, eggplant), soy, wheat, and corn. Intolerance reactions can include itchiness, hives, rapid heartbeat, fatigue, constipation or diarrhea, canker sores, or a worsening of your MS symptoms.

After a month, you can begin slowly adding trigger foods back in your diet. Your body will tell you if it likes them or not. If your body reacts, you know to stay away from them or to eat those foods only in moderation.

Variety is another way to avoid allergy and intolerance reactions. There are plenty of choices in each food group to make sure you are not eating the same thing day after day. As the saying goes, "Eat a rainbow of colored foods every day."

## LIQUIDS

Sodas, coffee, iced tea, and fruit juices are not substitutes for water, for, as F. Batmanghelidj says, "Water by itself is the best natural diuretic.

The human brain possesses about nine trillion nerve cells. Brain cells are said to be 85 percent water."[1]

This means that your body needs more water if you're to think and act rationally. The ideal for you to drink is one-half of your body weight in ounces of purified or filtered water each day (for example, if you weigh 150 pounds, you need to drink 75 ounces or a little over nine eight-ounce glasses of water daily).

To make it easier, drink six ounces—a little less than one cup—every waking hour until you go to sleep. If you notice that your urine is a dark color, that indicates that you're dehydrated. Don't let yourself get to the point of feeling thirsty. Drinking more water can eliminate a number of symptoms, such as headaches and pain in the body.

You can also obtain water from eating fresh organic fruits and vegetables. Another great hydrator for the body is fresh coconut water. And one of the only true sparkling mineral waters is Gerolsteiner from Germany. Most others are carbonated waters.

## HERBAL TEAS

Herbal teas count as water, but they're also cleansing, so make sure to put minerals back into your body by drinking purified water. Distilled water is good but it also leaches minerals out of the body. If you drink distilled make sure to take your vitamin/mineral supplementation daily. Among the many beneficial teas available, therapeutically I suggest red clover, pau d'arco, rosemary, green tea (caffeinated or decaffeinated), chamomile, and mint.

## JUICING

Fresh vegetable juices that have had the fiber extracted immediately fill your blood stream with live enzymes, vitamins, and minerals. Juicing is also alkalinizing to your body because it leaches out acidic waste products.

Juicing is a treatment, and it's important to do it correctly. First, don't make more than eight ounces of fresh juice at one

time. Drinking large quantities, such as 16 to 32 ounces of carrot juice at one time can do more harm than good because it is too much sugar for your system. Second, juice on an empty stomach, either an hour before a meal or two to three hours after a meal because it is a treatment to your bloodstream, not to be mixed with a heavy meal. Third, drink your juice as soon as you make it. Within thirty minutes, many of the vitamins and minerals are oxidized because of exposure to the air. Fourth, drink your juice slowly. Swish it around your mouth to mix it with your saliva, and then swallow. There are many books on juicing that you can use to see what recipes are best for you.

I recommend the following juice:

- ½ small carrot
- ½ apple, green (no seeds)
- 3 stalks celery
- 4–5 large handfuls of raw spinach, black kale, dandelion greens, watercress, *and/or* parsley
- 1 clove peeled garlic *and/or*
- 1 inch slice of ginger root (optional)

The Vitamix food processor keeps the fiber in the mixture, but this isn't what I recommend for juicing vegetables and fruits. It's a wonderful way to eat whole foods and make soup, but because the fiber is retained, your digestive system has to break it down. Breville is a juicer I recommend and can be bought on www.amazon.com or in many local department stores.

# ENVIRONMENTAL MANAGEMENT

A lthough you have little control over the general geo-graphical conditions in which you live, you can do much to neutralize environmental toxicity in your home and your office space.

Do all you can to control your personal environment by cleaning your airspace, drinking purified water, using nontoxic cleaning products, eating organic, hormone-free foods, and what you can't control let go of and trust that the steps you are taking will be sufficient.

## CLEAN AIR

One of the most important things you can do is clean the air in your home and work spaces. Air purifying technology is rapidly changing, so do your own research to see what best fits your needs.

Ionizers and filter systems are the two basic types of air puri-fiers on the market. Variations of ionizers are available: some just put out ions, others have ions and UV waves, and some machines put out ions and ozone.

HEPA filters have been around for a long time. These units collect dust and hair in the room where they're located. The filters can be expensive to change, and they don't get rid of molds and chemicals.

Ionizer machines put out ions, positively and negatively charged particles that attach themselves to airborne debris and cause it to drop to the floor. Some units add ozone. At high levels, ozone can be irritating to your upper respiratory system, but it's quite effective in neutralizing molds, odors, and chemicals. Ionizers that include UV lighting waves eliminate the risk of ozone irritation but are still effective in getting rid of chemicals and molds. Units that generate ozone are to be used in the living room—not your bedroom. They may irritate your lungs.

If you have many allergies, you might invest in a peak flow meter, which will help you identify which of the rooms or spaces where you spend time are causing you distress. You simply breathe into the meter and measure your breath level capacity. In spaces that contain allergens, you'll find that your breathing capacity is lower. You can use the Google search engine to find sources for meters.

## CLEAN WATER

Water, our scarcest and most contaminated resource, needs to be purified, filtered, or distilled. Bottled waters are not the best source of clean water because these companies that bottle aren't monitored, and the levels of heavy metals, chlorine, and fluoride can be just as high as in tap water. Also, chemicals from the plastic bottles leach into the water, especially when exposed to the sun on delivery trucks.

The best way to control the quality of your water is by buying a filtration system that hooks up to your faucet. Use a system that

filters out chemicals, heavy metals, parasites, and bacteria. As with air-purifying systems, you'll find many choices on the market. Structured matrix, reverse osmosis systems, and those that use ultraviolet light with a carbon filter are effective. (See Resources, page 299). If installing a home unit isn't an option, choose distilled bottled water over tap water.

## NONTOXIC CLEANING AND BODY-CARE PRODUCTS

Health food stores carry a wide range of safe cleaning and body-care products that are free of toxic chemicals. Changing to less-toxic products is a small step, but it will mean wreaking less havoc on your immune system.

## BALANCING ELECTROMAGNETIC FIELDS

The marketplace is filled with gadgets that claim to counter the effects of being exposed to electromagnetic fields (EMFs) and frequencies. I have not come across products that I feel can really neutralize those frequencies. A simple way is to realign your own energetic field each day by sleeping with your head at magnetic north and your feet facing south.

CHAPTER TWELVE

# STRESS BUSTERS

Stress is part of life. Without stress, you would not be motivated to survive. But for people with MS, stress is a main aggravator in creating and accelerating this condition. Exacerbations are provoked when stress is not managed. Your diseased body cannot rejuvenate new cells if it's constantly in a state of stress. Find outlets that allow you to escape from your symptoms by exercising, breathing, meditating, journaling, reading, visualizing your body as healthy, watching movies that make you laugh, getting out into the sunshine, and looking at nature.

## EXERCISE

Exercise is essential to rid your body and mind of distress, to keep your circulation flowing, and to maintain muscle tone. Exercise also releases endorphins (hormones), which elevate your mood.

To speed up your healing, it's essential to keep your circulation optimal so that you can adequately move toxins out of your body. Your lymphatic system is made up of organs and an extensive network of lymphatic vessels that play a major role in removing waste from the body. The lymphatic system operates by pushing fluid against gravity up to the heart and into the bloodstream. It doesn't have the luxury of a heart that pumps blood, so exercise, deep

breathing, skin brushing, and massage are needed to stimulate and push toxins out of the body.

Exercise doesn't mean going to the gym every day and lifting heavy weights. You don't need to work that hard to keep your body tone. The stage of MS you're at will determine how active you can be. Walking, swimming, isometric exercises, tai chi, qigong, and yoga are excellent. Yoga and isometric exercises are enough to stop muscle atrophy or wasting. Yoga is an excellent exercise because it combines physical strengthening and toning along with deep breathing. Three to five days a week of exercise is usually enough for almost everyone. If you are wheelchair-bound or have limited mobility, isometric exercises are beneficial and easy to do. You basically tighten and hold each muscle group for five seconds, exhale while still holding the muscles tight, then release. Work up to thirty to sixty seconds of holding each muscle group. Many books on isometrics are available by searching www.amazon.com.

## BREATHING

Breathing is vital for alleviating stress and removing toxins. Your lungs are your most efficient detoxifiers, because breathing releases more than 75 percent of the toxins in your body. The other 25 percent is eliminated through urination, defecation, and perspiration combined.

The value of breathing deeply is not to be underestimated or taken for granted. Focused, centered breathing calms down your mind, brings oxygen into your brain and cells, and releases poisons from the body.

Most of the time, many of us operate in fight-or-flight mode, never quieting our minds and doing a million tasks. This tends to create shallow breathing, from the chest up, rather than abdominal breathing, which engages the diaphragm and the respiratory

system. So go outside, or sneak into the bathroom, or lie on your bed, or close your office door and breathe. Take time out for yourself by deep breathing for a couple of minutes two to three times a day.

## MEDITATION

Meditation means stilling the mind. It's also crucial for creating a strong immune system and relieving mental, emotional, and spiritual stress. Although meditation is an easy technique, it's challenging to do because we can all find many excuses to not sit still for five to twenty minutes a day. The benefits are amazing and worth the practice.

Start with five minutes a day and build up. Sit in a comfortable position, such as the lotus position, with your legs crossed, or against the headboard of your bed, or in a chair with your feet flat on the ground. Keep your spine upright, close your eyes, and begin to take deep breaths. Whisper to yourself, "I give myself permission to slow down my mind." Then use a mantra—a tone or one word such as *one, aah,* or *love*—that you repeat over and over in your mind to help you go into a relaxed state. You can also focus your eyes toward your third eye, between your eyebrows, or you can gaze at a candle or at a spot on the wall in front of you to slow down the mind. Keep focusing on the rhythm of your breathing and allow each inhale and exhale to take you more deeply into relaxation.

Allow yourself to drift and float. If conscious thoughts keep flooding your mind, allow them to float by like the numbers on a ticker tape. It's okay if your conscious mind is overactive. The key is to not grab onto the thoughts and give them energy. Let them float by. Over time, you'll become more proficient at letting your mind slow down. During your meditation, let yourself be filled with the silence and a feeling of connection to all that is. Moments

of stillness can bring forth the wisdom and answers that will help you transcend imbalances because you are in the "now" moment —your place of power.

Near the end of your meditation, visualize and feel your body healthy. See and feel golden-white and pink light from above entering through the crown of your head, healing and repairing every cell, organ, and tissue in your body. Breathe in the light and exhale out pain, stress, and negativity. See and fill your brain and spinal cord with the golden-white and pink light.

Meditation brings about a stronger relationship with your higher self and creates health and balance in your life.

## BASKING IN THE SUNLIGHT

Just fifteen to twenty minutes of sunlight each day nourishes you with enough vitamin D that you can absorb calcium and other minerals. Sunlight also promotes a positive, optimistic, and healing outlook. Twenty percent of your skin needs to be exposed with your hands and face accounting for only five percent. If you're going to be out in direct sunlight for more than thirty minutes, put on sunscreen with an SPF of no more than 15. Higher concentrations contain more toxic chemicals.

## GIFT YOURSELF

Spoil yourself. Getting healthy means honoring yourself first. Indulge in a massage once a month—or more often. Massage helps to move waste and tension from your body. Treat yourself to lunch and a movie. Go shopping and buy yourself something special to wear, or another great book to read, or a tool for your hobby.

## FAMILY AND FRIENDS

Enjoying social activities and "play" with family members, children, and friends is a positive way to forget about being sick. Make sure to laugh as much and as often as you can. Laughter releases beneficial chemicals that support your healing. The key is not to isolate yourself, which can add to feelings of despair and hopelessness.

## JOURNAL WRITING

Writing without self-editing is a helpful way to relieve stress. It also gives you a greater awareness and understanding of the suppressed thoughts, feelings, and beliefs that may be affecting your health. Writing without judgment is important so that you can express your true feelings. You can even rip up and throw away what you write as a cleansing process of acceptance and release.

## HOBBIES

Whether you're interested in crafts, photography, or just reading mystery novels, hobbies allow your mind to slow down, like meditation, as you focus on one thing. The enjoyment you gain from hobbies helps to keep your body in balance. If your mobility is limited, create new ways to keep your mind active and focused. Try a crossword or jigsaw puzzle, for example.

## THE EARTH'S MAGNETIC FIELD

You can use the earth's gravitational pull to neutralize stress. It's easy—try hugging a tree that you can put your arms around. Hug

a tree for thirty seconds, and feel the tension run down and out of your legs into the earth. It took me a few months to stop looking around to see whether anyone was watching me and thinking I was a nut when I started hugging trees. If you feel self-conscious hugging a tree, you'll only create more stress, but give it a try.

You can also get in touch with the earth's gravitational pull by planting your bare feet on the grass or sand, or by putting a blanket on the grass or sand and lie on it stomach down. You'll feel your stress melt away.

## ACUPUNCTURE

Acupuncture is a traditional Chinese medicine technique that uses hair-thin needles to treat pain and stress. It is quite effective in alleviating stress and increasing circulation.

## GET HELP

You need to work on alleviating chronic stress or it will destroy your health. Invest in yourself by taking on the practices I've listed here. If you feel you need more help, get it. Seek out a therapist or hypnotherapist who works with stress reduction. Listen to stress reduction CDs. Find a trainer that can motivate and assist you to exercise. If you know that your stress levels are out of control, make the investment in reestablishing balance.

# EMOTIONAL AND MENTAL FITNESS

Your emotional and mental strengths are your most powerful allies in beating MS. You can use your conscious and subconscious to help yourself heal by stepping out of fear, denial, and other states that are suppressing your immune system. To begin to identify and release unhealthy emotions, you must become more aware of patterns and delve more deeply into your relationship with yourself.

This may seem like a lot of effort, or like something you just want to forget about. But the sooner you move out of denial and begin questioning your stored negative emotions and thoughts, the more quickly you can release them and arrive at a point where you truly feel that your past is past. It's easier said than done because you've reached a point in your life where you're not conscious of the ways in which actions are rooted in your fear-based emotions. Cleaning your emotional house doesn't mean that you need to go and relive every awful experience in your past. Rather, it means looking for patterns and themes that are continuing to play out and create dysfunctions in your current life.

## WHAT YOU THINK IS WHAT YOU ARE

Though you may not think so, you have absolute choice over everything you think and feel. It's your choice whether you let the diagnosis of MS devastate you—or whether you decide to beat it. By becoming more aware and by energizing positive thoughts and feelings, you can actually change your cellular function to become healthy again.

Uncovering your core fear-based emotions and releasing them is essential to your healing process. MS has a strong emotional core component centered around the devaluing of the self and suppressed anger or rage.

The first step toward emotional/mental healing is to start by looking at this disease from a point of denial. What am I not accepting? This is what it takes to begin uncovering what you've been hiding under the rug or putting on the shelf—whether anger, sadness, abandonment, rejection, or fear.

MS is a test in which you can learn how to reclaim your power by standing alone in confidence. It's an opportunity for you to transform, and to do that means finding ways to release the emotional and mental baggage that's keeping your central nervous system ravaged. As I mentioned above, there are many forms of assistance available today, such as counseling, hypnosis, prayer, energy work, journaling, and art therapy, among others, that can help you with this task.

Second, ask yourself, "Do I believe my body can regenerate on a cellular level?" If your answer is no, then it's not going to be possible, because your beliefs are the foundation of your existence. A new fleeting thought of being able to regenerate your body does not withstand years of a belief system (visions, perceptions and feeling) that say, "No this is not possible." You'll see improvement if you follow the diet and take your antifungal and supplements, but complete transformation happens only when

you are practicing daily being healthy on every level—mentally, emotionally, physically, and spiritually.

Begin to pay attention to your thoughts, and choose to energize only those that are for your well-being. When negative fear-based thoughts come up, acknowledge them immediately—and give them permission to "go play outside." Accepting, giving yourself permission to get rid of, and then replacing negative thoughts with positive ones or neutral action (take a deep breath, drink a glass of water, focus back on your work task) are the three most important steps in managing your mind.

## HOW TO REACH YOUR SUBCONSCIOUS MIND

As mentioned in Part Two, the subconscious is where you truly act from. It's a storehouse of repeated beliefs and habits. The secret of reaching the subconscious mind is that you can train it on a conscious level through focused speech and repetition. The two most powerful ways to accomplish this are hypnosis and speaking out loud, using affirmations and prayer. When you're unhealthy, it's important to change that imprint of illness that's been stored in your subconscious mind. You may be storing belief systems that need to be replaced, fear-based emotions that you need to eliminate, and negative thought patterns that need to be changed. But once you do this work, you'll experience inner peace and health on all levels.

## HYPNOSIS

Hypnosis, a technique that uses deep relaxation and focused attention, is one of the quickest and most powerful ways to speak to your subconscious mind and to release and change thoughts, fear-based emotions, and belief systems.

Unfortunately, hypnosis still has many negative connotations attached to it. There's nothing scary about hypnosis once you understand how it works. Hypnosis is simply deep relaxation and focused concentration. That's it. You don't need to fear that you'll be made to lose control or do something you don't want to do. If anything, you're more in control because hypnosis lets you slow down your conscious thoughts and become more aware of what's going on in the present moment. Once you're in a state of relaxation, your hypnotherapist has greater access to your subconscious mind and can offer suggestions that will assist your healing process. Your subconscious mind is always listening, but when you're relaxed and not consciously busy, spoken suggestions take greater hold.

To understand hypnosis better, you need to understand that we're all electromagnetic beings. We generate measurable units of electrical energy per second. The brain can go into four states that all have different energy frequencies: alpha, beta, theta, and delta. In your conscious waking state, you are in beta, which produces about twenty to forty energy units per second. In beta mode, you're not 100 percent focused; you're able to think, feel, and sense many things at once. When you go into hypnosis, you drop down into the alpha state, which is only ten to twelve energy units per second, and the conscious mind is lulled. The hypnotic state is an altered state, not like dreaming and not like being awake, but very similar to the feeling you have when you're just waking up in the morning or just before you fall asleep at night and you don't want to be disturbed. It's in this state that the greatest learning takes place and the removal of fears, habits, patterns, and emotions that don't serve you, can occur. There are two other states of the mind: theta and delta. These are deep somnambulistic states.

We all go into hypnotic states every day. For example, you're driving on the freeway and realize you're already at your exit, or you watch a two-hour movie and realize only when it ends that

two hours have gone by. That is hypnosis—focused concentration and relaxation.

Getting effective results from hypnosis requires two things. First, you need to have a strong desire to resolve the problem or issue. Second, you need to trust and feel a rapport with your hypnotherapist. I've found that integrating hypnosis into patients' treatments has been an extremely valuable tool in assisting their bodies to heal. I have my patients visualize and feel every cell, organ, and tissue repairing itself. I help them identify and release limiting belief systems and remove negative thoughts and emotions that are stored in their bodies. I open the door so that my patients can give themselves permission to heal. To make the work more effective, I record our hypnotherapy sessions so they can listen to them for the following twenty-one days as they are falling asleep and saturate their subconscious minds with positive suggestions.

Remember, thoughts create energy, and if you think, imagine, and feel a healthy body often enough, eventually you will become that vision and feeling.

## SPEAKING OUT LOUD

Another effective way to reach your subconscious mind is to speak out loud. The vibrations of sound create frequencies that alter physical matter. Positive daily self-talk and affirmations, spoken out loud, will reinforce and expedite your healing process.

This simple concept of talking out loud is incredibly powerful yet greatly overlooked. Most of us may view speaking out loud to ourselves as crazy, but I'm here to tell you that it works, especially when it comes to negative thoughts and fear-based emotions. Reflect on how the words of a song have affected you, or on a speech that moved you to tears, or on the connectedness you feel when you engage in a spoken prayer. It's the vibration of the

words that makes you feel. Sound coming together with light creates greater manifestation power to that which you are affirming and speaking about. Affirmations, prayer, chanting, toning, and speaking out loud with yourself have one thing in common—they change your reality.

## AFFIRMATIONS

Affirmations are statements, words, sentences, or phrases spoken out loud. They're most effective when you speak them every day because the subconscious responds to repetition. There's no magic number for how many times you need to say your affirmations out loud, but more often is better. A minimum of three times consecutively is essential. You may feel silly and embarrassed at first, but this will pass. Create your own privacy to make yourself comfortable. Speak your affirmations in the car, in the shower, in front of the mirror in your bathroom, or when you take a walk. By saying your affirmations day in and day out, you'll notice shifts taking place. Energize your affirmations by stating them with belief and conviction.

An important ingredient to having your affirmations fulfilled is by giving yourself permission. The reason is because you have been conditioned to be conditional, which keeps you stuck in resistance. By beginning your affirmation with the phrase, "I give myself permission to . . . ," you allow yourself to move forward. After a short time, you'll find you no longer need to give yourself permission—you can just speak your affirmation.

Some religions proclaim that asking for what you want is selfish. I disagree. Asking God for what you want means that you feel worthy to be all you can be. A little side note: pay attention and be specific with your words and how you ask for something because many times the thing you want most will come to you,

but in an unsettling way. A safe bet is to qualify your affirmation or want with words such as "easily and effortlessly" at the beginning or end of your sentence. Also, state your affirmation in the present moment by saying, "I am . . . ," not, "I want . . . " or, "I will have." You state it as if it already exists.

Below are some examples of affirmations that you can change or modify. Part Four, page 281 contains more examples. Don't be afraid to make up your own. You know better than anyone else what you need to move through your challenges.

## Examples of Affirmations

- I give myself permission to release all unconscious and conscious anger that I am carrying, easily and effortlessly.
- I give myself permission to accept who I am right now, easily and effortlessly.
- I give myself permission to heal physically, mentally/ emotionally, and spiritually, easily and effortlessly.

**Neutrality**   Neutrality is a feeling of observation without judgment or a negative emotional charge. It is a mode of thought and feeling that helps you deal with people and situations you can't control. It protects you because you stop taking on others' negative energy. It's also a way to handle negative experiences from your past.

The goal of releasing your fear-based emotions is to become neutral so the triggers of the past no longer cause you anger or fear. An example would be a woman who had been sexually abused as a child. The first step is for her to become aware and acknowledge that she's still carrying fear-based emotions around this issue. Next, she needs to give herself permission to accept and release

the feelings of anger, violation, and sadness that she experienced. The final step is for her to replace these fear-based emotions by working with her subconscious mind through hypnosis, affirmations, meditation, and other techniques. The key is for her to release the emotion of the past, carry the higher understanding and lesson from the experience consciously, and operate emotionally from a place of neutrality in the present. This takes a tremendous amount of courage, but she would benefit greatly by forgiving the abuser, which would allow her to move out of a place of anger to seek the higher truth of what she was to learn from that experience. The ideal outcome is for her to look back and feel completely neutral toward both the abuser and the experience.

Neutrality becomes more real when you use repetitive thoughts and actions to support letting go and moving forward. Every negative or traumatic event in your life can become either an opportunity to grow—or a prison in which you feel trapped.

## NO LONGER A VICTIM

Another point to keep in mind when examining your emotions is to realize that no one can "make" you feel anything. You have choice in everything you think and feel. And when you think that other people make you feel something, you give away your power.

For instance, if a man walks by you on the street and spits in your face, it's your choice whether you get angry, laugh, or remain neutral. People find it easier to assign blame to others for their challenges, but this action only sets up the vicious cycle of being a victim.

Being codependent—when you take on responsibility for other people you care about who are unhappy and want to fix or change them—also keeps you victimized.

Do not give your power away. Instead, get in touch with it by

accepting that you're the only one responsible for your emotions. Choose emotions that serve your highest good and the good of others. Learn to feel confident in setting boundaries. This will help keep you neutral and unaffected by those close to you.

## HOW TO MOVE OUT OF FEAR AND ANXIETY

How can you heal your body if you're trapped in fear? You can't. Moving out of fear means having the courage to accept its presence but also finding ways to move forward and beyond it. You must give yourself permission and make a choice to be free of fear, and then follow up with actions that support that permission.

Learning to move out of fear takes diligence and courage. Courage is the bravery, strength, and fortitude that enables you to move through situations even in the face of your fear. Diligence is the tenacity to work through a fear each time it comes up until it is gone.

The easiest and quickest technique to alleviate fear is to speak out loud. Address your fear directly, out loud, instead of trying to push your thoughts of it away. Speak to it as if it were a person. Let the fear know that you see it and that it can't keep sneaking up on you. Accept it. Next, affirm that you're in control and you won't let the fear dominate you. Give yourself permission to release it. Then replace it with what you want to feel that is positive or neutral.

For example, let's look at a woman who's afraid to drive on the freeway. As she approaches the freeway on-ramp, her heart starts to race, her palms sweat, and she has trouble breathing as her fears of getting into an accident surface. She needs to take a deep breath immediately, and speak to her fear out loud: "I see you try-ing to sneak up on me, but you're not going to. I accept that I'm terrified to get on the freeway. I'm not going to play into you right now. I'm in control. I refuse to give you any power. I give myself

permission to release all this fear. I am now making a choice to think and feel differently." Then she can take a deep breath and exhale all the fear into the atmosphere, telling herself over and over again either out loud or in her mind, "I'm confident and calm as I drive on the freeway."

Addressing your fears out loud instantly puts out the flames that are feeding them. This technique takes practice and conviction, but you will feel the results. Positive determination followed by positive action and reassuring your doubtful inner child can turn negative spirals into positive outcomes. The key is to be persistent in retraining your thoughts and feelings and to keep telling yourself that you, not your fears, are in control. Visualization, hypnosis, and emotional freedom technique (listed in Resources, page 299) are also powerful ways to move through fear permanently.

## WHAT DO YOU WANT TO CREATE?

Each of us is a painter, and every day you use your palette to make choices that add colors and shapes to your life and experience— or subtract them. Whether you want the responsibility or not, you are in control of your choices and actions, and you're the only one who determines the kind of minute, hour, day, week, and year you will experience.

What picture do you want to paint? When you embrace your power and recognize that you orchestrate each day, you can begin to paint colors and shapes that make you think and feel healthy. When you stop and examine how your reality is created, you can see that everything originates from a thought, a fantasy, or a belief that is then followed up with emotion and action. You paint and create your thoughts, moods, and actions each day. Your subconscious mind is working diligently to make sure you become precisely the person you've unconsciously described yourself to

be. Make sure you speak out loud and energize only words that are positive and supportive of you and others. Entertain and energize only thoughts that are positive and creative. Emotions are certainly not all fear-based, so choose feelings such as joy, love, and excitement and make them part of your daily experience.

When you operate from love instead of fear, you create rather than destroy. Though it may seem that your mind, filled with negative fear-based thoughts, is against you, it really isn't. Rather, this is simply a test—a chance for you to rise to the occasion and an opportunity to embrace your power to create and paint the picture of your choice.

Living without fear is the greatest freedom you can experience. You'll know that you've moved past your fear when you face that old situation again but you're no longer emotionally charged by it. You're neutral. By staying diligent about practicing the tools and techniques you feel are right for you, you'll reach the other side in confidence. Trust and allow yourself permission to be successful in living a life free of fear, anxiety, and anger.

# YOUR
# SPIRITUAL SELF

W e're seldom aware of the intangible though outdated beliefs that rule our lives. For example, the "belief" that "MS is incurable" is not a law chiseled in stone. Negative internal messages keep you enslaved in a diseased body. Most serious illnesses are due to neglect or poor lifestyle choices, but you can change your beliefs and gain healing power from feeling spiritually connected to something greater than ourselves.

Acknowledging your spiritual self means realizing that it too needs to be fed each day. You can do this taking time for yourself in solitude and opening up to that intangible power called *God* or *Tao*. Journaling, prayer, meditation, chanting, and affirmations are all ways you can expand your spiritual self. Busy lives and being able to make enough money to put food on the table can be distractions, but don't let these excuses stop you from tapping into tools that can change your life. Each breath you take is your first and last. Each breath is an opportunity to make a choice for the better. The more you connect with your spirituality, the more you'll find ways to enjoy the journey of life by living in the now moment, and the more you'll stop racing to reach a destination that never seems reachable.

## YOUR HIGHER SELF

A powerful connection to God resides within each of us. This connection is called your higher self. The higher self is all-knowing because it contains all the answers and guidance you need to move forward. It's that gut feeling you have, or that little voice you hear that you usually ignore and later say, "I should have listened to it." It's that place inside that you become aware of when you feel that something's "right." The more you connect with your higher self through prayer, affirmations, and meditation, the more you'll be able to utilize your full capacity to heal. Sometimes, asking God for assistance and giving yourself permission to let go is all that it takes to turn a challenge around.

To tune into your higher self, you need to be able to move out of your ego and into neutrality, a place of honesty and observation. Easy to say, but challenging to do. It's important to make time for yourself each day by slowing down. Meditation and prayer are wonderful ways to connect to your higher self because you slow down into that space of nothingness that connects you to all that is.

The ego is necessary, but many times it keeps you stuck in judgment, blame, and fear-based emotions. When you're connected to your higher self, you detach from the chaos around you and move into a space of clarity and wisdom that lets you make more positive choices. You can step back from yourself to see the macrocosm of your challenge and can connect to that realm where there are no limitations and many options. This clarity, vision, and power can be scary, and you may find it easier to stay stuck in self-limiting conditions and environments, but you have so much more to gain by having the courage to move forward with your spiritual expansion.

The God force may not be tangible, but it's always there if you believe in it and allow it in. Trust is the necessary ingredient to feel that power.

## TRUST

Trust is intangible, undoubting faith in your beliefs, whether about your health, relationships, money, or any other aspect of your life.

Without trust, fear can take over and destroy you because what you fear most is what you create. This is the simple law of attraction. Living without trust creates anxiety because you're always waiting for the other shoe to drop.

Trust—knowing that there's something greater than you that's positive and always assisting you to expand and move forward—takes practice, especially during times of challenge. If the word "trust" brings up resistance for you, then move into a feeling of compassion. Compassion is the feeding ground that allows trust to bloom. Be able to surrender and accept every part of you, which will spark compassion. Let that compassion encompass your dis-ease, choices that brought you here, and the steps needed to overcome it.

Trust also moves you to question your beliefs because they're the foundation of who you are. If you're unhealthy, it is certain that you're buying into, outdated belief systems that are working against you and creating resistance and imbalance. The place to go next is to stop and question your beliefs.

## BELIEFS

The solution to making your beliefs work for you is to consciously become aware of them and to then question ones that are limiting.

Ask yourself what you believe about health, money, self-worth, career, relationships, and the other aspects of your life. Begin to challenge everything, from the mundane to whether you believe your body can regenerate on a cellular level. Break apart your

beliefs by getting to their core. Ask yourself these questions about any belief: "Where did it originate? Why am I carrying it? Does it serve any purpose now? Is it productive and positive?"

This exercise may seem tedious, but is a life tool that can overcome any challenge and transform an unhealthy body into a healthy one. Take on this process not as a chore but rather as an exploration into the depths of who you truly are. (See Part Four, page 283).

As I've said before, it's your interpretation of a diagnosis or illness that determines whether it will cripple you or if you'll turn it around. At times, you may find it hard to believe that you have that much power, but you do. You have the power to change your reality at any time. If you believe that MS has come upon you because of something outside your control, then you will have no power to overcome it. But if you accept that your lifestyle, habits, patterns, and thoughts have brought you to this point, then you have the power to let go of the disease and manifest health once again.

The body is inherently intelligent and knows exactly what to do to change and create health. Health is the choice you make by your actions to help create the environment the body needs to function optimally. You can challenge the establishment called "society" and "family" and still come out a winner. It doesn't matter what anyone else thinks of you. You have no control over how others perceive you. So why waste time trying to appease those around you when you're suffering? Learn to tune in to what you trust and feel. Walk to your own beat. Create new beliefs that feel right to you and allow you to live out your heart's bliss.

## HOW TO CHANGE YOUR BELIEFS

You can grasp how to change a belief intellectually in few seconds, but feeling it takes time. It's important to keep your new belief in your consciousness and to uphold it each day. It takes

perseverance and courage to remove cornerstones of how you've operated in the past. You may even find that you need to let go of unhealthy environments and relationships. The key is to honor every day what you now feel as true. Soon that belief will become ingrained in your perceptions, thoughts, and feelings.

## GRATITUDE

Many MS sufferers are afflicted with buried anger and resistance, but every illness can be a learning experience. If you accept and feel grateful for every experience, whether good or bad, your healing will move along more rapidly.

Gratitude is the greatest gift you can give back to God. Gratitude is heartfelt thanks for lessons, experiences, and successes. You might ask, "Why would I give thanks to a disease?" The answer is simple. Were it not for this experience, you wouldn't have been able to discover the truths that can set you free.

The point is to give thanks and make a new choice to be healthy. You don't have to stay stuck in anything that's unhealthy. Living a life of gratitude and grace is what I call the quintessential way of being. Grace means acting from beyond your ego, and gratitude is being present with all you have and are right now by accepting what is and by letting go of the hunger for what you don't have or "need to" be doing. Being grateful each day is the quickest way to allow more love, more health, and more joy into your life.

## THE TWO MOST IMPORTANT PRAYERS

The two most important prayers you can say to God are: "I don't know how. . . . I'm willing to be guided and shown" and "Thank you." By praying to God and saying you don't know how to get healthy, you accomplish many things. First, you accept what is.

Second, you move past your ego and surrender. And third, you allow for something greater to guide you to people, places, and things that can help you get well. This step does not take away from you but actually empowers you to move into the driver's seat by allowing new avenues to open up to you.

Saying "thank you" is giving gratitude back to God and is also affirming that you know with belief and trust that what you've prayed for has already come to you.

## JOY OF THE SPIRIT

"Spirituality" doesn't mean "heavy and serious." On the contrary, it is your spirit that reminds you to connect with your inner child, who likes to play and be joyful. Fun, joy, and laughter nourish every cell in your body by releasing healthy hormones that improve the functioning of your immune system.

Even in the worst health crises, you can find joy and laughter if you look for it. Laughter conquers any darkness, and it's a powerful tool for healing, as Norman Cousins demonstrated when he turned around a life-threatening disease with daily doses of watching Marx Brothers movies and *Candid Camera*. Laughter positively affects your cells by releasing endorphins. It also keeps you in touch with the now moment, which is always your place of power. My mother was my comedian who kept me laughing throughout my ordeal.

Allow the joyful spirit that you are to shine through more each day by creating new beliefs that are healthy, by being in the now moment and accepting what is, and by trusting the power of God to assist you with your challenge. Your higher self, the element of your spiritual connection to God, is the unseen thread that weaves magic into your life each and every day—if you pay attention to it and allow it in.

# YOU DON'T HAVE TO BE PERFECT

To heal your MS, you need to commit yourself to a treatment plan. It's a challenge, but you don't have to do everything perfectly. You'll find it easier to stay motivated and inspired in the face of your fear and resistance if you keep in mind that there's always room for growth, which I now believe is the true meaning of perfection. Change your belief from "perfection means I'm not good enough, so I must make everything perfect to be accepted and validated" to "growth and progress and there is room for improvement."

Accept that your healing will happen at a pace that feels right for you. Pay attention to and recognize self-sabotaging behaviors, feelings, and thoughts, and replace them with the ones that let you be your own best friend: unconditional love, self-worth, tolerance, and acceptance of your individuality.

## SELF-WORTH

When I ask MS patients, "Do you feel you're worth your existence?," they usually answer "No." Sometimes they even break down in tears as they recognize this sad reality. If your answer is "No" or

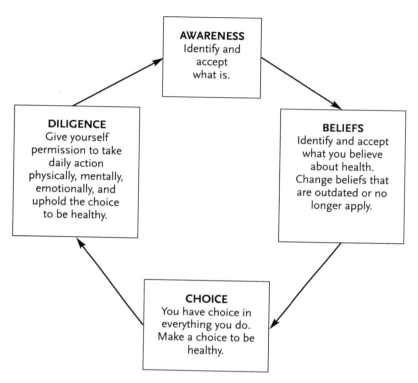

**FIGURE 15.1. The ABCDs of Transformation**

"I'm not sure," you're sending out signals that will bring about great imbalance in your body and mind. Feelings of unworthiness make it impossible for you to transform your body and heal.

Unfortunately, most of us were raised to believe that our self-worth depends on acceptance by others, how much money we make, if we are healthy or not, and our possessions. However, self-worth is based on our intrinsic existence, not on what we do or have in life. The fact that you exist is proof of your worth. Nothing more is needed. If you exist, you're worthy, because your energy is part of the whole, part of all that is. Whether your contribution is positive or negative is in your hands because it

depends on the choices you make, but your worth is not in question. It's inherent because of your existence.

Check in with yourself, question your beliefs about self-worth, and see if they're truly valid from where you are at today. Are those beliefs keeping you stuck resenting yourself or feeling intense pressure to succeed? If so, you have a choice to release those old beliefs and change them. Embracing my worthiness based on my existence alone has allowed peace, freedom, and health to be mine. It can do the same for you. (See Figure 15.1).

## SELF-ACCEPTANCE AND UNCONDITIONAL LOVE

Once you've established your self-worth, you can begin to open the door to unconditional love. What does this really mean? It means you give yourself permission to accept yourself on all levels. Few of us ever learned total self-acceptance when we were growing up. Learning to operate from a place of unconditional love creates a feeling of freedom and allows you to be self-compassionate and self-nurturing when you make mistakes. Unconditional love is the most powerful way to mend any divisions between your body and your mind.

Unfortunately, most of us have poor relationships with ourselves because we're products of negative conditioning. You've been programmed with messages and beliefs that are stored deep within your subconscious mind and are telling you that you're not good enough, that you've "failed," or that you "should have" or "could have" done this or that. If you treat your body like a bad dog that learns only when it's beaten, it will respond by creating more toxins and shutting down.

If you haven't stopped to question these negative and self-defeating messages, you're still playing them out in your adult life. The end result is that you're extremely self-critical and carrying old

burdens, and you've become your own worst enemy by looking for validation and acceptance through an illness. This lack of unconditional self-love is defeating your very core—your self-worth.

At this point, you've lost touch with your true essence—the part of you that loves yourself no matter what experience you go through, the part of you that's your own best cheerleader and lets you know you can do anything you desire. Instead, you get trapped in negativity and self-doubt.

The fact is, there's no one you need to prove yourself to.

Learning to treat yourself as your own best friend is an important ingredient to transformation. This may sound corny, but it isn't. Think about how you treat yourself compared to how you treat your best friend. Whether you like it or not, you're in a relationship with yourself. That relationship can be positive or negative . . . it's your choice.

Self-acceptance creates the opening for something new to unfold within you. The first step is to accept who you are right now, in this very moment, with compassion and to put aside limiting beliefs systems and judgments that you have upheld. Accepting every event in your past and knowing that there's no such thing as failure, only experience, will set you free. Recognize that negative and traumatic events from the past can be building blocks to a more positive future—if you let them.

This doesn't mean that you need to discount intention and integrity when taking action. Rather, it means to stop beating yourself up and carrying around guilt that serves no purpose, and to become aware of the powerful person you are by making wiser choices based on what you've learned from your past experiences. A wonderful feeling of freedom will become yours as you accept yourself today with all your challenges and shadow side. Self-acceptance lifts all burdens.

From self-acceptance, you can move into a place of choice. Make the conscious choice to uphold your commitment to love yourself unconditionally.

The goal is to become your own coach and to support yourself during good and challenging times alike. The fastest way to make that change is by saying affirmations and by catching and replacing your self-defeating thoughts. Speak affirmations such as, "I love and accept myself and my body unconditionally" and, "I am worthy."

Speak out loud to yourself in the mirror and repeat these affirmations every day many times over. Express your affirmations with conviction by feeling them resonate in your solar plexus, in the center of your abdomen. Soon you'll notice a shift in your self-esteem and confidence.

Also, pay attention to your self-defeating thoughts and catch them in action. When you make a mistake, observe your thoughts and see if you're using self-critical inner dialogue. If you are, accept and acknowledge those thoughts and then say, "Stop, I'm not going to engage in this. I'm tired of playing this game. Now, go play outside."

Then replace those thoughts with positive or neutral ones. Retrain your thoughts so they support you. You want to get to the point where you habitually think, "That's okay, next time I'll do better" and, "I can do it—I believe in myself." This technique is simple and effective when done with repetition. Replacing and energizing positive thoughts creates a new reality.

## INDIVIDUALITY

Sometimes illness is a wall you can hide behind because you feel you aren't good enough and you're unwilling to accept the value of your uniqueness. Each of us is an individual with skills, gifts, and contributions to be shared with the rest of the world. When you accept your individuality, you liberate yourself from the entrapment of illness. We all have purpose in this world. Each individual has an illuminating spark that makes him/her unique and powerful.

Building a positive relationship with yourself increases your self-esteem and confidence. The more you develop your relationship with yourself, the more you become empowered to create the reality that brings you joy, peace, health, and abundance. Self-empowerment is your inherent truth that lets your spirit soar without judgment, walls, fears, or barriers. By reaching out and grabbing your power, you can witness your body overcoming a so-called "incurable disease" and can create success in every area of your life.

To reap these benefits, you need to cultivate your relationship with yourself by being patient with yourself and by diligently following through with beliefs, thoughts, and actions that are for your highest good. You can't divorce yourself, so why not make the journey more enriching and powerful by becoming your own best friend filled with compassion, tolerance, courtesy, understanding, patience, and unconditional love?

## COURAGE AND TENACITY

I know that MS can be a very challenging condition, but dig deep for the courage and diligence to stick with a regime and trust that you're getting better every day. Staying committed to yourself does not mean monitoring and grading and judging yourself. It means having a game plan and doing the best you can to stick with it.

## BE HERE NOW

Staying in the now moment is essential to feel motivated. The past is over, so focusing on what you could have done will only weigh you down. Anxiety-filled thoughts about the future will only paralyze you more. The now moment is your place of power. Stay in today! Tell yourself: "Today I'm stronger. Today I make

better food choices. Today I have more compassion about my condition and myself. Today I'm healthy!"

## DON'T GIVE UP

Try reading this chapter over and over again whenever you start to feel discouraged and want to throw in the towel. Don't give up. Ups and downs are to be expected. Learn to ride the waves, which are common when reversing MS. Your central nervous system takes longer to heal than any other system in your body. Good days and bad days are to be expected. Realizing in your thoughts that you can be well can occur in a moment, but your physical body has a residual memory of its own and changes more slowly. Cellular memory is willing to learn, but it can sometimes act like a stubborn mule. If you're aware of this, you'll have the strength to keep doing your program and not give up thinking it isn't working. Be patient and trust.

You don't have to be perfect to heal your body. You do need to be diligent and tenacious, but on days when you just don't want to eat what you're supposed to or you can't get up enough energy to exercise, don't. Being committed to yourself means accepting every part of your journey. Self-sabotage is an easy out for most of us to say a program didn't work. The point is, you may very well experience moments of self-sabotage when you don't eat healthy, take your supplements, or "fall down" in other ways, so just be willing to love yourself even in those moments—and then get back on track. Each baby step equates to success because it brings you closer to your goal!

# PATIENTS' STORIES

The following case stories are from patients that have MS and are in remission and/or reversal. It has been an honor to assist and watch the courage, diligence and growth taken by each and every one of them.

*Leanne*

**BACKGROUND:** chicken pox, frequent ear infections and colds, mononucleosis at age fifteen, high periods of stress, high sugar intake

**SYMPTOMS UPON VISIT:** cold hands and feet, numbness and tingling, hypoglycemia, crave sweets, itchy skin and feet, bloating and gas, anxiety, frequent thirst, depression

**PHARMACEUTICALS TAKEN FOR MS:** Avonex and steroids

**ANTIBIOTICS:** sixty rounds (lifetime)

I went to college in Boston, about ninety miles away from where I grew up. I majored in music business and management and after graduating moved to Los Angeles, where I got a dream job working for Virgin Records in the art department. It was a high-stress, fast-paced world of work and parties and parties and work.

All that changed on February 14, 2000, Valentine's Day. Well, really in January, when my legs started to go numb. My doctor told me that I had a pinched nerve and put me on anti-inflammatory drugs.

When I called a week later to tell her that the numbness hadn't subsided, she said I was overreacting and needed to give it more time. I did exactly that and gave it another week.

On Super Bowl Sunday that year, my right arm and the right side of my face went numb. That was when my doctor decided I needed to come in for some tests. She sent me to a neurologist for a nerve conduction study. It came back normal. I started to panic. It was frustrating not to have anyone in the medical field to at least acknowledge that something was going on with my body. It couldn't have all been in my head!

Then my eyesight went when I was driving to work one day. My assistant had to come and pick me up. She took me back to my doctor, and I finally went in for a CAT scan. When the results came in, the neurologist sat me down and told me I had MS: "You'll have it for the rest of your life. The best thing for you to do is start the medication immediately."

Wow—that was a heavy thing to be told when just a month ago I'd been a healthy twenty-five-year-old. I immediately started a steroid drip every day. A nurse came to my house and hooked me up to the drip. I lost about ten pounds (and I've always had a problem keeping weight on), and I couldn't sleep, but I also couldn't sit at work for eight hours. My body was a mess.

Fortunately, someone in my office used to work with a woman who'd had MS and was now working with people who were suffering from many different diseases. That person was Ann. I called her and she got me in to see her within two days. I spent an hour and a half with Ann, and that was when I finally found someone who helped me understand my disease and made me want to beat it.

I've never been a person who takes the easy road, and this one wasn't easy. I had a lot of emotional issues that needed to be dealt with. My diet was horrible, and I was a physical ball of stress! Fortunately, after having a definite drinking problem, I had quit drinking about three or four months earlier.

It also wasn't easy convincing my family that the treatment plan Ann was recommending was the right thing for me to do. I now live about 3,000 miles away from home, so the call to my mother telling her that I was going to stop treatment and go the holistic route wasn't an easy one. Luckily for me, my family has always been open-minded about things once they know I've thought them through.

After stopping the steroid treatments and without starting the medication, I took Ann's nutrition and supplement suggestions and put them to work. My energy level came back and then some, and I started to feel like my healthy self again. The feeling slowly returned to my body. My balance came back and my eyesight went back to normal. I also started to feel confident that I had made the correct decision. Just changing my diet and noticing what was going on with my body more I came to realize that I could heal myself from this disease.

I also started working with Ann on emotional situations that we felt were hindering my healing. After some work—and yes, it was a lot of work—I was able start letting go of emotional baggage that I had been carrying around for years. I had a lot of insecurities and fear that added to dealing with this dreaded disease. I had lived my life trying to please everyone, and being diagnosed with MS was my wake-up call that it was time to take care of me.

Ann was instrumental in teaching me how to do this, and she was also a fantastic support system when I had lapses. It was never "You have to do this" with Ann. It was always, "When your time is right you'll see that this is what you need to do." And she couldn't have made me more comfortable during my growing pains.

At her suggestion, I also started doing yoga, and I'm now working on my third teacher's certification. I wanted to start working with other people who have MS. Ann has given me so much, and the least I can do is pass on the knowledge and support that she has given me throughout the years.

*Outcome:* Leanne is symptom-free and has had no further attacks. She is currently taking no pharmaceutical medications for MS.

*Asher*

**BACKGROUND:** chicken pox, pneumonia, stressful childhood, cravings for sugar and carbohydrates

**SYMPTOMS UPON VISIT:** fatigue, decreased sex drive, numbness, tingling, muscle weakness and paralysis, constipation, cold hands and feet, headaches, urinary frequency and incontinence, slurred speech, difficulty walking

**PHARMACEUTICALS TAKEN FOR MS:** interferon, steroids

**ANTIBIOTICS:** twenty-five rounds (lifetime)

I walked into Ann's office frightened and desperate. Only a couple of weeks earlier, I had been diagnosed as an MS patient after my first attack of double vision and numbness and tingling at age forty.

The doctor didn't even look me in the eye when she informed me that MS was a chronic disease, and that the way things looked I need to expect to need a wheelchair three to four years down the road. She also said the only thing she could do for me was put me on corticosteroids and interferon. From that point on, things quickly deteriorated. I felt fatigue, my sight and speech were impaired, I felt numbness in the tips of the fingers on my left hand, and walking more than a hundred yards was impossible.

My first visit to Ann was a very different story. She took the time to really understand the root of the problem. She was genuinely interested in me, and she was compassionate yet straight and direct.

Three years later, things look very different. From being a "steroids and interferon junkie," I've returned to leading a vital and productive life. I wake up each morning happy and grateful to be alive. The combination of new eating habits, supplements, swimming, and the transformation of old behavioral and emotional habits have put me back on my feet.

Through Ann's coaching, I've come to understand that there's no such thing as a chronic disease. There are only chronic habits.

Yes, of course there were moments during the journey when I felt despair and thought, "Things will never be the same again." After a few days of fatigue, I became aware that a part of me still didn't trust that healing would ever occur. "Don't panic," Ann said. "The body will continue to make adjustments." And so it did.

As I kept doing what Ann recommended, I kept making slow but steady progress. Three years later, I know for a fact that Ann's approach works. Even my taste buds have transformed, and I've lost fourteen pounds! My skin is transformed. I never catch a cold or a flu. People keep telling me how great I look. I'm doing amazingly well. I'm positive, calm, and happy, and I know the disease will never come back. I've come to view the slight damage that the MS attacks left as no more than a scar, not an open wound. And the old habits? I'll never be able to revert to them again.

I can't find the appropriate words to express my gratitude for what Ann's guidance has given me. She helped me to achieve a victory over the past by understanding that it was the negative emotions that had damaged me. I fell in love again, with life and with my wife. I've learned to love myself. I remain ever so grateful, Ann, for your guidance and coaching.

*Outcome:* Asher went on my program and improved greatly in a short time. All his symptoms are gone and he is in remission. Asher currently takes no pharmaceutical medications for MS.

## Heidi

**BACKGROUND:** chicken pox, sugar cravings, high periods of stress, period of alcohol and drug intake, smoked for ten years

**SYMPTOMS UPON VISIT:** debilitating fatigue, shortness of breath, constipation, depression, food intolerances, headaches, insomnia, blurred vision, earaches, acne, nausea, bloating, gas, poor memory and concentration, lack of coordination, mood swings, speech difficulties, numbness, tingling, PMS, dizziness

**PHARMACEUTICALS TAKEN FOR MS:** Avonex (bad reaction)

**ANTIBIOTICS:** twenty-five rounds (lifetime)

I had attended Interlochen Arts Academy, where I was co-principal clarinet, and I spent two summers sitting first chair in the World Youth Symphony Orchestra. I practiced five hours a day and spent an additional five hours in rehearsals. I ate, slept, and breathed music. My professors told me I would be playing in a symphony orchestra. It was only a matter of time. While in college, I had lots of paid gigs playing with local studio musicians and in local youth orchestras in a professional capacity. After earning my Bachelor of Fine Arts degree, I traveled to Germany, where I had won a scholarship to study music for one year. Upon returning home, I began working on my Master of Fine Arts degree. That's when the trouble started.

In 1991, when I was twenty-four years old, I began experiencing symptoms that any musician would find very frightening. Out of nowhere, I would lose my grip—unable to control my fin-

gers in any reliable way. I dropped my clarinet several times. Panicked, I went immediately to see a doctor who referred me to a specialist. The neurologist performed lots of tests and poked and prodded my fingertips, but in the end said there was nothing wrong with me and that the weakness that I was feeling was basically just in my head. I was pissed. I tried other doctors, but no one had answers. Before long, I couldn't play at anywhere near my potential, and I dropped out of school.

Somewhere in the middle of all this, I met my first husband, got married, and had a son. It all happened very fast, but I was lost without being able to play my instrument, and I wasn't thinking clearly at all. It was a terrible marriage to an abusive alcoholic. I spent my days working ungodly long hours in our music preparation business. To make matters worse, after I finally got up the courage to leave him, I dove into a rebound relationship with another alcoholic. I figured I was going in the right direction because at least he was a peaceful man. Still, nothing good came of that, except my beautiful daughter. My ex-husband had debts I didn't learn about until the divorce, and after spending the last of my money, I ended up in bankruptcy right along with him.

Somewhere around May 1995, I finally quit trying to do things my way. I decided to let it all go and allow the universe to guide me. Before all this negativity started, I had been an extremely sensitive and intuitive person, and I was feeling the need to reacquaint myself with those qualities. I moved back home with my parents, went back to school, got a degree in accounting (graduating with honors), and passed the CPA exam on the first try. To earn money, I taught clarinet lessons.

To make this transformation, I had to realize that no one had control over me—especially not my ex-husband, who told me I could never become a CPA. I was a smart, driven individual, but I really needed to work on the self-esteem.

By March 2000, I was finally able to afford my own place. I paid cash for a mobile home and was struggling to save money for a real house some day. I had moved on and accepted that I wouldn't be playing my instrument in the capacity I had hoped. My kids were happy, and I was happy, although very, very tired. Working full time and being a single parent really took it out of me. I went to bed really early and slept a lot on the weekends.

Then, in September 2000, I had a pronounced attack. This wasn't just the inability to move my fingers. It affected both feet, both hands, and parts of my stomach and back. After my 1991 experience, I was through with Western medicine, and I went to see a friend's chiropractor who leaned toward holistic treatment. He performed some muscle tests and immediately said he believed it was MS. I was relieved! I had been thinking it was a brain tumor. Wow! Finally an answer!

My friends encouraged me to get an MD's opinion, so I went in for some tests. The MRIs revealed lesions on my neck and in my brain. The specialist confirmed the diagnosis and told me there was no cure, but he could put me on medicine that would slow the progression. I agreed to try it and started giving myself shots in the thigh once a week. However, I hate needles, and the side effects were worse than anything I could have imagined. Each time I took the medicine, I felt as if I had the flu for three or four days. My quality of life was deteriorating rapidly. Before the diagnosis, I had been fairly athletic and had been training for a hike up Mount Whitney. The specialist told me that I should not exert myself and advised me to quit training. Depressed and feeling like shit, I started packing on the pounds.

Once again I turned to a higher source for help. I am very fond of Wayne Dyer's work and I started trying his meditations for manifesting. I visualized a healthy, happy me and asked for some answers. Once I got the hang of the meditation, interesting things began happening. Through a series of "coincidences"

(I don't really believe there are such things), I read about Ann Boroch and how she had cured herself of MS.

I had no doubt that I was on the right track now. When you know, you know. Ann put me on a radically different diet and vitamin regimen and things began to change. Over the next few months I went from a size sixteen to a size eight. My energy soared. I could think more clearly. You couldn't keep me down. I've always been a determined, strong-willed individual, but know I really knew there was nothing I couldn't do.

I've also worked with some wonderful folks at Yonemoto Physical Therapy. Their methods involve using Integrated Manual Therapy (IMT) and Neural Facial Processing (NFP), which encourage your body to help itself heal.

Keeping a positive attitude, using positive self-talk, and regular meditation have helped me attract the most incredible people into my life. When you're in tune with the universe, life is so much easier... magical things happen all the time. Today I'm married to a wonderful man who's working on adopting my children. I've moved to another state where the cost of living allows me to be a stay-at-home mom. Life is very, very fine indeed.

*Outcome:* Heidi has been free from attacks for three years. She's symptom-free except for a slight tingling in her fingertips when the weather is hot. She currently takes no pharmaceutical medications for MS.

## Jami

**BACKGROUND:** mercury fillings removed, craved breads and sugar

**SYMPTOMS UPON VISIT:** fatigue, insomnia, stress, depression, allergies and sinus problems, gait difficulties

**PHARMACEUTICALS TAKEN FOR MS:** Copaxone, Avonex, steroids, Decadron, Acthar

**ANTIBIOTICS:** five to seven rounds (lifetime)

When I was about fourteen, I lost my eyesight for a short time. It began with double vision and then my vision went black. This passed after a couple of days. Then, a few months later, I had come home from school to get ready for my ballet class and as I was putting on my tights my legs went out from under me. I tried to stand up and they went again. My mother called a friend who was a doctor and he had me admitted immediately. He ran a spinal tap and blood test. The results led him to suspect MS. I was only fifteen years old, and paralyzed from the waist down. But I got better within two weeks and was sent home.

A month later I woke up one morning and couldn't move from the neck down. I had no feeling at all. My mother's friend sent me to Gerard Lehrer, a doctor at Mount Sinai in New York who was researching MS. They did all kinds of tests on me, but it was the hot tub test (heats up the internal core of the body) that confirmed their suspicions. There I was, totally paralyzed from the neck down. I had been voted captain of the cheering squad that year and was embarking on a career as a dancer in New York.

Lehrer confirmed that it was MS and began a treatment he had developed. First, I was given a spinal tap and the medication was injected into my spine. I had to hang over the side of the bed for ten minutes and then lie flat for the remainder of the night. Over about a five-year period, I had thirteen of these injections. They got easier to tolerate, plus they gave me the ability to walk again. I also took Prednisone, Decadron, and Acthar intermittently. When I moved to California, I began to wean myself off of the medications.

I was off medication for about ten years until I met a doctor from Cedars-Sinai who eventually put me on Copaxone. I did fine on it except for the anxiety of having to inject myself, until one

night when I began to get dizzy and tired after the injection. I tried to get back to my bed but never made it. I blacked out, and when the paramedics arrived I had no vital signs. My heart had stopped beating and I nearly died. Needless to say, my doctor and I agreed that I wasn't going to take this medication anymore.

He later suggested to me that I try Avonex because I was getting older and needed to be on something. I tried it and it made me so sick every day I injected myself that I could no longer do it. I think I developed some kind of phobia, so my boyfriend had to do it for me. Once again I had to tell the doctor that I couldn't take being sick for two days out of every week because of the medication, so I stopped. That was when I started seeing Ann.

*Outcome:* Jami started my program and has had no further attacks. She's symptom-free with the exception of a slight tingling in her fingertips during extremely hot weather. She currently takes no pharmaceutical medications for MS.

## Terri

**BACKGROUND:** Chicken pox, severe case of mononucleosis, craved breads and salt; diagnosed with MS at age twenty-four; had four attacks a year; during a two-year period she was a quadriplegic for six to nine months and was blind for a period of time

**SYMPTOMS UPON VISIT:** Wheelchair-bound for two years, urinary incontinence, lack of coordination, dizziness, erratic vision, anxiety and depression, numbness, tingling, constipation, bloating, cold hands and feet, fatigue

**PHARMACEUTICALS TAKEN FOR MS:** Chemotherapy (which induced early menopause), Avonex, Trileptal, Bacoflen, Ditropan, Zoloft, monthly steroids

**ANTIBIOTICS:** Ten rounds (lifetime, plus daily doses for one year for urinary tract infections after having MS)

When Terri came to see me in October 2003, she was thirty-two and in a wheelchair. She changed her diet and began detoxifying her body by taking antifungal herbs and then Nystatin along with other supplements and herbs to help regenerate her body. She stayed on her monthly steroids but later began to slowly wean herself from them.

*Outcome:* By the end of December 2003, Terri started to walk intermittently with the use of a walker and then a cane. She continued to improve and by mid-2004 she was out of her wheelchair completely and walking on her own. She has stopped taking monthly steroids, Zoloft, Avonex, and Baclofen. She continues to take Trileptal.

## Karen

**BACKGROUND:** MS patient who purchased my first small self-help book entitled *How to Cure Multiple Sclerosis.*

It's been a long time since we have had any e-mail correspondence. Although it is long past due I'm sure you never mind hearing success stories. I was recently diagnosed with MS-Benign. I have been MS "symptom free" for five years now. Previous to that, I was in bad shape with optic neuritis, dizziness imbalance, numbness, and tremors.

I attribute this mainly to your book. I wanted you to know also, that I have directed many people to your Web site. I am also passionate about sharing my research on the candida link to the cause of MS (and many other illnesses). It's the key!

I am truly grateful to you for writing and sharing this information. Thank you so much.

# CONCLUSION

## WHERE IS THE CURE?

Why does it sound so unreasonable to talk about a "cure" for MS? Maybe because we've been brainwashed by the medical establishment to believe it's not possible.

The dictionary definition of cure is "to bring back to health, treatment intended to relieve or remove disease or any bad condition." (*Merriam Webster's Collegiate Dictionary* (11th Edition) says, "a complete or permanent solution or remedy.") Cures do occur in individuals. I'm one of them. There are cures out in the world for MS, cancer, and even AIDS, but we just don't hear about them because cures would put the pharmaceutical companies out of business. In our country today, despite all our technology and education, greed is a higher priority than health. That's why we're one of the sickest nations in the world.

When it comes to getting well, you have many approaches and methods to choose from. A cure for MS, or any chronic disease, does not come in one pill or one herb. It is a *combination* of protocols that turns the body around. Explore all the options and become educated. Realize there are many factors in getting healthy, and trust what you feel is right and the best course of action for you. That does not mean

ignoring or divorcing yourself from Western medicine. It does mean you need to be discerning and not buy into the word *incurable*. It is only yours if you own it mentally and emotionally.

## THE WINNING SECRET

The secret to changing the cellular function of your body lies in what you believe. Those beliefs then send messages to your central nervous system, which dictate every process in your body. So first make the choice to be healthy. Then claim that belief with conviction and put it into your every thought, feeling, and action. Soon your body will mirror that reflection.

# PART FOUR

~~~~~~

# YOUR
# TREATMENT PLAN

# CANDIDA HEALTH
# QUESTIONNAIRE

This questionnaire will help you and your healthcare practitioner evaluate how *Candida albicans* may be contributing to your health problems, but it won't provide an automatic "yes" or "no" answer. A comprehensive history and physical examination are important. Laboratory studies and other types of tests may also be appropriate.

The questionnaire lists factors in your medical history that promote the growth of *Candida albicans* (Section A) as well as symptoms commonly found in individuals with yeast-connected illness (Sections B and C). For each "yes" answer in Section A, circle the point score in that section. Total your score, and record it in the box at the end of the section. Then move on to Sections B and C, and score as directed.

## SECTION A: History                                    Point Score

1. Have you taken any tetracyclines (Sumycin, Panmycin,          50
   Vibramycin, Minocin, etc.) or other antibiotics for acne
   for one month (or longer)?
2. Have you at any time in your life taken other antibiotics      50
   for respiratory, urinary or other infections for two months
   or longer, or for shorter periods four or more times in a
   one-year span?
3. Have you taken an antibiotic drug—even for one round?           6
4. Have you at any time in your life been bothered by             25
   persistent prostatitis, vaginitis, or other problems
   affecting your reproductive organs?
5. Have you been pregnant two or more times?                       5
   One time?                                                       3
6. Have you taken birth control pills for more than 2 years?      15
   6 months to 2 years?                                            8
7. Have you taken prednisone, Decadron, or other cortisone-       15
   type drugs by mouth or inhalation for more than two weeks?*
8. Does exposure to perfumes, insecticides, fabric shop          15
   odors, or other chemicals provoke moderate to severe
   symptoms?

* This questionnaire is adapted from William G. Crook, *The Yeast Connection Handbook*, Professional Books, 2000. Used with permission.

9.  Are your symptoms worse on damp, muggy days or in        20
    moldy places?
10. Have you had athlete's foot, ringworm, "jock itch" or     20
    other chronic fungus infections of the skin or nails?
        Have such infections been severe or persistent?

11. Do you crave sugar?                                       10
12. Do you crave breads?                                      10
13. Do you crave alcoholic beverages?                         10
14. Does tobacco smoke really bother you?                     10

**Total Score, Section A**                                    _____

\* The use of nasal or bronchial sprays containing cortisone and/or other ste-
roids promotes overgrowth in the respiratory tract.

### SECTION B: Major Symptoms

For each symptom you experience, enter the appropriate number in the
point score column:
    If a symptom is occasional or mild                score 3 points
    If a symptom is frequent and/or moderately severe    score 6 points
    If a symptom is severe and/or disabling          score 9 points
Total the score and record it at the end of this section.

|  | **Point Score** |
|---|---|
| 1.  Fatigue or lethargy | _____ |
| 2.  Feeling "drained" | _____ |
| 3.  Poor memory | _____ |
| 4.  Feeling "spacey" or "unreal" | _____ |
| 5.  Inability to make decisions | _____ |
| 6.  Numbness, burning, or tingling | _____ |
| 7.  Insomnia | _____ |
| 8.  Muscle aches | _____ |
| 9.  Muscle weakness or paralysis | _____ |
| 10. Pain and/or swelling in joints | _____ |
| 11. Abdominal pain | _____ |
| 12. Constipation | _____ |
| 13. Diarrhea | _____ |
| 14. Bloating, belching, or intestinal gas | _____ |
| 15. Troublesome vaginal burning, itching or discharge | _____ |
| 16. Prostatitis | _____ |
| 17. Impotence | _____ |
| 18. Loss of sexual desire or feeling | _____ |
| 19. Endometriosis or infertility | _____ |
| 20. Cramps and/or other menstrual irregularities | _____ |
| 21. Premenstrual tension | _____ |
| 22. Attacks of anxiety or crying | _____ |
| 23. Cold hands or feet and/or chilliness | _____ |
| 24. Shaking or irritability when hungry | _____ |

**Total Score, Section B**                                    _____

**SECTION C: Other Symptoms***

For each symptom you experience, enter the appropriate number in the point score column:

| | |
|---|---|
| If a symptom is occasional or mild | score 3 points |
| If a symptom is frequent and/or moderately severe | score 6 points |
| If a symptom is severe and/or disabling | score 9 points |

Total the score and record it at the end of this section.

**Point Score**

1. Drowsiness
2. Irritability or jitteriness
3. Lack of coordination
4. Inability to concentrate
5. Frequent mood swings
6. Headaches
7. Dizziness and/or loss of balance
8. Pressure above ears or feeling of head swelling
9. Tendency to bruise easily
10. Chronic rashes or itching
11. Psoriasis or recurrent hives
12. Indigestion or heartburn
13. Food sensitivities or intolerances
14. Mucus in stools
15. Rectal itching
16. Dry mouth or throat
17. Rash or blisters in mouth
18. Bad breath
19. Foot, hair, or body odor not relieved by washing
20. Nasal congestion or postnasal drip
21. Nasal itching
22. Sore throat
23. Laryngitis or loss of voice
24. Cough or recurrent bronchitis
25. Pain or tightness in chest
26. Wheezing or shortness of breath
27. Urinary frequency, urgency, or incontinence
28. Burning on urination
29. Erratic vision or spots in front of eyes
30. Burning or tearing of eyes
31. Recurrent infections or fluid in ears
32. Ear pain or deafness

**Total Score, Section C** _____
**Total Score, Section B** _____
**Total Score, Section A** _____
**Grand Total Score** (Add totals from sections A, B, and C) _____

* Although the symptoms in this section occur commonly in patients with yeast-connected illness, they also occur commonly in patients who do not have candida.

The Grand Total Score will help you and your practitioner decide if your health problems are yeast-connected. Scores for women will run higher because seven items apply exclusively to women, while only two apply exclusively to men.

*Yeast-connected health problems are almost certainly present in women with scores over 180 and in men with scores over 140.

*Yeast-connected health problems are probably present in women with scores over 120 and in men with scores over 90.

*Yeast-connected health problems are possibly present in women with scores over 60 and in men with scores over 40.

*Scores of less than 60 for women and less than 40 for men indicate that yeast are less apt to cause health problems.

# FOODS TO EAT

**Animal protein (antibiotic- and hormone-free as much as possible)**

Beef, buffalo, lamb (grass fed, three- to four-ounce servings once or twice a
month; most people with MS do best avoiding any red meat entirely
because it can increase inflammation; prepare rare to medium rare)
Chicken
Duck
Eggs
Fish (no shellfish)
Turkey

**Oils (cold-pressed only)**

Coconut oil (can be used for cooking)
Flaxseed oil (not for cooking)
Grapeseed oil (can be used for cooking)
Olive oil (can be used for cooking)
Sesame oil (can be used for cooking)
Sunflower-seed oil (not for cooking)

**Note:** At restaurants, eat what is served; be more stringent when using oils
at home.

**Grains (whole and unrefined only)**

Amaranth
Barley*
Breads(wheat*, yeast, sugar, and dairy-free)
Brown rice
Buckwheat
Kamut*
Millet
Oats*
Pasta (brown rice or spelt only)
Quinoa
Rye*
Spelt*

* Avoid barley, kamut, oats, rye, and spelt for three to six months if you are
gluten intolerant.

### Nuts and Seeds (raw and unroasted only)

Almonds
Brazil
Chestnuts
Hazelnuts
Macadamia
Nut butters (almond and macadamia only, can be raw or dry roasted)
Pecans
Pine nuts
Pumpkin seeds and pumpkin seed butter
Sesame seeds (also raw tahini butter)
Sunflower seeds
Walnuts

**Note:** Limit quantity to a small handful at a time, and chew thoroughly.

### Dairy (antibiotic- and hormone-free only)

Butter (small amounts)
Clarified butter (ghee)

### Vegetables

All (except corn, and mushrooms)
Red potatoes, sweet potatoes, and yams (limit to three servings a
week total)

**Note:** Limit or avoid nightshade-family vegetables for the first three months:
eggplant, tomatoes, peppers, and potatoes because these can cause more
inflammation.

### Condiments

Apple cider vinegar (raw, unfiltered only—store in refrigerator)
Dry mustard (or mustard with apple cider vinegar)
Fresh herbs (basil, parsley, etc.)
Mayonnaise (made with apple cider vinegar only)
Pepper
Rice vinegar (unseasoned and unsweetened only—store in refrigerator)
Sea salt
Spices (without sugar, MSG, or additives), favor ginger and tumeric
(anti-inflammatory)

### Beverages

Herbal teas (red clover, peppermint, green, etc.)
Unsweetened almond milk; rice or soy (not more than two ounces at a time)
Unsweetened mineral water (Gerolsteiner)
Water (filtered, purified, or distilled only)
Fresh coconut water

### Beans and Legumes

All (except peas and fermented soy products)

**Note:** You may need to avoid this group entirely for two to three months
because of allergic reactions and high starch levels that raise blood sugar.

## Miscellaneous

Carob (unsweetened)
Salsa (without sugar or vinegar, except apple cider vinegar)

## Fruits

Apples (green only for the first month)
Avocado
Blueberries (discard if you see any visible mold)
Coconut (small amounts of milk, unsweetened)
Lemons, limes

**Note:** Limit fruit intake to one piece per day, about the size of a medium apple in volume. Avocado serving and lemon or lime juice can be additional to your one fruit per day.

## Sweeteners

Stevia
Xylitol (only in small amounts such as mints or lozenges)

# FOODS TO AVOID

After three months you can return the starred (*) foods to your diet. Add one food every third day and see if your body reacts, i.e., rapid heart beat, itching, bloat and gas, constipation, fatigue, or worsening of your MS symptoms. If so, keep these foods out of your diet for another three months and try again.

**Animal protein**

Bacon (except turkey bacon without nitrates and hormones)
Hotdogs (except chicken or turkey hotdog without nitrates and hormones)
Processed and packaged meats
Sausages (except chicken and turkey without added sugar, hormones, and nitrates)
Shellfish
Tuna, canned

**Vegetables**

Corn*
Mushrooms

**Dairy**

Cheeses, all including cottage and cream cheese
Buttermilk
Cow's milk
Goat's milk and cheese(raw)*
Ice cream
Margarine
Sour cream
Yogurt

**Condiments**

Catsup
Gravy
Jams and jellies
Mayonnaise (unless made with apple cider vinegar)
Mustard (unless made with apple cider vinegar)
Pickles
Relish
Salad dressing (unless made with apple cider or rice vinegar, and sugar-free)
Sauces with vinegars and sugar
Soy sauce and tamari sauce

Spices that contain yeast, sugar, or additives
Vinegars, all (except raw, unfiltered apple cider and unsweetened rice vinegar)
Worcestershire sauce

### Beans and Legumes

Fermented soy products (miso, tempeh, etc.). Many people are allergic
   to all soy products, so it may be best to avoid them altogether.
Peas*

## Oils

Canola oil (small amounts okay)
Corn oil
Cottonseed oil
Partially hydrogenated or hydrogenated oils
Peanut oil
Soy oil

### Nuts and Seeds

Cashews*
Peanuts, peanut butter
Pistachios*

## Grains

Breads (except wheat-*, dairy-, yeast-, and sugar-free)
Cereals (except wheat-*, dairy-, and sugar-free)
Corn* (tortillas and polenta)
Crackers (wheat* and/or white flour)
Kamut*
Pasta (except brown rice and spelt)
Pastries
Tapioca
White flours
White rice
Whole wheat*

## Miscellaneous

Candy
Chocolate
Coffee
Cookies
Donuts
Fast food and fried foods
Gelatin
Gum (unless sweetened with stevia or xylitol)
Lozenges/mints (unless sweetened with stevia or xylitol)
Muffins
Pastry
Pizza
Processed food (T.V. dinner, etc.)
Smoked, dried, pickled, or cured foods

**Beverages**

Alcohol
Caffeinated teas (except green tea)
Coffee (caffeinated and decaffeinated)
Fruit juices
Sodas (diet and regular)

**Fruits**

Apricots*
Bananas*
Berries* (all except blueberries)
Cherries*
Citrus* (all except lemons or limes)
Dried fruits (all apricots, dates, figs, raisins, cranberries, prunes, etc.)
Guava*
Grapes
Juices (all sweetened or unsweetened)
Mangos*
Melons*
Nectarines*
Papayas*
Peaches*
Pears*
Plums*
Persimmon*
Pomegranates*

**Sweeteners**

Agave nectar*
Artificial sweeteners (such as aspartame, Nutrasweet, maltitol, mannitol, saccharin, sorbitol, and sucralose (Splenda)
Barley malt
Brown rice syrup
Corn syrup
Dextrose
Fructose, products sweetened with fruit juice
Honey (raw* or processed). Raw honey can be used medicinally (See Energy Boosters, page 261).
Maltodextrin
Maple syrup
Molasses
Raw or evaporated cane juice crystals
White sugar

# FIVE-WEEK NUTRITIONAL MAKEOVER

Modifying your diet to get healthy can be a challenge. To be successful, it helps if you understand that these dietary changes are not about deprivation—they represent lifestyle changes that are based on what you now know you must do to detoxify and rebuild your body and your health. If you have a "bad" day and eat something that isn't on your plan, don't beat yourself up. Just get back on track and keep going. If you let guilt take over, you'll only go on eating more foods that aren't on your list.

**Week One**
Eliminate dairy products
(Less dairy = Less mucus and inflammation)

Check items off as you eliminate them

Check Off

Buttermilk
Cheese (soft and hard)
Cottage cheese
Cow and goat's milk (nonfat, low fat, low lactose)
Goat's cheese (raw*)
Ice cream
Margarine
Milk shakes

* Avoid for the first three months.

Protein drinks, powders, or bars that contain
  cow dairy ingredients
Sour cream
Yogurt

## Week Two
### Eliminate refined carbohydrates
(Fewer refined carbohydrates = Less inflammation and plaque)

Check items off as you eliminate them

Check Off

Bagels
Breads with yeast (sourdough, white, buns, rolls)
Cereals (dry)
Cookies
Corn*
Crackers (wheat* and white flour)
Donuts
Flour tortillas
Pasta (brown rice and spelt pasta are
  permitted twice a week)
Pastries
Pizza
Tapioca
White rice
Whole wheat products*

* Avoid for the first three months.

**Week Three**
Eliminate sugar
(Less sugar = Less plaque, pain, inflammation,
and progression of MS)

Check items off as you eliminate them

Check Off

Agave nectar*
Artificial sweeteners (aspartame, maltitol,
    mannitol, saccharin, sorbitol, Splenda)
Barley malt
Brown rice syrup
Brown sugar
Cakes, candy, cereals, chewing gum/lozenges
    (except with xylitol), chocolate, cookies,
    donuts, ice cream, Jello and gelatins,
    pastries, pies, puddings, soda
Corn syrup
Dextrose
Fruit-juice sweetened products
Fructose
Honey (raw* or processed)
Maltodextrin
Maple syrup
Molasses
Sucanat, evaporated cane juice crystals,
    raw turbinado sugar
Sucralose
White sugar

* Avoid for the first three months.

**Week Four**
Eliminate miscellaneous foods
(Avoiding chemicals = Less stress on
your body to remove toxins)

Check items off as you eliminate them

Check Off

Alcohol (even nonalcoholic beers,
   because of their yeast content)
Cashews*
Coffee (caffeinated and decaffeinated)
Condiments (ketchup, relish, pickles,
   soy sauce, jams, jellies, etc.)
Hydrogenated oils in any food product
   (chips, margarine, breads, etc.)
Mushrooms
Peanuts
Peas*
Pistachios*
All fast foods (hamburgers with buns,
   fried foods, burritos, sandwiches, pizza, etc.)
All fermented foods (miso, tempeh)
All processed foods (TV dinners, bacon,
   beef jerky, bologna, pork sausage, etc.)
All smoked, cured, dried, and pickled
   foods (bacon, bologna, smoked salmon)
Soft drinks and sodas
Cigarettes and recreational drugs

* Avoid for the first three months.

**Week Five**
Eliminate fruit
(Less sugar = Less plaque, pain, and inflammation)

Check off items as you eliminate them.

Check Off

All berries (except blueberries)*
All citrus fruits (except lemons and limes)*
All dried fruits (cranberries, dates, figs,
   raisins, prunes, etc.)
All fruit juices (sweetened and unsweetened)
All melons*
Apricots*
Bananas*
Cherries*
Guava*
Grapes
Mangoes*
Nectarines*
Papayas*
Plums*
Peaches*
Pears*
Persimmon*
Pomegranates*

* Avoid for the first three months.

# CANDIDA DIET MEAL IDEAS

## Breakfast

- Eggs (scrambled, hard-boiled, sunny side up, poached)
- Omelets with vegetables (avocado, spinach, and onion)
- Hot cereal (oatmeal, brown rice, rye flakes, amaranth, or quinoa) with nuts, splash of almond or rice milk, cinnamon, and stevia
- Turkey patties, chicken sausage (without sugars, preservatives, hormones, or pork casings)
- Protein drink with egg-white, goat, or rice protein powder (no sugars)—see Recommended Products (page 243) Make with water, add almond milk if desired, and add your one piece of fruit from your list. Add nuts and seeds to balance out the insulin spike from the carbohydrates
- Diced sweet potatoes with onions
- Vegetable Alkalizer juice, made with organic veggies: 8 ounces of fresh-squeezed juice: 3 stalks celery, ½ apple, ½ small carrot, 4–5 handfuls spinach, watercress, black kale, dandelion greens, *and/or* parsley. Drink on an empty stomach (1 hour before eating or 2 hours after a meal). Add one clove of garlic *and/or* a 1-inch piece of fresh ginger root if desired
- Wheat-free waffles or pancakes with stevia, almond milk, and cinnamon
- Wheat- and yeast-free bread with nut butters or butter
- Sweet potato pancakes

- Brocoli quiche with spelt flour
- Leftover dinner from the night before

## Lunch and Dinner

- Salads (spinach, arugula, baby greens, onions, sprouts, carrots, jicama, nuts, green apple, etc.)
- Brown rice and steamed or sautéed vegetables
- Buckwheat soba noodles in a stir-fry or sautéed with vegetables, tofu, or chicken
- Turkey burger with baked sweet potato fries
- Broiled, poached, or sautéed fish (salmon, halibut, trout, etc.) and vegetables
- Baked yam with vegetables
- Chicken salad on a half an avocado
- Stews
- Soups, non-dairy and sugar-free (chicken, turkey, leek and potato, carrot-celery-ginger, lentil, adzuki, mung bean, vegetable)
- Brown rice or spelt pasta with olive oil and garlic, fresh tomatoes, and other vegetables if desired
- Turkey chili
- Quinoa with vegetables
- Chicken or turkey tacos in spelt or brown rice tortillas with guacamole, salsa, and lettuce
- Chicken (broiled, roasted, baked, poached)
- Lamb or beef steak with onions with sautéed asparagus
- Vegetable stir-fry with or without chicken (use cold-pressed sesame oil)
- Turkey dogs (no nitrates or sugar or dairy) with oven-baked turnip fries
- Turkey or chicken sandwich on wheat-, yeast-, dairy-, and sugar-free bread

- Egg salad sandwich on wheat-, yeast-, dairy-, and sugar-free bread (use mayonnaise with apple cider vinegar)
- Cornish hen stuffed with wild rice
- Cabbage rolls stuffed with pumpkin and brown rice

### Side Dishes

- Cabbage salad
- Sautéed collard greens or black kale with olive oil and raw apple cider vinegar
- Adzuki or mung beans
- Sliced cucumbers with rice vinegar and sea salt
- Wild rice pilaf
- Mashed sweet potatoes with milk (substitute almond milk for regular milk) and olive oil
- Artichokes with melted butter or apple cider mayonnaise
- Sautéed onions and squashes
- Cold brown rice salad with raw apple cider vinegar, vegetables, and seasonings
- Sweet potatoes or yams with butter
- Sautéed asparagus with toasted sesame seeds and sesame oil
- Baked butternut squash with small amount of butter and stevia
- Quinoa with seasonings and spices
- Millet with herbs and olive oil or tomato sauce
- Broccoli and olive oil
- Barley with butter
- Green beans sautéed with olive oil and spices
- Sautéed onions with butter
- Oven baked turnip fries with olive oil
- Brown basmati rice with pine nuts or sliced almonds in olive and cumin

- Fresh sprouts (broccoli, alfalfa, radish, sunflower), with fresh lemon or raw apple cider vinegar

## Snacks and Desserts

- Wheat-, yeast-, dairy-, and sugar-free bread with almond butter or sesame seed tahini, drop of stevia and cinnamon
- Hard-boiled egg
- Brown rice cakes or rice crackers with almond, macadamia, or pumpkin seed butter
- Cut-up vegetables (carrot sticks, jicama, green beans)
- Hummus dip with Wasa light rye crackers
- Celery with almond, macadamia nut butter, or pumpkin seed butter
- Fruit, 1 piece
- Baked apple with cinnamon and nuts
- Carob brownies (look in recipe books or internet and use wheat-free whole-grain flours and stevia)
- Cookies and treats made without wheat, dairy, or refined sugars (use stevia or nut butter)
- Egg white protein powder (Jay Robb, vanilla), 6 oz. almond milk (unsweetened), handful of blueberries, dash of cinnamon, and drop of vanilla—blend.

## Sauces/Seasonings

- Salsa with no vinegar (except raw apple cider) or sugar
- Guacamole (avocados, tomatoes, onion, and spices)
- Cold-pressed sesame seed oil with ginger and garlic
- Olive oil, garlic, and lemon (good over wheat-free pasta)
- Fresh-squeezed lemon and lime juice
- Bragg's amino acids (unfermented soy sauce; salty flavor is good for stir-frys)

- Italian dressing: 3 tbsp raw, unfiltered apple cider vinegar, 4 tbsp olive oil or flaxseed oil, 3 tbsp fresh lemon juice, 2–3 drops stevia, and seasonings—fresh garlic or garlic powder, oregano, rosemary, thyme, basil, sea salt, pepper, pinch of cayenne—as desired. Keep refrigerated.
- Unsweetened orange or pineapple juice as a marinade for fish or chicken
- Seaweed flakes
- Curry (coconut milk, tumeric, cumin, ginger and garlic paste)
- Macadamia cream sauce (15 raw macadamias, $\frac{1}{2}$ tsp sea salt, $\frac{1}{2}$ fresh lemon juice, $\frac{1}{4}$ cup basil, 1 garlic clove—blend)
- Spices—cayenne, tumeric, ginger, cumin, epozote, corriander, curry, cinnamon, bay leaves, and basil

# Two Weeks of Sample Menus

The starred (*) dishes are included in the recipe section, which also includes recipes not listed in these sample menus.

## WEEK ONE
### Day One

| | |
|---|---|
| Upon arising | 2 cups of red clover tea |
| Breakfast | Omelet with vegetables (onions, spinach, avocado) |
| Snack | Apple (green) with a small handful of raw almonds |
| Lunch | Sesame Millet* with No-cheese Pesto* |
| | Broccoli with Sliced Almonds* |
| Snack | Celery sticks with macadamia butter |
| | 2 cups of red clover tea |
| Dinner | Salmon with dill-lemon juice |
| | Baby greens salad with Italian Vinaigrette Dressing* |

## Day Two

| | |
|---|---|
| Upon arising | 2 cups of red clover tea |
| Breakfast | Turkey scramble with onions and diced squashes |
| Snack | Blueberries with small handful of pumpkin seeds |
| Lunch | Seared halibut salad with Wasabi–ginger Dressing* |
| Snack | Jicama slices |
| | 2 cups of red clover tea |
| Dinner | Brown rice and vegetable stir-fry |

## Day Three

| | |
|---|---|
| Upon arising | 2 cups of red clover tea |
| Breakfast | Poached eggs with spelt or rye bread (yeast free) toasted with butter |
| Snack | Raw vegetables (broccoli, carrots, jicama, green beans) with Zesty Tahini Sauce* |
| Lunch | African Style Turkey* |
| | Spinach, red onion, and sprout salad with Italian Vinaigrette Dressing* |
| Snack | Handful of Spicy Almonds* |
| | 2 cups of red clover tea |
| Dinner | Spelt pasta with garlic, basil, lemon, and vegetables |

## Day Four

| | |
|---|---|
| Upon arising | 2 cups of red clover tea |
| Breakfast | Cinnamon Oatmeal* |
| | 1 tbsp ground flaxseed, and a splash of almond milk |
| Snack | Hard boiled egg |
| Lunch | Chicken fajitas with vegetables, guacamole, salsa on a brown rice tortilla |
| Snack | Olive Tapenade* on brown rice crackers |
| | 2 cups of red clover tea |
| Dinner | Vegetable soup with quinoa |

## Day Five

| | |
|---|---|
| Upon arising | 2 cups of red clover tea |
| Breakfast | Egg sandwich (cooked egg on yeast-free spelt or rye bread with mayonnaise, spinach leaves, sprouts, and avocado) |
| Snack | Sunflower seeds (small handful, raw or dry-roasted) |
| | 2 cups of red clover tea |
| Lunch | Halibut with Macadamia Nut Sauce* |
| | Oven-baked yam fries with olive oil |
| | Sautéed black kale *and/or* collard greens |
| Snack | Vegetable Alkalizer Juice* (8 ounces) |

Dinner                              Indian Risotto*
                                    Arugula, Beet, and Walnut
                                        Salad*

## Day Six

Upon arising                        2 cups of red clover tea
Breakfast                           Vegetable scramble with
                                        squash, mustard greens,
                                        chives, and sweet potato
Snack                               Brown rice cakes with
                                        almond butter
Lunch                               Quinoa Medley*
                                    Cucumber Salad*
Snack                               Green apple
                                    2 cups of red clover tea
Dinner                              Tuscan Roast Chicken*
                                    Artichoke* with butter
                                        or mayonnaise
Dessert                             Carob Chip Cookies*

## Day Seven

Upon arising                        2 cups of red clover tea
Breakfast                           Buckwheat Blueberry Pancakes*
Lunch                               Ground turkey burger
                                        (with mustard, onion, baby
                                        greens, avocado, and
                                        sautéed onion, wrapped
                                        in lettuce leaf)
                                    Sliced carrots

| | |
|---|---|
| Snack | Rye bread (yeast-free) toasted with tahini and a drop of stevia and cinnamon |
| | 2 cups of red clover tea |
| Dinner | Cornish Game Hen* stuffed with wild rice |
| | Brussels sprouts and carrots with butter |
| Dessert | Baked Apple* with cinnamon |

## Week Two
### Day One

| | |
|---|---|
| Upon arising | 2 cups of red clover tea |
| Breakfast | Vegetable Alkalizer* (8 ounces) |
| Snack | Hummus and brown rice crackers |
| Lunch | Grilled asparagus with toasted sesame seeds |
| | Salmon and Ginger Wasabi Dressing* |
| | Citrus soda* |
| Snack | Half an avocado with a sprinkle of sea salt |
| | 2 cups of red clover tea |
| Dinner | Quinoa Burger* |
| | Asian Coleslaw* |

### Day Two

| | |
|---|---|
| Upon arising | 2 cups of red clover tea |
| Breakfast | Rice Almond Pancakes* |
| Snack | Green apple |

| | |
|---|---|
| Lunch | Chicken Soup* |
| Snack | Celery and carrot sticks |
| | 2 cups of red clover tea |
| Dinner | Fish Curry* over basmati |
| | brown rice |
| | Marinated Kale Salad* |

## Day Three

| | |
|---|---|
| Upon arising | 2 cups of red clover tea |
| Breakfast | Scrambled eggs with |
| | vegetables |
| Snack | Cucumber slices and sprouts |
| | with apple cider vinegar |
| Lunch | Cabbage Roll* |
| Snack | Pumpkin seeds |
| | (small handful) |
| | 2 cups of red clover tea |
| Dinner | Brown rice penne with |
| | pine nuts and vegetables |

## Day Four

| | |
|---|---|
| Upon arising | 2 cups of red clover tea |
| Breakfast | Hash (ground turkey and |
| | diced red potatoes) |
| Snack | Brown rice crackers with |
| | pumpkin seed butter |
| Lunch | Egg salad sandwich on |
| | yeast-free spelt or rye bread |
| Snack | Blueberries with small |
| | handful of walnuts |
| | 2 cups of red clover tea |

| Dinner | Roast Duckling* |
|--------|-----------------|
|        | Leek and Leaves* |

## Day Five

| Upon arising | 2 cups of red clover tea |
|--------------|--------------------------|
| Breakfast    | Tahini Toast* |
| Snack        | Handful of Spicy Almonds* |
| Lunch        | Chicken tacos and guacamole on spelt tortillas |
| Snack        | Blueberries and a small handful of pecans |
|              | 2 cups of red clover tea |
| Dinner       | Cod with Olive Tapenade* |
|              | Sautéed zucchini with garlic and olive oil |
|              | Half a baked yam |

## Day Six

| Upon arising | 2 cups of red clover tea |
|--------------|--------------------------|
| Breakfast    | Ground chicken with vegetables |
| Snack        | Jicama with Ranch Dressing* |
| Lunch        | Wild rice pilaf and turkey sausage |
| Snack        | Blueberry Buckle Shake* |
|              | 2 cups of red clover tea |
| Dinner       | Buckwheat Soba Noodles* with vegetables |
| Dessert      | Oatmeal cookies (made with stevia) |

## Day Seven

| | |
|---|---|
| Upon arising | 2 cups of red clover tea |
| Breakfast | Goatein, hemp, or egg white protein shake with Almond Milk* with blueberries and stevia |
| Snack | Rye crackers with almond butter |
| Lunch | Nutty Brown Rice* |
| | Sautéed asparagus |
| Snack | Spicy Walnuts* (small handful) |
| | 2 cups of red clover tea |
| Dinner | Chicken salad on half an avocado |
| Dessert | Baked apple with cinnamon |

# RECIPES

Some of these recipe ingredients may be added to your diet after three months of adhering strictly to the Foods to Avoid list. Use this information as a reference. Special thanks go to Julie Jones-Ufkes for her recipe contributions.

## DRINKS

### Chai Latte

Decaffeinated chai tea (hot or cold)
Splash of unsweetened almond milk

### Citrus Soda

Mineral water
Fresh wedge of lemon or lime
1 drop stevia liquid

### Ginger Ale

3½ cups water
¾ cup peeled and chopped ginger root
2 tbsp vanilla
1 tbsp lemon extract
¾ tsp stevia powder
Sparkling mineral water (Gerolsteiner)

Rapidly boil ginger root in water for ten minutes. Strain and place liquid in a jar. Stir in vanilla, lemon, and stevia. Cool

and store in the refrigerator. Add sparkling mineral water to desired concentration when serving.

### Vegetable Alkalizer (juice)

  3  stalks celery
$^1\!/_2$  small carrot
$^1\!/_2$  apple, green (no seeds)
4–5  large handfuls of raw spinach, watercress, black kale, dandelion greens *and/or* parsley
  1  clove peeled garlic *and/or* 1-inch slice of ginger (optional)

Place ingredients in a vegetable juice extractor and drink immediately on an empty stomach or two hours after a meal.

### Lemon Poppy Seed Shake

  2  oz coconut (not low-fat), almond, or rice milk, unsweetened
  8  oz purified water
$^1\!/_4$  tsp natural lemon extract (alcohol-free)
  1  tsp poppy seeds
  1  tbsp flaxseed oil
  2  scoops Jay Robb vanilla egg-white or Goatein (Garden of Life) protein powder
  2  tbsp nut butter (almond or macadamia)

Put all ingredients into a blender and mix.

### Blueberry Buckle Shake

  2  oz coconut (not low-fat), almond, or rice milk, unsweetened

Handful of fresh or frozen blueberries
1 tsp natural vanilla extract (alcohol-free)
10–15 drops liquid stevia
1 tbsp flaxseed oil
2 scoops Jay Robb vanilla egg white or Hemp (Living Harvest) protein powder
Handful of walnuts *or*
2 tbsp nut butter (almond or macadamia)
1 tsp cinnamon

Put all ingredients into a blender and mix.

### Herbal Teas

Various teas—lavender/mint, roobios, chamomile, oolong
1 drop stevia to sweeten, if desired

### Almond Milk

1 cup blanched almonds
4 cups water (less or more for desired consistency)
⅛ tsp sea salt
1 drop vanilla (optional)
3–4 drops stevia (optional)

Put all ingredients into a blender and mix. Put in glass jar and refrigerate. Will store for 6 days.

## SAUCES

### Italian Vinaigrette Dressing

¾ cup extra virgin olive oil
¼–½ cup of raw, unfiltered apple cider vinegar
2 stalks rosemary sprigs
1 cup fresh basil, chopped
3 garlic cloves, peeled and mashed
1 tsp dry mustard (optional)
1–2 drops of stevia liquid or ¼ tsp stevia powder (optional)

### Ranch Dressing

½ fresh lemon-squeezed
1 tbsp sea salt
1 tbsp fresh or dried chives
1 tbsp fresh or dried rosemary
1 tbsp fresh or dried oregano
1 tbsp fresh or dried sage
1 cup whole raw macadamia nuts
⅓ cup extra virgin olive oil (cold-pressed)

Put all ingredients in blender until smooth. Add water to achieve desired consistency.

### Ginger Wasabi Dressing

1 tbsp ginger, freshly grated
¼ tsp horseradish
¼ cup rice vinegar, unsweetened
1 tsp sea salt

## Zesty Tahini Sauce

1/4 cup of raw tahini
2 drops stevia liquid or 1/4 tsp stevia powder
Pinch of cayenne

## No-Cheese Pesto

3 cups fresh basil
3/4 cup extra-virgin olive oil
1 tsp sea salt
4 garlic cloves, peeled
1/2 cup dry-roasted pine nuts
2 tbsp fresh lemon juice

Combine in blender and serve over vegetables or brown
rice pasta.

## Olive Tapenade

1/2 cup of black olives, pitted and chopped
3 tbsp fresh lemon juice
1 tbsp extra virgin olive oil
1 tsp sea salt
1/4 cup of dry-roasted pine nuts, finely chopped

## Guacamole

1 medium-sized ripe avocado, peeled and pitted
4 tsp fresh lemon juice
1 tsp onion, finely chopped
Sea salt to taste
Fresh cilantro, chopped (optional)

## Salsa

2  cups tomatoes, diced
1  tbsp extra-virgin olive oil
1  medium onion, chopped
1  tbsp fresh lemon juice
1  jalapeno, finely chopped
   Sea salt and pepper to taste

## Tofu "Cheese" Sauce

1/2  pound soft tofu (organic, non GMO)
1  tbsp raw, unfiltered apple cider vinegar
2  garlic cloves, peeled and sliced
1/3  cup raw tahini
1  tsp turmeric
1/4  tsp pepper
1/2  tsp sea salt

Blend ingredients until smooth. Use on vegetables and grains.

## GRAINS

### Rice Almond Pancakes

1 1/2  cups brown rice flour
1/4  cup almond flour
1  egg
1/4  cup almond milk
1/4  tsp cinnamon
2/3  cup water
4  drops or 1/2 tsp stevia
   Dash of vanilla
   Unsweetened applesauce

Combine all ingredients to desired consistency (more liquid equals thinner pancakes). Butter skillet and cook until golden brown. Lightly coat pancakes with unsweetened applesauce just before serving.

### Buckwheat Blueberry Pancakes

|   |   |
|---|---|
| 1 | cup Bob's Red Mill buckwheat pancake mix |
| 2 | tbsp grapeseed or coconut oil |
| 2 | eggs, beaten |
| 1 | cup almond milk (enough to get desired consistency) |
| 1 | tsp vanilla extract (alcohol free) |
| ½–1 | cup chopped walnuts |
| ½–1 | cup blueberries, fresh or frozen |
|   | Pinch of nutmeg |
| 15 | drops liquid stevia |
| 1 | scoop of Jay Robb's egg white protein powder |
|   | Unsweetened applesauce |

Mix together eggs, oil, vanilla, stevia, cinnamon, and nutmeg. Add pancake mix, protein powder, walnuts, and blueberries, stirring well after each addition. Heat butter or coconut oil in a skillet on medium-low temperature (if you cook the pancakes on high, the outsides will burn before the insides cook through). Flip over when bubbles on uncooked surface pop. Top with unsweetened applesauce, stevia, and cinnamon. Makes 4–5 servings.

### Sesame Millet

    1 cup millet
    3 cups water
    1 tsp sea salt
    2 tbsp extra-virgin olive oil
    ¼ cup raw, hulled sesame seeds

Wash millet and drain. Boil water and add sea salt. Add millet, cover, and simmer for 25 to 30 minutes. Let stand for 5 to 10 minutes to increase fluffiness. While millet is standing, put sesame seeds into a frying pan and toast over low flame for 5 minutes, stirring frequently, until golden brown. Into another pan add olive oil, millet, and sesame seeds. Once seeds are brown, add olive oil and millet. Stir mixture over medium heat for 5 minutes and serve.

### Quinoa Medley

    2 cups uncooked quinoa
    ⅔ cup red bell peppers, finely diced
    1 bunch scallions, finely chopped
    ½ cup dry roasted pecans, finely chopped
    1 cup Italian vinaigrette, or to taste

Cook quinoa for 10 to 15 minutes. Drain and let cool, then add peppers, scallions, pecans, and dressing. Stir and serve.

### Nutty Brown Rice

    1 cup basmati brown rice, rinsed well (in three changes
      of water)
    1 tbsp olive oil

$\frac{1}{2}$ cup raw pine nuts
    Sea salt and pepper to taste

Boil brown rice as directed. In a separate pan, roast pine nuts over a low flame, stirring frequently until lightly browned. Add olive oil and cooked rice. Mix together and season.

### Cinnamon Oatmeal or
### Brown Rice Hot Cereal

$\frac{1}{2}$ cup Bob's Red Mill Oatmeal or Creamy Rice cereal
$1\frac{1}{2}$ cups water
$\frac{1}{2}$ tsp sea salt
  1 tsp cinnamon
    Unsweetened rice or almond milk
$\frac{1}{4}$ cup raw pecans, chopped

Bring water and sea salt to a boil. Add cereal and simmer for 5 to 8 minutes, stirring occasionally. Stir in cinnamon and top with pecans and a splash of almond or rice milk.

## MAIN DISHES

### Pico de Gallo Omelet

4 eggs
    Splash of soy, almond, or rice milk (unsweetened)
1 avocado, sliced
1 cup Pico de Gallo Sauce

### Pico de Gallo Sauce

 ¼  cup onion, chopped
 1  large tomato
 ¼  cup cilantro, chopped
    Squeeze of fresh lime juice
 ¼  cup jalapenos, chopped

Beat eggs and milk together. Cook as an omelet. Fill with
avocado and Pico de Gallo Sauce.

### Cabbage Roll

  1  lb ground white turkey meat
 ¼  cup onion chopped
 ¼  cup toasted pine nuts
    Dash of cayenne
    Sea salt and pepper to taste
 ½  cup fresh tomato, pureed
4–6  green cabbage leaves
  8  oz. vegetable broth

Sauté turkey meat, onion, spices, and tomato purée over
medium heat for about 10 minutes, stirring occasionally. Let
cool. While cooling, rinse and dry cabbage leaves. Pour veg-
etable broth into a baking dish. Fill each leaf with turkey mix-
ture, fold over and place in the baking dish. Cover with foil and
bake at 325° for 30 minutes.

## Butternut Squash Breakfast

1  baked butternut squash
1  tbsp butter
⅓  cup chopped pecans or walnuts
   Spices to your liking (cinnamon, nutmeg, or pumpkin
   pie spice)
   Pinch of stevia

Bake halved squash cut-side down in pan with ¼ inch of water
at 375° for 1 hour or until soft. Scoop out desired amount of
squash flesh and top with butter, nuts, and spices to taste.

## Egg Salad

2  hard-boiled eggs
1  tbsp mayonnaise
¼  cup onion, chopped
   Sea salt and pepper to taste

## Chicken Salad

2  boneless chicken breasts
¼  cup pecans, raw and sliced
½  tsp dill, freshly minced
1½  tbsp mayonnaise
   Sea salt and pepper to taste

## Homemade Chicken Soup

  2  large chicken breasts, including bone and skin
  1  clove garlic, peeled
  1  tbsp extra-virgin olive oil
  1  4 oz can of tomato sauce
 ½  cup carrots, sliced
  2  stalks celery, diced (add tops as well for flavor)
  1  bunch kale, chopped
  4  small red potatoes, diced with skins on
 2–3 quarts water
     Sea salt and pepper to taste

Place all ingredients in a 6-quart stock pot. Bring to a boil, then simmer on low for 3 hours, stirring occasionally.

## Fish Curry

  1  tsp Thai Kitchen red or green curry paste
  1  cup coconut milk, unsweetened
  1  tsp fresh lime juice
  3  stalks of lemongrass, cut into quarters
 1–1½ lbs thawed white fish of your choice

Combine coconut milk, lime juice, lemongrass, and curry paste in a skillet. Simmer on low for 5 minutes. Add fish. Cook on low for 5–10 minutes.

## Chicken Stir-Fry

 ½  cup broccoli florets, cut into bite-size pieces
 ½  cup carrots, sliced
 ¼  cup water chestnuts

4 oz boneless and skinless chicken tenders, cubed
1/2 cup onion, sliced
3/4 cup bok choy, chopped
1 tbsp Bragg's amino acids
1 tbsp coconut oil
Toasted sesame seeds

Place wok or skillet over medium heat. Add coconut oil and heat for 3 minutes. Add the rest of the ingredients, except the sesame seeds. Stir-fry on high heat for another 5 to 10 minutes. Cook until vegetables are the desired texture. Top with sesame seeds and serve.

## Cornish Game Hens

2 Cornish game hens
1 onion, peeled and sliced thinly
5 garlic cloves, peeled and halved
1/4 tsp fresh thyme, finely chopped
1/4 tsp fresh sage, finely chopped
1/4 tsp fresh rosemary, finely chopped
Sea salt and pepper to taste
Butter and extra-virgin olive oil
1 cup wild rice
1/2 cup toasted pine nuts

Cook wild rice as directed. Mix in 1 teaspoon olive oil, herbs, and toasted pine nuts. Stuff game hens with rice mixture and place on a roasting pan. Scatter onions around the outside of the hens. Brush hens with melted butter and olive oil, and season with salt and pepper. Bake at 375° for 1 hour, basting occasionally.

## Brown Rice Penne with
## Chicken Sausage and Vegetables

    1  lb brown rice penne
    2  chicken sausage links (peel off pork casings after cooking)
   ½  red bell pepper, diced
    3  Roma tomatoes, diced
    1  cup fresh arugula, washed and finely chopped
    1  tbsp olive oil

Cook brown rice penne in boiling salted water as directed. Broil
chicken sausage links until cooked, then slice. In a large
saucepan, add olive oil and bell peppers and tomatoes. Simmer
for 10 minutes. Add arugula and cook until wilted. Remove
from heat, mix in sliced sausage and penne, and serve.

## Quinoa Burger

    1  medium onion, chopped
    3  garlic cloves, minced
    1  carrot, finely grated
    1  cup cooked black beans
   ½  cup baked sweet potato
    1  cup cooked quinoa
    1  tbsp caraway seeds
    3  tbsp cilantro, chopped
    2  tbsp tomato paste
    1  tsp raw apple cider vinegar
       pinch cayenne (optional)
       pinch sea salt

Sauté onions and garlic in a small amount of olive oil. Add
beans and cook for two minutes. Turn off heat and mash beans

in pan, put into bowl and add rest of ingredients. Form patties and grill or bake until heated.

## Indian Risotto

- 1 tbsp ghee
- 1 jalepeño, minced
- 1 tsp cumin seeds
- 1/8 tsp asafedtida
- 1 cup split yellow mung beans
- 1 cup basmati brown rice
- 1 small cauliflower, cut into florets
- 6 cups water
- 1/2 tsp ground tumeric
- 1 1/2 tsp sea salt
- Fresh ground pepper to taste

Heat 1/2 tbsp ghee. Add jalepeño and cumin seeds. Cook until seeds begin to darken. Add asafetida and stir for a minute. Then add beans, rice, and cauliflower and cook for 3 minutes. Add 4 1/2 cups of water, tumeric, salt, and bring to a boil. Lower heat, cover and simmer, stirring frequently until the beans and rice are tender (30–40 minutes). Add more water if necessary. Stir in black pepper and drizzle remaining ghee.

## Tuscan Country Roast Chicken

- 1 roasting chicken, 3 lbs. or more, thawed
- Bay leaves to taste (18 fresh, 12 dry)
- 1/2 lemon, halved
- Several garlic cloves, halved
- Sea salt and fresh ground pepper

Preheat oven to 400°. Rinse chicken and wipe dry. Fill cavity with bay leaves, lemon, salt, pepper, and a couple of garlic cloves. Salt and pepper chicken on all sides. Tuck garlic clove halves into hollow of thighs and wings. Place chicken on a rack in a roasting pan with about 1 inch of water in the bottom to keep drippings from burning. Bake at 400° for 90 minutes, then reduce temperature to 350° for 15 to 30 minutes, or until legs move easily and juices run clear.

*Optional:* Make gravy with pan juices, or pour over a whole grain of your choice.

## Roast Duckling

- 1  4–5 lb duckling, completely defrosted
   Chef's Salt (see recipe below)
- 1  parsnip or carrot, chopped
- 2  stalks celery, chopped
- 1  onion, chopped
- 2  garlic cloves, thinly sliced
- 4  tbsp butter
- 4  black peppercorns
- 1  bay leaf
   Marjoram

## Chef's Salt

- ½  cup sea salt
- ½  tbsp paprika
- ½  tsp pepper
- 1  tsp white pepper
- 1  tsp celery salt
- 1  tsp garlic salt (not powder)

Mix all ingredients for Chef's Salt. Preheat oven to 300°. Put butter in bottom of a roasting pan with a tight-fitting cover. Remove neck and giblets from duck cavity, rinse in cold water, and rub duck inside and out with Chef's Salt. Place duck, breast-side down, directly on butter in roasting pan. Put vegetables and garlic inside and around the duckling. Add about 2 inches of water to the pan. Add the peppercorns, bay leaf, and sprinkle all with marjoram. Cover and cook for two hours.

Carefully remove duckling to a platter and let cool, or it won't turn out right. Split duckling lengthwise by standing it on the neck end and cutting with a sharp knife from the tip of the tail down to the center. Quarter if desired. Save leftovers for soup.

## Turkey Soup with Winter Vegetables

    One or two day large turkey legs
2  bay leaves
1  tsp dried parsley and thyme
1  daikon radish *or*
2  carrots, chopped
1  large parsnip, chopped
2  turnips, chopped
3  stalks celery, chopped
4  lbs red potatoes
    Sea salt and pepper

Place turkey legs in a large soup pot. Cover with purified water. Add bay leaves, parsley, and thyme and bring to a boil. Simmer for 4 hours, until meat falls off the bones. Strain soup and remove bones. Dice meat and add back to broth. Add vegetables and simmer 1 more hour. Salt and pepper to taste.

## African-Style Turkey

- 2 lbs boneless, skinless turkey breasts, cut into bite-sized pieces
- ¼ cup chicken or vegetable broth
- 1 large onion, chopped
- 4 garlic cloves, minced
- ½ tsp crushed red pepper flakes
- 1 tsp fresh ginger, minced or grated
- 1 tsp sea salt
- ¼ tsp black pepper
- 1 tbsp fresh lemon juice

Place all ingredients in a large, covered pot or crockpot and cook on low for 8 hours. Serve over a whole grain of your choosing.

## Marinated Tri-Tip Roast

- 1 1½–2 lbs tri-tip roast
- ½ tbsp sea salt
- ½ tbsp cracked black peppercorns
- 1 tbsp garlic cloves, minced
- 1 tbsp fresh ginger root, grated
- 1 tbsp Bragg's liquid aminos
- ½ tbsp white pepper
- 5 drops stevia

Mix all ingredients well, cover meat with them, and place in plastic bag in refrigerator for at least an hour or, better, overnight. Roast at 425° for 30–35 minutes. Check after 15–20 minutes. Be sure to cover meat with all the seasonings before cooking it. When meat is cooked to desired doneness, carve across the grain into thin slices.

## SIDE DISHES

### Artichokes

1   artichoke per serving
1   bay leaf
    Sea salt
1   tsp raw, unfiltered apple cider vinegar per serving
1   tbsp mayonnaise per serving

Wash artichokes. Cut off stems to base and stand upright in
a large saucepan. Add 2 to 3 inches of water and sprinkle the sea
salt and bay leaf into the water. Cover and simmer over medium
heat until the base is tender—about 45 minutes. Add more
water if needed. Blend mayonnaise and apple cider vinegar to
make a dipping sauce.

### Stir-Fried Green Beans

2   pounds fresh green beans, trimmed
4   tbsp extra-virgin olive oil
6   cloves garlic, minced
3   tbsp sesame oil
1/2 tsp sea salt
    Crushed red pepper to taste

Heat wok or skillet over medium flame. After 1 minute, add oil.
Let oil heat for 1 minute, then add green beans and turn heat
to high. Stir-fry for 5 minutes or until green beans are seared.
Add garlic, salt, and red pepper, and stir-fry for about 2 more
minutes. Serve hot.

### Broccoli with Sliced Almonds

1  large head broccoli
2  tbsp olive oil
¹/₄ cup raw sliced almonds
   Sea salt and pepper to season

Steam broccoli for 7 minutes. Dry-fry almonds in skillet over
low heat for 2 to 3 minutes, then add olive oil and broccoli.
Sauté for 2 to 3 minutes and serve, adding sea salt and pepper
as desired.

### Arugula, Beet, and Walnut Salad

1  large bunch arugula, washed well
¹/₄ cup red onion, chopped
¹/₂ cup tomatoes, diced
1  apple, diced
¹/₄ cup beets, cooked and diced
¹/₄ cup walnuts, raw or dry-roasted in oven at 350° for
   10 minutes
   Italian vinaigrette dressing

### South Greens Mix

2  cups collard greens, chard, mustard greens
1  tbsp olive oil
1  tbsp raw apple cider vinegar
1  tsp sesame seeds
   pinch sea salt

Sauté in pan until tender.

## Marinated Kale Salad

3–4  cups black kale, shredded
  2  tomatoes, diced
  1  carrot, grated
 1/4  cup red onion, diced
 1/2  avocado, diced

### Dressing

 3/4  cup raw apple cider vinegar
 1/4  cup toasted sesame or olive oil
  3  garlic cloves, minced
  1  tsp mustard powder

Toss kale and vegetables with the vinegarette. Let marinate for four hours to overnight in refrigerator so vegetables become tender. Add avocado when ready to eat.

### Asian Coleslaw

2–3  cups cabbage, chopped
 1/4  cup daikon radish, grated
 3/4  cup green onions, finely chopped
  1  green apple, finely chopped
  1  cup sliced almonds or sunflower seeds
  2  tbsp sesame seeds
     Sea salt and pepper to taste

### Dressing

- ¼ cup sesame oil
- ¼ cup rice vinegar (unseasoned)
- 2 tbsp fresh lemon juice
- Few drops of liquid stevia

Put all ingredients in a jar and shake well. Pour over coleslaw mixture. Season with salt and pepper.

### Candied Yam

- 1 small yam
- Butter
- Stevia

Bake yam at 350° until tender. Slice open and add butter and stevia.

### Leeks and Leaves

- 6 leeks, large
- 2–3 tbsp butter
- ½–1 cup vegetable stock (use larger amount if you like a soupier mixture)
- 2 bunches spinach, chard, or kale, or a blend, chopped
- Pinch of nutmeg
- Sea salt to taste

Trim the leeks, using only the white and pale green parts. Slice in half lengthwise, wash well, and dry. Slice crosswise into small pieces. Sauté leeks in a large skillet until they soften and begin to fall apart. Add stock and season lightly with sea salt and nutmeg. Stir and simmer for 5 minutes. Add greens and simmer until cooked.

## DESSERTS AND SNACKS

### Tofu Carob Pudding

8  oz silken tofu (organic)
3  tbsp carob powder
1/2  tsp or 4 drops stevia
1/4  cup almonds, ground

Combine all ingredients except almonds in a blender until smooth. Chill and serve with ground almonds sprinkled on top.

### Baked Cinnamon Apple

1  medium Pippin apple
1  tbsp butter, softened
1  tbsp cinnamon
   Nutmeg (optional)

Remove 75% depth of apple core, leaving the bottom intact. Mix cinnamon and butter and spoon into cavity of apple. Place in a buttered baking pan with about 1/4 inch of water and bake at 350° until tender. Sprinkle with nutmeg.

### Spicy Almonds/Walnuts/Pecans

1  cup raw almonds/walnuts/pecans
   Few dashes of cayenne
2–4  drops stevia liquid
1/4  tsp sea salt

Stir all ingredients together. Spread on baking sheet and bake at 300° for 10 minutes.

## Carob Chip Cookies

  1 stick butter, softened
1/4 tsp stevia powder
  1 egg
1/2 tsp vanilla
1/2 cup whole spelt or buckwheat flour
1/2 tsp sea salt
1/2 tsp baking soda
  1 cup rolled oats
1/4 cup raw pecans or walnuts, chopped
1/2 cup unsweetened carob chips

Mix together the first four ingredients in a bowl. Add remaining ingredients in order. Drop tablespoonfuls on baking sheet and bake 10 minutes at 375°.

## Tahini Toast

  1 slice bread, wheat-, yeast-, sugar-, and dairy-free
Raw tahini spread
Pinch of cinnamon
Pinch of stevia

Blend tahini, cinnamon, and stevia, and spread on toasted bread.

# WHEAT ALTERNATIVES

These are all whole grain, not refined or bleached.

Almond—butter, meal

Amaranth—cereal, flour

Barley—flakes, flour, whole hulled

Buckwheat—cereal, flour, noodles, whole groats

Chestnut—flour

Hazelnut—flour

Kamut—bread, cereal, crackers, flour, pasta, tortillas

Legumes—flours (black bean, garbanzo bean, mung bean, pinto bean, red and green lentil, white bean)

Millet—flour, whole grain

Oat—bran, flour, meal

Potato—flour

Rice (brown)—bread, brown basmati, crackers, flakes, tortillas, whole grain

Rye—whole grain, flakes, bread, crackers

Soy—cereal, flour, grits

Spelt—bread, cereal, crackers, flakes, pasta, tortillas, whole grain

Teff—flour

Wild rice

# RECOMMENDED PRODUCTS

### Pastas

- Rice elbows—Food for Life
- Brown rice pasta—Lundberg
- Brown rice pasta, sprouted whole wheat pasta*—Trader Joe's
- Spelt pasta—Vita Spelt
- Whole wheat pasta*—Westbrae

### Butter

- Organic butter (no salt)—Horizon

### Luncheon meats

- Roasted turkey, herb-roasted turkey—Applegate
- Herb roasted turkey, peppered turkey, oven-roasted turkey—Diestel
- Oven-roasted turkey, uncured turkey salami (in deli case)—Whole Foods

### Tofu

- Tofu (firm, soft)—Wildwood (organic and non GMO)

*Avoid first three months.

## Vinegar
### (Always keep refrigerated)

- Apple cider vinegar (raw and unfiltered)—Bragg's
- Apple cider vinegar (raw and unfiltered)—Spectrum
- Rice vinegar (unseasoned, no sugar)—Maruakan

## Crackers

- Rice snaps (crackers—plain, toasted onion, vegetable, onion/garlic, sesame)—Edward & Sons
- Brown rice crackers—Hol Grain Crackers
- Rye crackers—Kavli Crispy Thin
- Brown rice cakes—Lundberg
- Rye crackers—Ryvita
- Rye crackers—Wasa Light Rye

## Whole Grains

- Quinoa—Ancient Harvest
- Wheat-free hot cereals, grains, and flours— Bob's Red Mills
- Brown rice—Lundberg

## Salsa

- Habanera salsa—Frontera
- Mild or hot salsa—Green Mountain
- Mild salsa—Whole Foods

## Condiments

- Garden style, organic green garlic, basil and garlic vinaigrette—Annie's Natural Salad Dressings

- Amino acids (liquid) unfermented soy sauce—Bragg's
- Coconut butter—Artisana
- Guacamole—Casa Sanchez
- Guacamole—Scotty's
- Sea salt—The Grain & Salt Society
- Sea salt—Pacific
- Mayonnaise (apple cider vinegar only)—Trader Joe's
- Mayonnaise (apple cider vinegar only)—
    Whole Foods
- Mustard (apple cider vinegar only)—Trader Joe's
- Mustard—Whole Foods

### Hot Cereals

- Brown rice, oatmeal, multi grain (wheat-free)—
    Bob's Red Mills
- Irish oatmeal, steel cut—McCann's

### Sparkling Water

- Sparkling mineral water—Gerolsteiner
- Smart waters—Glaceau

### Nuts

- Tahini—Arrowhead Mills
- Organic tahini butter—Once Again
- Almond nut butter—Marantha
- Raw nuts, raw or dry roasted almond nut butter,
    macadamia nut butter—Trader Joe's
- Raw nuts and nut butters—Whole Foods
- Pumpkin seed butter—Jarrow

## Breads
### (Yeast-, wheat-, dairy-, and sugar-free)

- Rye bread, spelt bread, Women's bread,* Men's bread,* —French Meadows
- Spelt bread, spelt tortillas, brown rice tortillas, sprouted corn tortillas*, Ezekiel tortillas*—Food for Life
- Whole rye manna bread—Nature's Path
- Rye bread—Rudolph's
- Kamut bread,* rye bread, spelt bread—Pacific Bakery

## Milk Substitutes
### (Rice, soy, almond—unsweetened)

- Rice and soy milk—Eden Blend
- Original and vanilla rice milk—Rice Dream
- Organic, original, and vanilla rice or soy milk— Whole Foods
- Original and vanilla almond milk—Blue Diamond Almond Breeze

## Protein Powders

- Egg white powder—Jay Robbs
- Rice powder (vanilla)—Nutribiotic
- Hemp seed powder (unsweetened)—Living Harvest
- Goatein powder—Garden of Life
- The Ultimate Meal—Ultimate Life

*Avoid first three months.

# Supplementation

## SUPPLEMENT AND TREATMENT PROTOCOL

Outlined below is a general MS protocol that summarizes the best remedies to use. Work with your health-care practitioner to meet your own individual needs. Feel free to add to or subtract from the suggestions I've made here.

Here are some general guidelines to follow as you embark on this treatment plan:

- Check with your doctor/health-care practitioner before taking any supplements. This is especially important for pregnant women and those on pharmaceutical medications who need to take precautions when using supplements without consulting a doctor or health-care practitioner first.
- Purchase your supplements from a reputable source such as a practitioner, online vitamin warehouse, or a health food store. Supplements sold in drugstores and supermarkets often contain sugar, synthetic dyes, and fillers. Read labels to make sure they say "no added dyes, fillers, sugar, corn, or yeast." I've listed many reliable companies and their contact information in the Resources section, page 299.

- If you live outside the United States, look for comparable products with similar ingredients. You can view product ingredients by going on the Internet.

### Essential

- Candida diet (for a minimum of one year): No sugars, fermented or yeast products, dairy products, refined carbohydrates, or trans fats. Follow the "Foods to Eat" and "Foods to Avoid" charts, pages 189–195.

- Antifungal(work up slowly): Take Nystatin tablets, or Nilstat powder (both by prescription), or herbal compounds. Herbal compounds are Candida Cleanse, Primal Defense, or pau d' arco. You can take Nystatin or herbal antifungals for long periods of time—from one to three years. Diflucan is an additional option that can give your body a jump start and kill off systemic fungus at the beginning of your program. Ask your doctor to prescribe three 150 mg tablets, to be taken one pill every other day for one week at the beginning of your program. If you decide to use Diflucan for a longer period, have your doctor monitor your liver enzymes. After your jump-start of three Diflucan tablets, begin taking Nystatin tablets, Nilstat powder, or one of the herbal antifungals listed. Brands: Primal Defense (Garden of Life), Candida Cleanse (Rainbow Light), pau d' arco (Gaia Herbs, tincture; Pacific Botanicals,tea.)
  **Note:** Antifungals can make you feel worse before you feel better. Work dosage up slowly to allow your system to keep up with the elimination of toxins. If wheelchair-bound or bedridden, do not start with Nystatin or Diflucan, start with herbal formulas.

- Vitamin C (3,000–7,000 mg daily): Buy a vitamin C that contains mineral ascorbates and/or bioflavonoids. Plain ascorbic acid crystals will irritate the lining of your stomach and intestines. Spread out the dosage through the day because your body will absorb only so much at one time. The powder form is more bioavailable to your body than the pill form, but both will work. Increase your dose of vitamin C slowly. If you experience diarrhea, cut back your dose by 1,000 mg. You can take the powder with or without food, but it's best to take pills after a meal or snack. Brands: Ultra Potent C 1000—pills or powder (Metagenics), QBC capsules (Solaray), Quercitin + C capsules (Twin Labs), Emer'gen-C Lite powder (Alacer).

- Vitamin E (1,200–3,000 i.u. daily): When buying vitamin E, be sure the source is natural. Look for "d-tocopherol" on the label and not "dl-tocopherol," which is synthetic. Also use an E vitamin that has mixed tocopherols and tocotrienols. Increase your dose slowly. For those who are ambulatory, 1,200–2,000 i.u.; those who are wheelchair-bound need to work up to 3,000 i.u. Vitamin E is best absorbed after a meal or snack.
  **Note:** Do not take vitamin E if you're on blood thinners, and stop taking it two weeks before surgery so your blood will clot. If you begin to bruise easily then reduce your dose. Brands: E Gems Elite (Carlson), familE (Jarrow).

- Omega 3 liquid fish oil (twice the recommended dose on the bottle, or 10 grams daily): The brands I recommend have disguised the fishy taste in the liquids, which supply greater amounts of both EPA/DHA than gel capsules. Take either source after a meal or snack. Brands: EPA/DHA Lemon High Potency liquid (Metagenics), Ultimate Omega liquid (Nordic Naturals), Lemon Fish Oil liquid (Carlson).

- Vitamin D$_3$ (2,000 i.u. daily): Vitamin D is needed for healthy neurological function, balancing an immune system, and maintaining bone density. Vitamin D deficiency is prevalent in MS. The skin makes vitamin D when it comes into contact with direct sunlight. Most people with MS live farther away from the equator and don't take in enough sun. A high-carbohydrate diet can decrease vitamin D$_3$ absorption. Brand: Iso D$_3$ (Metagenics).

- Digestive enzymes (one after each meal): It's usually a good idea to add digestive enzymes in the first three months of your program to make sure you're digesting, absorbing, and eliminating properly. If you have trouble digesting animal protein (burping and heartburn), buy an enzyme that contains pepsin and hydrochloric acid (HCl). If you have low or high blood sugar imbalances, use a pancreatic enzyme that contains pancreatin, lipase, protease, and amylase. If you're vegetarian or have mild digestive complaints, use a plant-based digestive enzyme. Brands: Metagest (HCl and pepsin, Metagenics), Azeo Pangeon (pancreatic, Metagenics), Spectrazyme (plant-based, Metagenics), Full Spectrum Enzymes (plant-based, Caren Advanced Nutraceuticals), Digest Gold (plant-based, Enzymedica).

- Metacrin DX (work up slowly to one pill three times daily): This herbal supplement is designed to assist phase I and II of liver detoxification, which is important to keep up with toxin removal. Take this product in the beginning for two to three months. Brand: Apex.

- Red clover tea (work up slowly to two to four cups daily): This herb cleanses your bloodstream, liver, and kidneys. One heaping teaspoon of the loose herb equates to one cup of tea. Steep for fifteen minutes and drink throughout the day. After brewing, you can add ice cubes to make iced tea. Red clover must be drunk the same day it's made because it will get moldy if stored in the refrigerator. **Note:** Some people have reported that drinking red clover tea at night keeps them up. This is due to the tea's cleansing effects on the bloodstream, so if you feel it's affecting your sleep, it's best to finish taking it by 6 p.m.

### Important

- Mynax Chelated Calcium/Magnesium/Potassium EAP (2–3 pills three times daily, with or without food): Minerals that repair myelin and assist with the proper firing of electrical nerve charges. Allieviates fatigue, tremors, spasms, headaches, and moodiness. Brand: (Koehler, distributed by Carotec).

- Molybdenum (100 mcg three times daily): A trace mineral that assists with the breakdown of acetaldehyde—a main by-product of candida. Can alleviate die-off symptoms such as brain fog, spaciness, headaches, and vertigo.

- B complex (100 mg twice daily): This vitamin assists with liver function, neurotransmitters, and energy. Make sure your source is yeast-free. Take one pill after breakfast and lunch. Brands: Glycogenics (Metagenics), B complex (Solaray), B Right (Jarrow).

- Oxygen Elements Plus (ten drops, three to five times daily in six to eight ounces of water, with or without food): When poured into water, this liquid turns into oxygen, which regenerates cells and eliminates microbes. Shake the bottle well, then carefully squeeze three drops into six to eight ounces of water. Drink this mixture immediately to avoid losing the oxygen effect in your body. Keep your dose at three drops for three days because die-off symptoms from viruses, bacteria, fungus, or parasites can occur if you take the full dose right away. After three days, increase your dose to seven drops twice daily for three days, then increase to ten drops twice daily for three days, and so on. Experiment until you find the dose that gives you the greatest energy and mobility. There's been one account of a bedridden, critically ill MS sufferer who took a total of 200 drops daily and fully recovered her health. If you take more than five doses a day, add a calcium-magnesium (chelated) supplement equal to 1,000 mg of calcium and 500 mg of magnesium at bedtime.
  **Note:** This product contains amino acids, and some people experience insomnia if they take it after 6 p.m. Must be taken 1 hour away from pharmaceutical medication. Brand: Global Health Trax.

- Brain Support: These vitamin blends of nutrients are designed specifically to regenerate and rejuvenate brain and nerve function. Examine ingredients as they may overlap with other individual products I recommend. Brands: Brain Vitale (Designs for Health), Ceralin Forte (Metagenics), Brain Sustain NeuroActives (iNutritionals).

- Free-form amino acid complex (1,000–2,000 mg daily before breakfast and lunch): Amino acids are the building blocks to repairing and regenerating every cell, tissue, and organ in your body. They also assist the liver's detoxification process and are the precursors to neurotransmitters such as serotonin, dopamine, and epinephrine. Brand: Super Daily Amino Blend (Carlson).

- Evening primrose oil (1,500 mg. daily): This essential fatty acid is rich in gamma linoleic acid (GLA), part of the omega 6 family that assists with repair of the myelin sheath. Brands: Meta EPO (Metagenics), Omega Woman (Nordic Naturals), Evening Primrose Oil (Jarrow or Carlson).

- Green food: Your body needs extra minerals to repair and to keep the body alkaline. Brands: Alfalfa tablets or Chlorophyll mint flavored liquid (Bernard Jensen Products), Nettle Leaf (Gaia Herbs), or Hydrilla (MegaFood), NanoGreens[10] (BioPharma Scientific through Emerson Ecologics.

- Probiotics (dairy-free strains of acidophilus and bifidus, take as directed on bottle): Probiotics replace and balance bacteria in the GI

tract. Brands: Ultra Flora Plus DF (Metagenics, refrigerate), Dr. Ohhira's Probotics 12 Plus (Essential Formulas, no refrigeration) PB8 (Nutrition Now, no refrigeration).

- Ginkgo biloba (liquid or pills): This herb promotes circulation and healthy brain function. Brands: Gingko-Rose (Metagenics), Gaia Herbs (liquid capsules).

- Multivitamin and mineral supplement (as directed on the label): A good multivitamin and mineral supplement will compensate for what isn't included in your diet. Make sure your source is free from iron, because it can be toxic to the brain and that it has chelated minerals that are bound with amino acids to improve absorption. Take after meals or snacks. Brands: Multigenics Intensive Care Formula Without Iron (4 tablets daily, Metagenics), Twice Daily (iron-free capsule, Solaray), Complete Nutritional System (iron-free tablets, Rainbow Light), All One Multi Vitamins and Minerals (powder multivitamin-mineral formula, Nutritech).

The following supplements can be added based on your individual symptoms and imbalances. Note that in each category there might be more than one product that has the same effect. Research which product would best fit your body's needs and what is the accessibility for you to purchase it.

### Brain and Nerve Regenerators/Immune Modulators

- Alpha Lipoic Acid (100–250 mg daily): A powerful antioxidant that recycles vitamin C and E and supports the health and regulation of neurological tissue. Brands: Meta Lipoate (Metagenics), Jarrow.

- Myelin Sheath Support: Herbal blend to regenerate myelin sheath. Brand: Planetary Herbals.

- Acetyl L-Carnitine (1 to 2,000 mg daily): Antioxidant amino acid involved with neuronal metabolism and supports energy utilization into the mitochondria. Brands: Jarrow, Designs for Health.

- Phosphatidylserine: This lipid is needed by every cell and is abundant in nerve cells. It's important for the integrity of healthy cell membranes. Brand: AdrenaCalm (Apex) (Apply cream, $\frac{1}{4}$–$\frac{1}{2}$ tsp, once to three times daily on soles of feet, behind knees, or crease of elbows).

- L-histidine: This essential amino acid (protein) helps with tissue growth and repair and is vital in the maintenance of myelin sheath. It has been found that those with MS have low histidine levels, and histidine deficiency is also seen in those with dysbiosis. Don't take it if you have ulcers because it increases hydrochloric acid secretion in the stomach. Brand: Douglas Laboratories.

- *Polypodium leuctomos*: A fern found in Honduras that has powerful immuno-regulating effects to stop inflammatory damage in the body without the side effects of the A, B, C pharmacuetical drugs used for MS. Brand: Kalawalla (Aragon Products).

### Elimination Problems

- Fiber powder or pills (on arising or one hour before bed on an empty stomach): Daily elimination is essential. Fiber sweeps the linings of the colon to remove plaque buildup, eliminates excess cholesterol, and keeps the stools formed. For constipation, use pectin or ground flaxseed. For diarrhea, use psyllium products. Brands: Grapefruit pectin (Carlson), Gentle Fiber powder (Jarrow Formulas), Herbulk (Metagenics), Fiber Smart (Renew Life).

- Herbal laxative (start with the minimum dose on the label and increase gradually as needed to achieve daily elimination): This formula is for stubborn, chronic constipation and can be used for up to six months. Brand: Naturlax 2, 3, or Aloelax (Nature's Way).

- Aloe vera juice: Drink 4 oz upon arising and 4 oz at bedtime without food. Brand: Lily of the Desert.

- Magnesium citrate: Strong laxative for stubborn constipation. Brand: Metagenics.

- Triphala: Aryuvedic bowel cleansing blend to relieve chronic constipation. Brands: Planetary Herbals or Himalaya.

### Liver and Gallbladder Support

- Bilemin (build up to one pill three times daily): This herbal-supplement compound stimulates bile secretion and the elimination of toxins from the gallbladder and liver. Good to use for one to two months if you have a history of constipations. Brand: Apex.

- Lipo-Gen (build up to one pill three times daily): This supplement formula combines lipotropic nutrients with select amino acids, vitamins, and herbs to support healthy liver and gallbladder function.

- Liver Health: Herbal compound to support healthy liver function. Brand: Gaia Herbs.

- Milk thistle seed (liquid or pills): This herb helps to detoxify, regenerate, and restore liver and gallbladder function. Can be used long-term. Brand: Gaia Herbs (liquid capsules).

### Antioxidant Boosters

- Glutathione injections: Go to www.brainrecovery.com or buy Dr. David Perlmutter's book, Brainrecovery.com for more details.

- Antioxidant Supreme: A superb antioxidant formula that protects the body from free radicals. Brand: Gaia Herbs.

- Antioxidant Supreme: Blend of pycnogenols, rosemary, bilberry, resveratrol, and green tea. Brand: Health Force Nutritionals.

- PycnOlive: Pycnogenol, a potent antioxidant to help with the inflammation response by reducing histamine production. Brand: Jarrow.

- Blueberry Syrup: Antioxidant that is good for circulation and urinary tract. Brand: Wise Woman Herbals.
- Co Q10 (100 mg daily): Antioxidant supporting brain/neurologic health, muscle performance, and immune system. Brands: Jarrow, Metagenics.
- Super Oxicell: An antioxidant cream with high concentrations of glutathione, a superoxice dismutase. Apply $1/4$–$1/2$ tsp topically. Brand: Apex.

### Anti-inflammatory agents

- Vitalzym X (work up to two to three capsules three times daily without food; five capsules three times daily during an exacerbation): This enzymatic blend alleviates inflammatory processes, relieves pain, and removes immune complexes, scar tissue buildup, and plaque. Use for one to three months at a time. Brand: World Nutrition.
- Tumeric Supreme: Herbal blend that reduces inflammation. Brand: Gaia Herbs.
- Quercitin (1,000 mg. three times daily): Anti-inflammatory bioflavoid. Brand: Jarrow.
- Aloe vera juice: Drink 4 oz upon arising and 4 oz at bedtime without food.

### Cold/Flu/Allergy Remedies

- Wellness Formula: This herbal-vitamin combination knocks out cold and flu viruses. Brand: Source Naturals.
- Garlic: Assists with stubborn bacterial infections such as chylmadia pneumoni bacteria or Lyme disease. Brand: Allicin (Designs for Health). This products has a high concentration of allicin, the active ingredient in garlic.
- Pau d'arco, fresh sage leaves, fresh basil leaves steeped in hot water and made into a tea. These herbs eliminate a variety of infections, including viruses, bacteria, fungus, and parasites.
- First Aid Throat Spray with Zinc and GSE: Throat spray good for bacterial/viral infections. Brand: NutriBiotic.
- Aller-Leaf: Herbal blend to support upper respiratory health. Brand: Gaia Herbs.
- Sinufix (capsule and mist): Formula supporting clear sinus and nasal passages. Promotes healthy immune response. Brand: NaturalCare.

### Hormonal Balancers for Women

- Evening primrose oil (1,300–1,500 mg daily, with food): This is an Omega 6 essential fatty acid that balances hormones and assists with endometriosis, fibroids, and repair of the myelin sheath. Brands: Meta EPO (Metagenics), Omega Women (Nordic Naturals), Jarrow.

- Selestro: Phytonutrient source (black cohosh and isoflavones) that helps alleviate menopausal symptoms, hot flashes, occasional sleep disturbances, irritability, and mood swings. Brand: Metagenics.

- Motherwort (liquid tincture, 20–60 drops three times daily in a small amount of water with or without food): This herb is useful for menopausal symptoms (hot flashes, depression, vaginal dryness, insomnia, uterine pain and cramping, and memory problems). Brand: Wise Woman Herbals.

- Alfalfa: Herb that supports the endocrine system, especially the pituitary and hypothalmus (helps stimulate growth hormone).

- Nettle Leaf: Herb that is minerally dense helping balance the reproductive system, kidney and adrenal function, and upper respiratory health. Brand: Gaia Herbs.

- Wild yam (topical cream—take as directed on bottle/jar): The topical cream is used for menopausal symptoms. You may need to reduce the dose if you notice weight gain. Brands: ProgestaCare (Life-Flo), Progesterone cream (Emerita).

- Estrovite: This vitamin-herbal blend normalizes hormonal imbalances and estrogen dominance. Brand: Apex.

- Women's Libido: Herbal blend to increase female libido. Brand: Gaia Herbs.

- Le Feminine Advantage: Glandular and herbal blend to rejuvenate female hormonal system. Brand: Doctor's Research.

- Methyl SP (for women on birth control pills): Vitamin blend to assist with proper liver metabolism of this drug, and provide the essential nutrients needed that are depleted while on the pill. Brand: Apex.

- Bio-identical hormones: These hormones are made from beta-sitosterol derived from soybeans, or diosgenin taken from wild yam. Compounding pharmacies formulate compounds based on your specific hormonal levels. If you take bio-identical hormones, synthetic hormone replacement therapy (HRT), or birth control pills, also take Methyl-SP (Apex Energetics) to support liver metabolism of hormones.

**Note:** Use bio-identical only as a last resort if natural alternatives are not working.

### Hormonal Balancers for Men

- Prosta DHT: This combination herbal-supplement formula is used for prostatitis or benign prostate hyperplasia (BHP). Brand: Apex.

- Male Libido: Herbal blend to increase stamina and performance. Brand: Gaia Herbs.

- Prosta Power: Glandular and herbal blend to alleviate prostate symptoms. Brand: Doctor's Research.

- Testanex: This topical cream is used for andropause to balance normal testosterone-estrogen ratios. Brand: Apex Energetics.
- Tribulus Synergy (one tablet twice daily): Ayurvedic herbal formula to help with male sexual function, stamina, and vitality. Brand: Metagenics.

## Circulation Booster

- Ginkgo biloba (liquid or pills): This herb promotes circulation and healthy brain function. Brands: Gingko-Rose (Metagenics), Gaia Herbs (liquid capsules).

## Energy Formulas

- Adrenozyme: This herbal-vitamin supplement blend is useful for chronic adrenal exhaustion and fatigue. Brand: Apex.
- Advanced Ambrotose (Powder, work up to 1 tsp., two to three times a day, in water with food: A glyconutrient designed to rapidly support effective cell-to-cell communication and increase energy. The messages cells exchange directly affect your natural defense (immune) and endocrine (glandular)systems, as well as affecting proper gland and organ function. Brand: Mannatech.
- Max GXL (work up to 3 pills twice daily, breakfast and lunch): A glutathione product. Glutathione functions both as an antioxidant and an antitoxin, and is a major defense system against illness and aging. Max GXL will enhance the immune system, increase energy, improve concentration, permit increased exercise, and improve heart and lung function. Brand: Max International.
- Adaptogen herbal formulas: These herbal-supplement blends used for both adrenal hypofunction and hyperfunction. Brands: Adaptocrine (Apex Energetics), Adreset (Metagenics), Adrenal Health (Gaia Herbs).
- DHEA (start with a small dose, 5–10 mg under your tongue upon arising and in the afternoon between 2 and 3 p.m., dose can be increased as needed for energy): This hormone helps with healthy adrenal function and promotes healthy immune function and brain balancing. DHEA is most beneficial if used for only one to two months but can be used longer in cases of extreme and chronic exhaustion. Brand: Bio-Som Spray (Metagenics).
- Korean (hot)ginseng: Exhaustion; American (cool) ginseng: stress and wired. Brand: Ginseng Company.
- Thyrozyme: An herbal/vitamin supplement designed to balance thyroid function. Brand: Apex.
- Thyroid Strength: Herbal blend designed to regulate thyroid function. Brand: Gaia Herbs.

- Vitamin B$_{12}$ shots or sublingual pellets (injections of 1,000 mcg daily for one week, then twice weekly for four weeks, then twice monthly; use the sublingual form daily or three times a week): B$_{12}$ repairs nerves and myelin and assists with iron and energy. Brand: B$_{12}$ sublingual lozenges (PhysioLogics).
- Vital PSP: This formula is comprised of polysaccharide peptides, derived from whole rice fractions to help protect neuronal cells from attack by neurotoxins and assist with energy and cellular function. Brand: CyberWize.

**Sugar Cravings, Leaky Gut, and Blood Sugar Imbalances**

- L-glutamine (1,000 mg two to three times daily): This amino acid helps to alleviate brain fatigue, stops sugar cravings, and repairs leaky gut syndrome. Brand: Glutagenics (Metagenics).
- GI Repair: Vitamin-herbal blend to heal gastric lining and alleviate leaky gut syndrome. Brand: Vital Nutrients (Emerson Ecologics).
- Aloe Vera juice (4 ounces a.m. and p.m. on empty stomach): Reduces gastrointestinal inflammation and repairs leaky gut. Brand: Lily of the Desert.
- Endefen: Powdered nutritional support to heal an inflamed gastric lining and promote beneficial bacteria growth. Brand: Metagenics.
- Proglyco Sp: Excellent herbal-vitamin combination to assist with hypoglycemia and sugar cravings. Brand: Apex.
- Glycemic Health: Herbal blend to balance sugar levels. Brand: Gaia Herbs.
- Fenugreek Plus: This herbal blend helps with sugar cravings and balancing blood sugar levels. Brand: Metagenics.
- Glysen: This herbal-supplement compound assists with high blood sugar and insulin resistance. Brand: Apex.

**Urinary Tract Infections/Bladder Control**

- D-mannose: This simple sugar gets rid of E. coli bacteria and helps to eliminate and prevent urinary tract infections. Brands: Mannose (powder, Bio-Tech), D-mannose with Cranactin (Solaray).
- Uro-Kid: Glandular support to help rebuild weak kidney and bladder functions. Brand: Doctor's Research.
- Urinary Support: Herbal blend to alleviate kidney and bladder infections. Brand: Gaia Herbs.
- Bladder-Control: Herbal-vitamin blend to reduce bladder over activity. Brand: The Natural Bladder.
- Kidney Bladder formula: This combination of herbs helps to eliminate kidney and bladder infections. Brand: Nature's Way.

**Sleep Remedies (Important to sleep in complete darkness so that the pineal gland secretes optimal melatonin, a powerful antioxidant).**

- Chamomile or mint tea: These mild herbs assist with relaxation. Brand: Traditional Medicinals.
- Valerian root (liquid or pills): This herb assists with sleep and anxiety. Brand: Gaia Herbs.
- 5 HTP (Hydroxytryptophan): This herbal remedy is a precursor to making serotonin and helps with insomnia and depression. Don't take it if you're on MAO inhibitors or SSRI medications. Brands: PhysioLogics, Jarrow.
- Sound Sleep: Herbal blend to relieve insomnia. Brand: Gaia Herbs.
- Sleep Fix: Herbal-homeopathic blend to relieve insomnia. Brand: NaturalCare.
- Benesom: A powerful vitamin blend that supports restful sleep and relaxation. Brand: Metagenics.
- Magnesium (chelated, 100–200 mg. at bedtime): Magnesium relaxes the muscles, spasms, and encourages sound sleep. Brand: Magnesium Glycinate (Metagenics), Magnesium Opitmizer (Jarrow).
- Melatonin: This hormone, produced by the pineal gland, regulates sleep-waking cycles. Brands: PhysioLogics, Jarrow.

### Anxiety Remedies

- Anxiety X: Excellent vitamin-amino acid blend that relieves anxiety. Brand: Olympian Labs.
- Serenity (liquid capsules): This herb complex sedates the central nervous system. Brand: Gaia Herbs.
- Nervous Tension Remedy: Homeopathic remedy designed to relieve anxiety or depression. Brand: Metagenics.
- Trancor: Vitamin-herbal blend that regulates GABA and the exitatory effects of glutamate. Reduces nervousness and supports tranquility. Brand: Metagenics.
- Liquid Serenity: This herbal formula relieves anxiety. Brand: Wise Woman Herbals.
- Serenagen: This is a Chinese herbal formula for "stressed and wired" symptoms. Brand: Metagenics.

### Depression Remedies

- St. John's Wort (liquid capsules or pill form): This is a natural antidepressant and antiviral. Don't take it if you're on MAO inhibiters or SSRI medications. Brands: Gaia Herbs, Metagenics, Perika Pro (MMS).
- Depress-X: Herbal-vitamin blend to assist with serotonin production. Brand: Olympian Labs.

### Muscoskeletal Builders

- Glucosamine, chondroitin, MSM: Foundational components to repair and support joints, cartilage, and bone. Brands: Glucosamine Chondroitin Maximum Strength capsules (Metabolic Response Modifier), Chondrocare (Metagenics), Glu-Chon-MSM (Olympian Labs), Emergen C Lite with glucosamine/chondroitin (Alacer) powder packets.

### Anti-Wasting and Weight-Gain Remedies

- Perfect Protein: This cross-flow micro-filtered whey protein is composed of 25 percent branched chain amino acids (BCAAs), easy-to-absorb forms of amino acids that support optimal absorption and nitrogen retention in an easy-to-use powder mix. Brand: Metagenics.

- ProGain: This is a high-calorie, high-nitrogen, peptide-based supplement that features many of the macro- and micronutrients needed to promote healthy weight gain and lean muscle mass. Brand: Metagenics.

- Goatein Powder: Predigested goat-milk protein powder. Easy to assimilate, even for those who are lactose intolerant. Brand: Garden of Life.

# DAILY SAMPLE SUPPLEMENT SCHEDULE*

| Supplement | Breakfast | Lunch | Dinner | After meal* | Empty stomach* |
|---|---|---|---|---|---|
| Antifungal[1] (dose depends on which product is used) | 2 | | 2 | | X |
| Mynax | 2-3 | 2-3 | 2-3 | X | X |
| Vitamin C[2] | 2,000 mg | 2,000 mg | 2,000 mg | X (pills) | X (powder) |
| B complex (100 mg)[3] | 1 | 1 | | X | |
| Vitamin E (400 iu)[4] | 1 | 1 | 1 | X | |
| Evening primrose oil (1,300 mg)[5] | 1 | | | X | |
| EPA/DHA fish oil[6] | 1 tbsp | | 1 tbsp | X | X |
| Vitamin D₃ | 1 (2,000 i.u.) | | | X | X |
| Amino acid complex | 1,000 mg | 1,000 mg | | X | |
| NeuroActives | 2 capsules | 2 capsules | | X | |
| Multivitamin/mineral[7] | Dose depends on which product is used | | | X | |
| Digestive enzyme | 1 | 1 | 1 | X | |
| Oxygen Elements Plus[8] | 10 drops | 10 drops | 10 drops | X | X |
| Metacrin DX[9] | 1 | 1 | 1 | X | |
| Gingko biloba | 1 | | | X | |

*X's after meals and empty stomach denotes your choice to take the supplement with or without food.

continued overleaf

## DAILY SAMPLE SUPPLEMENT SCHEDULE, *continued*

1. Antifungal/antimicrobial—Nystatin (1 pill–three times a day) or Nilstat powder (1/8 tsp–three times a day) can be used for up to 2 years. Candida Cleanse (2 pills–two times a day), Primal Defense (2 pills–two times a day), or pau d' arco (3 pills, two dropperfuls twice a day, or three cups of tea a day) can be rotated and used for a lifetime. Start slowly with any of these products—one pill for three days to one week, next increase to two pills for three days to one week, and so on.

2. Buy vitamin C with mineral ascorbates and/or bioflavonoids.

3. Buy a yeast-free B complex.

4. Buy vitamin E with mixed tocopherols and tocotrienols—make sure that it says d-alpha, not dl-alpha, which is synthetic.

5. Buy hexane-free evening primrose oil.

6. Buy high-potency good-quality liquid fish oil—see Resources, page 299.

7. Buy a multivitamin/mineral that is iron-free and has chelated minerals for better absorption.

8. Shake Oxygen Elements Plus well each time before squirting drops out. Put into six to eight ounces of water and drink immediately. Can be taken with or without food. Start by taking 3 drops in water once a day for two or three days. Then increase to 7 drops twice daily for two or three days. Next increase to 10 drops three times daily. For more-severe cases of MS six times daily is recommended. Take this product one-half hour away from pharmaceutical medication as it can enhance the medication. Some find that taking oxygen drops after 6 p.m. keeps them awake at night.

9. Slowly work up liver support detoxification supplement.

**Add supplements slowly**, there is no race, as everyone's system will not react the same. Most important is to start with the digestive enzyme to make sure you are absorbing your supplements and food. Then add another supplement, one by one, and work up slowly to the recommended dosage. See how you do. The antifungal, oxygen, liver support, and red clover are the ones that can make you feel worse before you feel better because there are getting rid of yeast/fungus, parasites, toxins, etc. Make sure your bowels move daily making your detoxification process easier. If not, use a formula listed under elimination problems, page 252. If any of the other supplements cause ongoing stomach discomfort, itchy skin, nausea, diarrhea, or other upsetting symptoms discontinue usage.

Water—drink half your body weight in ounces throughout the day (you can subtract from water the number cups of herbal tea you drink)

Red clover tea (drink two to four cups daily, unsweetened, hot or cold (after brewed) with or without food)—start with one cup for two or three days and then increase to two cups daily for two or three days and so on. Initially stop drinking tea by 6 p.m. because the cleansing response to your bloodstream may keep you awake at night even though there is no caffeine in the herb. (See Chapter Nine, "Internal Treatments, Supplements, and Detoxification.")

# ENERGY BOOSTERS

Looking for more energy? Try one or more of these suggestions.

## B$_{12}$

- B$_{12}$ shots (from your physician)—weekly for the first four weeks, then monthly
- Sublingual B$_{12}$ tablets daily (1,000 mcg)

## Honey-Rosemary Tea Cocktail*

- Place 1 heaping tsp raw, unfiltered orange honey under tongue and let it dissolve slowly. Place 1 tsp of rosemary sprigs and/or needles in 8 oz boiling water. Let rosemary steep for 5 minutes, strain, and drink. Honey brings oxygen to your cells and is a tranquilizer that relieves spasticity, while rosemary opens up breathing passages and balances the nervous system. This cocktail is beneficial for attacks, spasticity, and extreme fatigue. You can use it while treating candida, because your body recognizes the emergency situation versus feeding candida.

*Avoid honey if you're allergic to bees.

## Bee Pollen or Propolis*

- Take 1 tsp of local bee pollen and/or bee propolis mixture under your tongue first thing in the morning and in

the mid-afternoon. If you have bad airborne allergies, start slowly and work up to 1 tsp daily.

*Avoid if you're allergic to bees.

### Free-Form Amino Acid Blend

- Take 1,000 mg twice daily, before meals.

### Green Tea

- One caffeinated cup in the morning and afternoon.

### DHEA Hormone Sublingual Spray

- Take 10 mg daily, one 5-mg spray under your tongue when you arise and one at 3 p.m. You can increase this dosage as needed for energy. Do not take DHEA for more than one or two months—helps relieve extreme adrenal exhaustion.

### Ginseng

- Korean (hot) ginseng is good for extreme exhaustion (hypofunction).

### Endocrine/Immune Enhancers

- Adrenal Health (Gaia Herbs)—take as directed on bottle to stimulate adrenal function and eliminate fatigue.
- Energy Vitality (Gaia Herbs)—helps support body stamina from being overstressed.

- Adrenozyme (Apex)—one pill three times daily with food. Glandular support to help balance the endocrine system and relieve chronic stress.
- Thyrozyme (Apex)—one pill breakfast and lunch. Herbal vitamin formula to boost thyroid function and increase energy.
- Advanced Ambrotose (Powder, work up to 1 tsp., two to three times a day, in water with food: A glyconutrient designed to rapidly support effective cell-to-cell communication and increase energy. The messages cells exchange directly affect your natural defense (immune) and endocrine (glandular)systems, as well as affecting proper gland and organ function. Brand: Mannatech.
- Max GXL (work up to 3 pills twice daily, breakfast and lunch): A glutathione product. Glutathione functions both as an antioxidant and an antitoxin, and is a major defense system against illness and aging. Max GXL will enhance the immune system, increase energy, improve concentration, permit increased exercise, and improve heart and lung function. Brand: Max International.

### Deep-Breathing Exercises

- Mouth closed, inhale (expanding your stomach out) and exhale (pulling your stomach in tightly) as rapidly as you can for 30 seconds to 1 minute. Keep your focus on the movement in your belly region. At the end of the exercise, take one to three slow, deep breaths to get centered again. Get up slowly before walking.

# ENVIRONMENTAL CHECKLIST

Install air purifier at home and office

Install water-filtering system at home

Eliminate any mold growth in house or apartment

Eliminate synthetic pesticides and/or herbicides used on plants and in the garden

Remove down and/or feather pillows and comforters

Remove baskets and dried flowers

Install carbon-filter showerhead

Eliminate aluminum zirconium and propylene glycol deodorants

Change to using natural body-care products

Change to using natural, non-toxic cleaning products

## STRESS BUSTERS

### Shower Release

Stand in your shower and let the warm water caress the crown of your head. Take a deep breath and mentally give yourself permission to release everything negative, stressful, and fear-based that you've been holding onto. When you exhale, see and feel all your stress and fear draining out of your body through your fingertips and the soles of your feet as black smoke and debris. Let it go down the drain.

When finished letting go, imagine the colors golden-white and pink light coming out from the faucet head down into your head and out through your body. The golden-white light is universal healing energy, and the pink light represents unconditional love. Breathe it in and let it replace what you just let go of. Inhale and feel the light healing every cell, tissue, and organ, and bringing in more oxygen, energy, strength, courage, and hope.

### Shoulder Release

Mouth closed, inhale while pulling your shoulders up toward your ears. Exhale while dropping shoulders and rib cage. Repeat for one to three minutes, increasing the speed slowly.

## Cat-Cow Flexions

Place the palms of your hands and knees down on a firm but padded surface. Mouth closed, inhale while letting your back sag toward the floor and raising your head to look gently up toward the ceiling. Don't force the movement. Keep your mouth closed as you exhale while dropping your chin to your chest and rounding back upward. Do for one to three minutes, starting slowly and building up speed.

## Exercise

Take a walk. Breathe, look at the landscape, the flowers, the sky, the trees. Notice the sensuous pleasures of Mother Earth.

Swimming, tai chi, qi gong, yoga, and cycling are also excellent ways to relieve stress and increase circulation.

## Yoga Stretches

Stand and spread legs a shoulder-width apart. Bend over without locking your knees and let your arms and hands drop until they touch the ground. Stay there for one minute taking deep breaths.

Place your feet shoulder-width apart, bend your knees, lower yourself into a squatting position, and breathe. Keep your heels on the ground. This exercise opens up the lower back and is great if you sit all day at work.

## Hug a Tree

Wrap your arms around a tree and lean your body from the waist up against it. Feel the tree pulling out the stress from the bottom of your feet. Inhale and exhale slowly for 60 seconds, releasing tension and stress from your mind and body.

## Self-Hypnosis
## (Takes ten minutes)

Lie down or sit comfortably in a chair.

Focus on a spot on the wall or gaze at an object. Fixate on it until you feel your eyelids getting heavy.

Close your eyes.

Take five slow, deep breaths.

Give yourself permission to relax every muscle, nerve, and fiber in your body. Begin sending relaxation and golden-white and pink light down into the crown of your head and spreading out into your scalp, facial, and jaw muscles.

Feel the relaxation moving behind your head, down your back, buttocks, thighs, knees, calves, and feet. Let all tension, stress, and negativity go. Move the light and relaxation into the tops of your shoulders, down your arms, and into your chest, abdominal, and pelvic regions. Then move it down into your legs, knees, and down into your ankles and toes.

Visualize and feel the relaxation and light permeating every cell, tissue, and organ. Breathe.

Allow your mind to still for five minutes. Let conscious thoughts just pass by.

Once you've been in a still point for five minutes, focus on your body. Inhale golden-white and pink light into your brain and spinal cord. See your myelin sheath smooth and continuous. Visualize your electrical circuits working optimally. If you see or feel any dark spots or imbalances, draw in the golden-white and pink light and exhale the imbalances out through your feet. Feel yourself completely balanced, whole in every organ and tissue.

Take three deep breaths and return your awareness to the room.

Open your eyes and notice the difference!

# BREATHING TECHNIQUES

It's important to breathe deeply each day. Most people who are leading stressful lives shallow-breathe from the chest up. However, a correct breath involves full expansion of the chest and abdomen starting from the groin, up through the belly, through the ribs, and into the chest. Taking one to three minutes a couple of times a day to practice deep breathing will remove toxins and stress, and put you back into your point of power, the now moment. Proper breathing is crucial for supporting a healthy immune system.

## Deep-Breathing Technique

*Inhale:* Mouth closed (or open if you have sinus or breathing problems), inhale slowly, expanding your belly, then your rib cage, and then your chest, to a count of seven. Hold your breath for seven seconds. (If your abdominal area doesn't move, put your hands on your lower abdomen, at the level of your navel, to help train yourself to fill this area with breath.) Don't give up on your first try. Keep practicing. Sometimes it's easier to get the belly to expand if you start by lying down flat on your back. After you learn this movement, you can adjust to deep breathing while sitting up.

*Exhale:* Open your mouth slightly with lips pursed and exhale slowly, making a noise as if you were blowing out a candle, letting the air leave first from your belly, then from your rib cage, and finally from your chest to the count of seven.

*Optional:* Each time you inhale, visualize golden-white and pink light entering through the crown of your head and healing every cell, tissue, and organ in your body. On each exhale, release

any physical imbalances, tension, stress, fear-based emotions, and negative thoughts by feeling them leave as black smoke through the soles of your feet.

### Breath of Fire
#### (Cleanses the blood and stimulates the brain)

Keeping your mouth closed, breathe in and out as if you're blowing out a candle with your nose.

On the inhale, expand your stomach outward.

On the exhale, pull the stomach in.

Inhale and exhale vigorously and quickly for thirty seconds and slowly work up to three minutes.

### Moon Breath
#### (Relaxes the body's parasympathetic nervous system)

Make an "antenna" with the fingers of your right hand by pointing them straight up to the ceiling. Block your right nostril with your thumb.

Take a long, deep inhale, hold for ten seconds, and exhale through the left nostril.

Do for thirty seconds and slowly work up to three minutes.

### Sun Breath
#### (Energizes the body's sympathetic nervous system)

Make an "antenna" with the fingers of your left hand by pointing them straight up to the ceiling. Block your left nostril with your thumb.

Take a long, deep inhale, hold for ten seconds, and exhale through the right nostril.

Do for thirty seconds and slowly work up to three minutes.

# Strengthening Exercises

**By Kendel Pink**
Certified Pilates Instructor
(www.pilatesinthecanyon.com)

It is important when doing the following exercises that you move on the exhale instead of the inhale and keep focused on the abdominal area, making it the center point of each exercise.

## Basic Mid-Core Awareness

While seated, standing, or lying down on your back, imagine pulling the back of your belly button to the front of your spine and keeping a constant tension there for twenty seconds. You can do this everywhere through out your day—while driving, doing dishes, at lunch, brushing your teeth . . . everywhere!

## Pelvic Floor Elevators

While seated, standing, or lying down inhale into the pelvic region. Then, on the exhale, feel the muscles in your pelvic floor lifting up slowly like an elevator (otherwise known as a Kegel). Inhale, then exhale, and take it up to the first, second, and third floor. Then exhale and resist your muscles back down into your pelvic region. Slowly release your pelvic floor back down to the start position. You can do this as often as you are able to.

## Seated Roll-Down

Sit on the floor or edge of a bed, in an upright position with your knees bent and your feet flat on the floor or bed. Inhale to lengthen your spine, then exhale and slowly allow your pelvis to gently roll under you as you imagine your spine touching the floor/bed one vertebra at a time. Feel a sense of concavity in the abdomen. Only go down as far as you can while maintaining that concavity in the abdomen (no holding, just a static pause). Exhale and slowly feel the abdominal wall pulling you up until you return to a full upright position. Repeat eight to ten times.

## Knee Drops

Lie on your back with your knees bent and all four corners of your feet making contact with the floor. Keep both shoulders squarely on the floor to maintain proper stability. Inhale then exhale and pull your navel toward your spine to support your lower back. Then, keeping your feet on the floor, allow both knees to drop toward the floor on your right. Feel your abdomen supporting the weight of your legs, and go only as far as it can support that weight. When you reach your maximum position, inhale and exhale, then raise your legs back to center using the oblique muscles in your abdomen. Repeat the movement the left side, and continue alternating for a total of eight times on each side.

## Leg Floats

Lie on your back with your knees bent and all four corners of your feet making contact with the floor. Exhale and focus on using the muscles in your lower abdomen to raise one leg off the floor. Bring your leg into "tabletop position" with your knee at ninety degrees to your hip and your shin parallel to the ceiling. Then

exhale and raise your other leg. Pay close attention to keeping your lower back flat on the floor by pulling your navel deeper toward your spine. Once both legs are in tabletop position, alternate lowering and raising each one of your legs so your foot reaches the floor and then raising them back into tabletop. The objective is to keep your lower back flat so it doesn't arch away from the floor. You can increase your awareness of this by imagining that the area of your back below your waistband (the sacrum) is like a triangular stone that's sinking deeper into mud. Feel the freedom in your hip joint as it moves with ease. Focus on your abdomen, moving your legs, not your hips.

### Hip Hinge

Lie on your back with your knees bent and all four corners of your feet making contact with the floor. Imagine that your torso is sandwiched between two two-by-fours that start at the middle of your chest and extend out beyond your pubic bone and tailbone. Press your feet firmly into the ground while you make equal contact with your abdomen and glutes (butt muscles). Lift torso/hips off the ground as one unit. You may go up as high as your shoulders, as long as you maintain a long and parallel spine. If you experience discomfort in your lower back, do not raise up so high. Lower yourself back to the floor in the same manner that you came up. Repeat twenty times.

### Plank

Kneel on the floor on all fours, with your hands directly under your shoulders and your knees under your hips. Inhale and imagine your spine lengthening like taffy from the crown of your head to your tailbone. Use your abdomen and pull your navel to the sky. Slide one leg behind you, straightening it with your toes curled under on

the floor. Increase the focus of your navel to the sky as you send the other leg behind you. You will be in a push-up position. Think strongly about every aspect of your body—your neck is lengthened, your back is strongly supporting you over your hands, your abdomen is lifting your torso and elongating your spine, your legs are strongly pressing together and into the floor (don't lock your knees). Breathe in deeply through your nose and exhale forcefully out your mouth. Try to hold the position for sixty seconds. You can modify this by placing yourself on your elbows instead of on straightened arms, and/or by starting on your knees instead of on your toes.

# FEAR BUSTERS

Fear can be your enemy. It is the dragon, the trickster—and our greatest teacher. Fear is rooted in past events, whereas anxiety is dread of future events. Your best weapon against both is to stay in the present moment—the now. The now is your place of power!

## BASIC PROCESS FOR
## DEALING WITH FEAR AND ANXIETY

There are three basic steps to dealing with fear and anxiety.

1. First and foremost, you need to let yourself be aware of when you are feeling fear and thinking fear-filled or anxious thoughts. Denial will only make you feel more paralyzed.
2. Second, talking out loud to yourself is a powerful action step for dispelling fear and anxiety. Words are powerful, and the vibration rate of words spoken out loud is seven times more powerful than that of words spoken internally. Light and sound come together and enhance the manifestation power of affirmations when you speak them out loud. So, immediately acknowledge and identify your fear-filled or anxious thoughts and feelings. Speak to them out loud. If you're in a situation where you can't speak out loud, speak to yourself silently and listen to your inner voice.

3. Third, after you acknowledge your fear-filled or anxious thoughts and feelings, give yourself permission to release them and replace them with positive thoughts and feelings or neutral actions, i.e. take a deep breath, drink some water, focus back on your work project.

   You may find it helpful to speak to your fears or anxieties as if they were persons. You might say, "Okay, I see you trying to sneak up on me again. I accept that I'm feeling fear about the numbness in my legs. I'm afraid I won't be able to walk."

Let yourself feel these words, then say, "I give myself permission to release these thoughts and feelings now."

Then replace your fear-filled and anxious feelings and thoughts with something peaceful or positive: "I am safe, I am healthy and whole. I can walk, will continue to walk, and my central nervous system is better every day." Or just take a short walk, take a deep breath, call a friend, or read a book.

While going through this process, you might also use these visualizations:

- After you acknowledge your negative and fear-filled thoughts, stuff them into a large balloon of whatever color you choose. Tie a knot, set it free, and see white light exploding the balloon as it drifts into space. Visualize your fear-filled thoughts transforming into positive thoughts and feelings.
- Visualize a radio dial in your mind's eye. Hear, see, and feel the volume of your fear at ten on the dial. Start turning the dial from ten to nine, eight, seven . . . and visualize your fear or anxiety becoming mute as you turn down the volume. Visualize the fear disappearing as the dial reaches zero.

- Imagine a ticker tape moving through your mind's eye. As you acknowledge your fear-based or anxious emotions or thoughts and see them racing past, say, "I see you. Now, go play outside. I don't have time for you today."

## ILLUSIONS

Many of our fears are rooted in our childhood experiences, so it's important for you as an adult to take control over your fearful inner child and reassure him or her that you're safe and protected by your adult self. You can say, "We've both had enough of these fears, and I'm tired of being jerked around, so let's let this pattern go and do something different." "That was then and this is now."

Positive intentions followed by positive action and reassurance to your doubtful child can turn negative spirals into positive ones.

## PANIC ATTACKS

If you feel a panic attack setting in, exhale all the air from your diaphragm and, at the end of your exhale, push out the sound "huh" three times. This forces the panic and breath out of your body. Follow with a deep, full breath. Repeat until you feel calmer.

You can also rub or press the area just below your collarbone and next to your rotator cuff. This area is an acupressure point that opens up your lungs so you can take the full breaths that will help you calm down.

Lack of oxygen can make you feel anxious, fearful, or "speedy." Avoid lazy breathing. Practice deep breathing as often as you can during the day.

## MOVING THROUGH FEAR

Realize that you're bigger than your fears and anxieties. Step back, as if you're looking down on a mass of fear that you're holding in your hand, and remind yourself that you're more than this energy of illusion. Remind yourself of all the other challenges you've met and moved through successfully. Do everything you can to encourage yourself to find new ways of releasing fear and anxiety.

## MAKE ACTION A HABIT

Take action each time fear or anxiety surfaces. Repetition is what creates habits, so stick with acknowledging and getting rid of fearful thoughts and feelings each time they arise. If you do, you'll soon stop having them because you'll have retrained your subconscious mind with a new habit, or created feelings of neutrality about those situations, events, or possibilities. The key is to take advantage of the wisdom and lessons you can gain from those negative events, but to end up feeling neutral rather than negatively charged by them.

# SAMPLE AFFIRMATIONS

(Either at the beginning or end of your affirmation,
state "easily and effortlessly.")

---

- I am expanding in spirit, in health and in purpose. I am essential. I am whole.
- Every cell, tissue, and organ in my body is healing and repairing itself easily and effortlessly.
- I love, accept, and respect myself and my body unconditionally.
- I allow myself to be healthy.
- I choose only those thoughts that are positive and supportive.
- I am safe and secure in all spaces and places. I am guided and protected.
- I am worthy because I exist. I exist, therefore I am worthy.
- I am patient and tolerant.
- I am peaceful, happy, and grateful.
- I am trusting. I let go and let God.
- I am free of fear and anxiety. I am sound of mind.
- I am courageous and tenacious.
- I am confident and powerful.

- My central nervous system is whole, balanced, and working optimally.

- My muscles are balanced and strong.

- I am lovable. I am okay just the way I am.

- I am successful personally and professionally.

# CHALLENGING OUTDATED BELIEFS

(See Chapter Fourteen, "Your Spiritual Self")

For each of these exercises, start by putting yourself in a comfortable environment where you won't be disturbed. Then begin uncovering your deep-seated beliefs by asking yourself with honesty these questions.

**My Beliefs About Health**

Think about the following questions globally so you can get to the root answer to the questions below.

- Do I believe I can cure myself of a disease?

- Do I believe MS is curable?

- Do I believe I have the right to live a healthy life?

- Do I believe health is within my reach?

- Do I believe health is a choice?

- Do I believe I have the courage and strength to get well?

Does my present
belief make me happy? _____

Does this ring true
for me at this time? _____

Does this belief
keep me inflexible? _____

Is this belief a
hand-me-down that I
received from someone
else when I didn't
conciously realize I had
the power to choose my
own beliefs (for example,
when I was a child?) _____

Does this belief
augment my life,
others' lives, and my
world as a whole? _____

I now choose to believe (write out your new beliefs):

_____

_____

_____

_____

_____

_____

_____

_____

_____

_____

_____

_____

_____

_____

Affirm these new beliefs every day with conviction and emotion. Think and act as if these new beliefs are true. Feel them, breathe them, affirm them by speaking out loud, and mirror them until they truly become yours.

## My Beliefs About Myself

Think about the following questions globally so you can get to the root answer to the questions below.

- Do I believe I am worth my existence?

- Do I believe my worth is based on whether others love and validate me?

- Do I believe I am not good enough?

- Do I believe loving myself unconditionally is a key ingredient to health?

- Do I believe I have a purpose and can make a difference in this world?

- Do I believe perfection equates to not being good enough?
  Versus imperfect growth, meaning there is always room to grow?

Does my present
belief make me happy? _____

Does this ring true
for me at this time? _____

Does this belief
keep me inflexible? _____

Is this belief a
hand-me-down that I
received from someone
else when I didn't
conciously realize I had
the power to choose my
own beliefs (for example,
when I was a child?) _____

Does this belief
augment my life,
others' lives, and my
world as a whole? _____

I now choose to believe (write out your new beliefs):

_____

_____

_____

_____

_____

_____

_____

_____

_____

_____

_____

_____

_____

_____

_____

Affirm these new beliefs every day with conviction and emotion. Think and act as if these new beliefs are true. Feel them, breathe them, affirm them by speaking out loud, and mirror them until they truly become yours.

## My Beliefs About Love

Think about the following questions globally so you can get to the root answer to the questions below.

- Do I believe I am worthy of being loved?

- Do I believe I can attract my equal?

- Do I believe I place my value in the hands of others by their acceptance of me?

- Do I believe I can give and receive love?

- Do I believe sickness is a way of getting love and attention?

Does my present
belief make me happy?       _____

Does this ring true
for me at this time?       _____

Does this belief
keep me inflexible?       _____

Is this belief a
hand-me-down that I
received from someone
else when I didn't
conciously realize I had
the power to choose my
own beliefs (for example,
when I was a child?)       _____

Does this belief
augment my life,
others' lives, and my
world as a whole?       _____

I now choose to believe (write out your new beliefs):

_____

_____

_____

_____

_____

_____

_____

_____

_____

_____

_____

_____

_____

_____

Affirm these new beliefs every day with conviction and emotion. Think and act as if these new beliefs are true. Feel them, breathe them, affirm them by speaking out loud, and mirror them until they truly become yours.

## My Beliefs About Abundance

Think about the following questions globally so you can get to the root answer to the questions below.

- Do I believe money defines my worth?

- Do I believe I am lacking because I don't have wealth or possessions?

- Do I believe being sick gives me an excuse not to succeed?

- Do I believe I deserve abundance, prosperity, and health?

Does my present
belief make me happy?  _____

Does this ring true
for me at this time?  _____

Does this belief
keep me inflexible?  _____

Is this belief a
hand-me-down that I
received from someone
else when I didn't
conciously realize I had
the power to choose my
own beliefs (for example,
when I was a child?)  _____

Does this belief
augment my life,
others' lives, and my
world as a whole?  _____

I now choose to believe (write out your new beliefs):

_____

_____

_____

_____

_____

_____

_____

_____

_____

_____

_____

_____

_____

_____

_____

_____

Affirm these new beliefs every day with conviction and emotion. Think and act as if these new beliefs are true. Feel them, breathe them, affirm them by speaking out loud, and mirror them until they truly become yours.

## My Beliefs About Success

Think about the following questions globally so you can get to the root answer to the questions below.

- Do I believe I have what it takes to succeed?

- Do I believe being sick excuses from having to take risks and to move past challenges?

- Do I believe something always goes wrong preventing me from succeeding?

- Do I believe in the fear of failure and/or the fear of success?

- Do I believe I have to struggle in life and that everything happens the hard way?

Does my present
belief make me happy?        _____

Does this ring true
for me at this time?         _____

Does this belief
keep me inflexible?          _____

Is this belief a
hand-me-down that I
received from someone
else when I didn't
conciously realize I had
the power to choose my
own beliefs (for example,
when I was a child?)         _____

Does this belief
augment my life,
others' lives, and my
world as a whole?            _____

I now choose to believe (write out your new beliefs):

_____

_____

_____

_____

_____

_____

_____

_____

_____

_____

_____

_____

_____

_____

_____

_____

Affirm these new beliefs every day with conviction and emotion. Think and act as if these new beliefs are true. Feel them, breathe them, affirm them by speaking out loud, and mirror them until they truly become yours.

## My Beliefs About Spirituality

Think about the following questions globally so you can get to the root answer to the questions below.

- Do I believe in hope?

- Do I believe I can create my own reality?

- Do I believe I have a purpose in this world?

- Do I believe in God or a universal energy?

- Do I believe thoughts create energy?

- Do I believe fear-based emotions can weaken my immune system?

Does my present
belief make me happy?     _____

Does this ring true
for me at this time?      _____

Does this belief
keep me inflexible?       _____

Is this belief a
hand-me-down that I
received from someone
else when I didn't
conciously realize I had
the power to choose my
own beliefs (for example,
when I was a child?)      _____

Does this belief
augment my life,
others' lives, and my
world as a whole?         _____

I now choose to believe (write out your new beliefs):

_____

_____

_____

_____

_____

_____

_____

_____

_____

_____

_____

_____

_____

_____

_____

_____

Affirm these new beliefs every day with conviction and emotion. Think and act as if these new beliefs are true. Feel them, breathe them, affirm them by speaking out loud, and mirror them until they truly become yours.

## WEEKLY OVERALL PROGRESS CHART (Tracking your treatment plan)

| | Mon | Tues | Wed | Thurs | Fri | Sat | Sun | Total |
|---|---|---|---|---|---|---|---|---|
| I ate a healthy diet. | | | | | | | | |
| I did yoga, exercise, or physical therapy. | | | | | | | | |
| I did breathing exercises. | | | | | | | | |
| I maintained my schedule of supplements and vitamins. | | | | | | | | |
| I drank my quota of water and herbal teas. | | | | | | | | |
| I did my dry skin brushing. | | | | | | | | |
| I got enough sleep. | | | | | | | | |
| I spent at least 15 minutes outdoors or in sunlight. | | | | | | | | |
| I wrote in my journal. | | | | | | | | |
| I spoke affirmations. | | | | | | | | |
| I laughed and smiled. | | | | | | | | |
| I meditated, did visualizations, or focused on positive thoughts. | | | | | | | | |

## WEEKLY OVERALL PROGRESS CHART (Tracking your treatment plan), *continued*

| | Mon | Tues | Wed | Thurs | Fri | Sat | Sun | Total |
|---|---|---|---|---|---|---|---|---|
| I released fear-based emotions and forgave myself. | | | | | | | | |
| I read something relaxing or inspiring. | | | | | | | | |
| I connected with others by visiting or speaking with a friend or family member. | | | | | | | | |
| I rewarded myself with a massage, movie, small gift, or a pat on my own back for how well I got through the day. | | | | | | | | |
| I delegated duties to relieve stress. | | | | | | | | |
| I received or gave a hug to loved one or animal. | | | | | | | | |

# RESOURCES

## Books and Information Packets

Crook, William G., M.D. *The Yeast Connection: A Medical Breakthrough*, (Vintage, 1986), www.candida-yeast.com

_____ with Elizabeth B. Crook and Hyla Cass, *The Yeast Connection and the Woman* (Professional Books/Future Health, 2003)

_____ *The Yeast Connection Handbook* (Professional Books/Future Health, 1999)

_____ *Yeast Connection Success Stories: A Collection of Stories from People Who Are Winning the Battle Against Devastating Illness* (Professional Books/Future Health, 2002)

Graham, Judy. *Multiple Sclerosis: A Self-Help Guide to Its Management* (Healing Arts Press, 1984)

Kaufmann, Doug A. *The Fungus Link: An Introduction to Fungal Disease Including the Initial Phase Diet* (Media Trition, 2001)

_____ *The Fungus Link, An Introduction to Fungal Disease Including the Initial Phase Volume 2: Tracking the Cause* (Media Trition, 2003)

Perlmutter, David, M.D. *BrainRecovery.com: Powerful Therapy for Challenging Brain Disorders* (Perlmutter Health Center, 2000). His clinic treats MS and Candida and offers hyperbaric oxygen treatments. http://www.perlhealth.com/index.htm (800) 530-1982

Trowbridge, John Parks, M.D., and Morton Walker, D.P.M. *The Yeast Syndrome: How to Help Your Doctor Identify and Treat the Real Cause of Your Yeast-Related Illness* (Bantam, 1986)

Truss, C. Orion, M.D. *The Missing Diagnosis* (Missing Diagnosis, 1985)

## Cookbooks

Connolly, Pat, and Associates of the Price-Pottenger Nutrition Foundation, *The Candida Albicans Yeast-Free Cookbook: How Good Nutrition*

*Can Help Fight the Epidemic of Yeast-Related Diseases* (McGraw-Hill, 2nd edition, 2000)

Crook, William G., M.D., and Marge Hurt Jones, R.N., *The Yeast Connection Cookbook: A Guide to Good Nutrition and Better Health* (Professional Books/Future Health, 1989)

Greenberg, Ronald, MD, and Angela Nori, *Freedom from Allergy Cookbook* (Blue Poppy Press, 2000)

Jones, Marjorie Hurt, R.N., *The Allergy Self-Help Cookbook* (Rodale Books, 2001)

Semon, Bruce, M.D., PhD., and Lori Kornblum, *Feast Without Yeast: 4 Stages to Better Health* (Wisconsin Institute of Nutrition, 1999)

Turner, Kristina, *The Self-Healing Cookbook* (Earthtones Press, 1989)

## Books and Catalogs on Nutrition and Health

Bernard Jensen International
    http://www.bernardjensen.org
    (760) 291-1255
    Natural products and books

Price-Pottenger Nutrition Foundation
    http://www.price-pottenger.org
    (800) 366-3748

Amazon Books
    www.amazon.com

## Research Papers, Books, Articles

Natural Books and Products Catalog
    (888) 743-1790 or (760) 743-1790

Trudeau, Kevin, *Natural Cures* (Alliance Publishing, 2005)
    www.naturalcures.com
    Natural health newsletter with valuable information on health, advocacy, nutrition, natural solutions to disease.

Natural-health newsletter site with valuable articles on nutrition, diseases, supplements, and other topics.
    www.mercola.com

## Books and Resources on Mind-Body Healing

Emotional Freedom Technique
> http://www.emofree.com
> You can do this technique and therapy on your own to release fears and phobias, addictions and cravings, fear-based thoughts and emotions, and physical symptoms.

The Secret (DVD)
> http://thesecret.tv/home.html
> A DVD movie to help you understand, inspire, and change your life for the better.

Hay, Louise L., *You Can Heal Your Life* (Hay House, 1985)

Myss, Caroline, *Anatomy of the Spirit* (Crown, 1996)

Chopra, Deepak, *Quantum Healing: Exploring the Frontiers of Mind* (Bantam, 1990)

Dwoskin, Hale, *The Sedona Method: Your Key to Lasting Happiness, Success, Peace and Emotional Well-Being,* (Sedona Press, 2003

Siegel, Bernie S., *Love, Medicine and Miracles* (Rider & Co., 1999)

Wilde, Stuart, *Infinite Self* (Hay House, 1996)

## Supplements and Products

Apex Energetics
> www.apexenergetics.com
> (800) 736-4381
> (Use my patient account number P2017 when ordering)
> Products: Adaptocrine, AdrenaCalm cream, Adrenozyme, Bilemin, Estrovite, Glysen, Metacrin DX, Methyl-SP, Proglyco SP, Prosta DHT, Thyrozyme.

Aragon
> www.aragonproducts.com
> Product: Kalawalla (*Polypodium leucotomos*).

Clear Way
> www.clearwayhealth.com
> (310) 391-2017
> Colonics; Nationwide—www.i-act.org.

EcoQuest International
   www.ecoquestintl.com
   (800) 486-4994. Sign up under #315799
   Products: Air purifying and water systems.
Emerson Ecologics
   (High-grade doctor line of vitamins, supplements, and herbs)
   www.emersonecologics.com
   (800) 654-4432. Tell customer service that you want to set up a
   patient account under Ann Boroch. Brands: Bio-Pharma Scientific,
   Bio-Tech, Caren Advanced Nutritionals, Carlson, Designs for
   Health, Douglas Laboratories, Emerita, Gaia Herbs, Metabolic
   Maintenance, MMS, MetabolicResponseModifier (MRM), Nature's
   Way, Nordic Naturals, PhysioLogics, iNutritionals, Wise Woman
   Herbals, World Nutrition.
Global Health Trax
   www.ghtdirect.com/boroch
   Products: Oxygen Elements Plus.
Koehler Co., USA
   www.koehlerusa.com
   (800) 320-6035
   Products: Mynax, Canax, Peaca, Tropicor.
Metagenics
   www.drann.meta-ehealth.com, (Register and order online)
   Products: Adreset, Azeo Pangeon, Benesom, BioSom Spray, Ceralin
   Forte, Chondrocare, EPA/DHA High Potency Liquid, Endefen,
   Fenugreek Plus, Gingko Rose, Glycogenics, Herbulk, LipoGen,
   Magnesium Citrate, Magnesium Glycinate, Meta EPO, Metagest,
   Multigenics Intensive Care Formula without Iron, Nervous Tension
   Remedy, Perfect Protein, ProGain, Selestro, Serengen, Spectrazyme,
   Trancor, Ultra Flora Plus DF.
The Natural Bladder
   www.thenaturalbladder.com
   (800) 566-5522
   Product: Bladder-Control.
Light Force Distributors
   Roger and Diana Doucet
   www.lightforce2.com

(909) 595-1495
Products: Max GXL, Vital PSP and other unique quality products.
Say you were referred by Ann Boroch.

Olympian Labs
www.olympianlabs.com
Products: Anxiety X, Depress X, Glu-Chon-MSM.

Pacific Botanicals
www.pacificbotanicals.com
(541) 479-7780
Products: Organic fresh and dried bulk herbs to make tea (red clover
—Red Clover, herb OG, and pau d'arco). Buy one pound at a time to
ensure freshness.

Phut-C (Ionic Spa)
www.phutc.com
(877) 694-3298. Say you were referred by Ann Boroch.

Pure Water Place (Structured matrix water filtration systems for
home/office)
www.purewaterplace.com
(888) 776-0056 (toll free)

Vitamin Warehouse (Supplement warehouse that sells name brands at a
reduced cost)
www.vitacost.com
Brands: Alacer, Bernard Jensen Products, Carlson, Garden of Life,
Jarrow, Nature's Way, Nutritech, Nutrition Now, Rainbow Light,
Source Naturals, Traditional Medicinals, Twin Labs,
World Nutrition.

Waiora
http://www.mywaiora.com/740982
(866) 699-3467
Product: Natural Cellular Defense.

World Nutrition
www.nutrascripts.com
(866) 586-7246
Customer Login: boroch; password:b65ic3
Product Code: 001 (90 capsules); 002 (180 capsules); 003 (360 capsules)
Product: VitalzymX, (Professional Strength Systemic Enzyme).

## Laboratories

Diagnos-Techs
    www.diagnostechs.com
    (206) 251-0596
    Salivary hormonal testing.

Genova Diagnostics
    www.gdx.net
    (800) 522-4762
    Stool testing for Candida, parasites, and gluten intolerance.

Immunosciences Lab., Inc.
    www.immuno-sci-lab.com
    (310) 657-1077
    Blood testing for candida, allergies, autoimmune diseases.

Women's International Pharmacy
    http://www.womensinternational.com
    Bio-identical hormone replacement therapy.

## Manufacturers and Suppliers of Specialty Foods and Beverages

Food for Life
    www.foodforlife.com
    (800) 797-5090
    Yeast-free, wheat-free breads and tortillas.

French Meadow Bakery
    www.organicbread.com
    (612) 870-4740
    Yeast-free, wheat-free breads.

Teeccino
    www.teeccino.com
    (800) 498-3434
    Caffeine-free herbal coffee (assorted flavors).

Traditional Medicinals
    www.traditionalmedicinals.com
    (707) 823-8911
    Pau d'arco and other blends of organic and herbal teas.

# NOTES

### CHAPTER 1

1. William G. Crook, *The Yeast Connection: A Medical Breakthrough*, (New York: Vintage Books, 1986).
2. Andrew Weil, *Spontaneous Healing: How to Discover and Enhance Your Bodies Natural Ability to Maintain and Heal Itself*, (New York: Ballantine Books, 1995).

### CHAPTER 2

1. Michael Goldberg, www.neuroimmunedr.com/index.html.
2. Christina M. Hull, and M. Ryan, "Evidence for Mating of the 'Asexual' Yeast *Candida albicans* in a Mammalian Host," *Science* 289 (5477) (2000): 256–57.
3. C. Orian Truss, *The Missing Diagnosis* (Birmingham, AL: The Missing Diagnosis, Inc., 1985).
4. David Perlmutter, *Brain Recovery.com: The Powerful Therapy for Challenging Brain Disorders* (Naples, FL: Perlmutter Health Center, 2000).
5. David Perlmutter, "Fatigue in Multiple Sclerosis," *Townsend Letter for Doctors and Patients* (1995): 6–11.
6. William G. Crook, *The Yeast Connection Handbook* (Jackson, TN: Professional Books, Inc., 1999).
7. J. P. Nolan, "Intestinal Endotoxins as Mediators of Hepatic Injury: An Idea Whose Time Has Come Again," *Hepatology* 10 (5) (1989): 887–91.
8. C. Orian Truss, *The Missing Diagnosis* (Birmingham, AL: The Missing Diagnosis, Inc., 1985).

### CHAPTER 3

1. Keith W. Sehnert, Gary Jacobson, and Kip Sullivan, "Is Mercury Toxicity and Autoimmune?" *Townsend Letter for Doctors and Patients* (August/September, 1999): 100–03.

2. Donald H. Gilden, "Viruses and Multiple Sclerosis," *JAMA*; (2001) December, 286 (24), 3127–29.

3. Miller, et al., *British Medical Journal* 2 (1967): 210–13.

4. D. Geier, and M. Geier, "Chronic Adverse Reactions Associated with Hepatitis B Vaccination," *The Annals of Pharmacotherapy* 36 (12), (2002): 1970–1971.

CHAPTER 4

1. Gerald Ross, "Toxic Brain Syndrome: An Interview with Gerald Ross, M.D.," *Mastering Food Allergies* XI (2), ( March–April 1996).

2. Ann Louise Gittleman , *How to Stay Young and Healthy in a Toxic World* (Chicago: Keats Publishing, 1999).

3. Ray C. Wunderlich, Jr, and Dwight K. Kalita, *Candida Albicans: How to Fight an Exploding Epidemic of Yeast-Related Diseases* (New Canaan, CT: Keats Publishing, Inc., 1984).

4. Sharon Begely, "The End of Antibiotics? Antibiotics Are for Bacterial Infections and Patients Demand Them for Colds, Flues," *Newsweek* (March 28, 1994): 47–51.

5. F. Batmanghelidj, *Your Body's Many Cries for Water* (Falls Church, VA: Global Health Solutions, Inc., 1995).

CHAPTER 5

1. M. Percival, *Functional Dietetics: The Core of Health Integration* (Ontario, Canada: Health Coach Systems International Inc., 1995).

2. Jeffrey S. Bland, "Leaky Gut, a Common Problem with Food Allergies," (Interview with Jeffrey Bland, Ph.D., by Marjorie Hunt Jones, R.N.), *Mastering Food Allergies* VIII (5), (Sept–Oct 1993).

3. N. Klotz, and N. Ulrich, "Natural Benzodiazepines in Man," *The Lancet*, vol. 335 (1990): 992.

CHAPTER 6

1. Serammune Physicians Laboratories, *Health Studies Collegium Information Handbook* (Reston, VA: Serammune Physicians Laboratories, 1992).

2. US EPA Office of Toxic Substances, Stats from 1989 Toxic Release Inventory National Report, 1989.

3. W. Ott, and J. Roberts, "Everyday Exposure to Toxic Pollutants," *Scientific American* (February 1998): 86–91.

4. Gerald Ross, "Toxic Brain Syndrome: An Interview with Gerald Ross, MD," *Mastering Food Allergies* XI (2) (March–April 1996).

## CHAPTER 7

1. Shad Helmsetter, *What to Say When You Talk to Yourself* (New York: Pocket Books, 1986).

## CHAPTER 8

1. John Parks Trowbridge, and Morton Walker, *The Yeast Syndrome* (New York: Bantam Books, 1986).
2. C. Orian Truss, *The Missing Diagnosis* (Birmingham, AL: The Missing Diagnosis, Inc., 1985).
3. John Parks Trowbridge and Morton Walker, *The Yeast Syndrome*.
4. Ibid.
5. Ibid.

## CHAPTER 9

1. G. Wolswijk, "Chronic Stage Multiple Sclerosis Lesions Contain a Relatively Quiescent Population of Oligodendrocyte Precursor Cell," *Journal of Neuroscience* 18 (1998): 601–09.
2. J. Noseworthy, et al., "Multiple Sclerosis," *New England Journal of Medicine*, vol. 343 (13) (2000): 938–52.
3. David Perlmutter, *Brain Recovery.com: The Powerful Therapy for Challenging Brain Disorders*, (Naples, FL: Perlmutter Health Center, 2000).

## CHAPTER 10

1. F. Batmanghelidj, *Your Body's Many Cries for Water* (Falls Church, VA: Global Health Solutions, Inc., 1995).

# INDEX

Dyer, Wayne, 176
dysbiosis, 72–73

E. Coli (*Escheria coli*), 112
EAP (ethanol-amino-phosphoric
    acid), 115
earth's magnetic field, stress
    reduction from, 141–42
EFAs. *See* essential fatty acids
Effexor, 31
eggplant allergy, 66
eggs
    allergy to, 66
    Egg Salad, 227
    Pico de Gallo Omelet, 225–26
ego, moving out of, 156
electromagnetic fields (EMFs), 82
    balancing, 135
    in human body, 146
eliminating foods, 58
elimination, 74, 100
    bowel movements, 100, 110
    quality of diet and bowel
        function, 55
    supplements for problems in, 252
Emergen-C Lite powder (Alacer),
    248, 258
EMFs. *See* electromagnetic fields
emotional and mental fitness,
    143–53
    affirmations, 148–49
    in author's experience, 16–18
    creating your reality, 152–53
    effect of thinking on, 144–45
    hypnosis, 145–47
    moving out of fear and anxiety,
        151–52
    neutrality, 149–50
    reaching subconscious mind,
        145–50
    responsibility for emotions, 150–51
    speaking out loud, 147–48
emotions
    at core of every disease, 87
    effect of diet on, 57

fear-based, 86–87, 144, 149–50
    imbalances in, with *Candida*
        overgrowth, 41–42
    interaction of thoughts and, 85
    and physiological func-
        tioning, 57
    psychological and spiritual stress
        from, 85–87
    refined sugar as pacifier of, 59
    responsibility for, 150–51
    suppressed, as disease factors, 15
Endefen (Metagenics), 256
endocrine system boosters, 262–63
endocrine system conditions
    caused by yeast or fungal
        overgrowth, 40
    from chronic stress, 51
endorphins, 137, 160
energy
    boosters for, 261–63
    created by thoughts, 21
    soul as energy-form, 89
    supplements for, 255–56
energy healing, 22
environment, 79–82
    air quality, 17, 133–34
    balancing electromagnetic
        fields, 135
    checklist for, in treatment plan
        for MS, 265
    chemicals, 79–80
    clean air, 133–34
    clean water, 134–35
    electromagnetic fields, 82
    fungus, 81
    genetically altered food, 80–81
    indoor pollution, 80
    internal, 45–46
    molds, 81
    nontoxic cleaning and body-care
        products, 135
    tap and bottled water, 81
    xenoestrogens, 82
environmental management,
    133–35

# ABOUT THE AUTHOR

**Ann Boroch** is a Naturopath, Certified Nutritional Consultant, Certified Iridologist, and Clinical Hypnotherapist. She is also an

inspirational speaker letting us know that with choice and diligence each one of us has the power to overcome any challenge.

Ann has helped thousands of patients to achieve optimum health. She has been in private practice for nine years in Los Angeles, California. She specializes in allergies, auto-immune diseases, gastrointestinal disorders, and is an expert on *Candida albicans.*

PHOTO BY LEE WYLDE

For more information visit her at:
    Web site: http://www.annboroch.com
    Email: ann@annboroch.com
    Phone: (818) 763-8282